Advanced Lithography

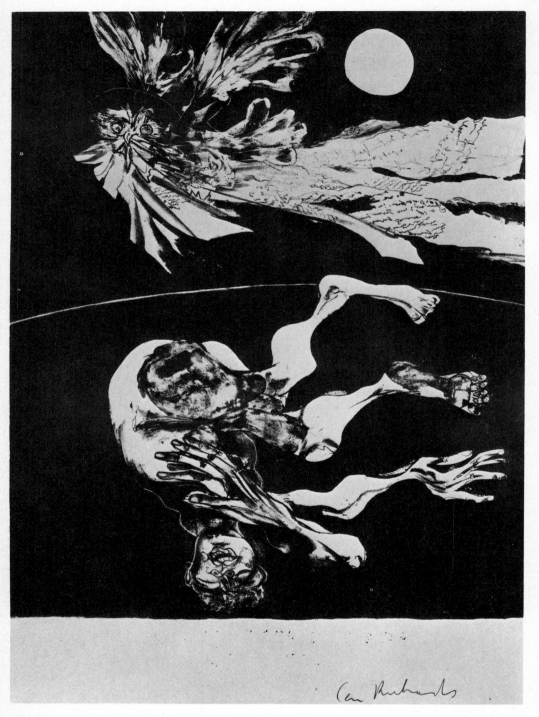

Ceri Richards, *Do Not Go Gentle into that Good Night*, from the *Dylan Thomas Suite*, 1965. Colour lithograph, 81.9 × 60.3 cm. Courtesy, Marlborough Graphics, London.

Richard Vicary

Manual of
Advanced Lithography

Charles Scribner's Sons
New York

1 3 5 7 9 11 13 15 17 19 I/C 20 18 16 14 12 10 8 6 4 2

Printed in Great Britain
Library of Congress Catalog Card Number 76–56890
ISBN 0–684–14937–0

Contents

Acknowledgements

Firstly, I would like to thank those artists who have generously given permission for their lithographs to be reproduced.

I am also indebted to the following persons, schools, print workshops, and galleries for their patient and willing co-operation in supplying research information, illustrations or facilities for photographing: the principals and staffs of Camberwell School of Arts and Crafts, London; Newport College of Art and Design; Shrewsbury School of Art; the Trustees of the British Museum; the BBC, Written Archives Centre; the Courtauld Institute; Rosemary Simmons of Curwen Prints Ltd; Stanley Jones, Bert Wootten and the staff of the Curwen Studio; the Escher Foundation, Haags Gemeentemuseum, the Hague; Messrs Hawthorne Baker Ltd, Dunstable; Ganymed Original Editions Ltd, London; Gemini G.E.L., Los Angeles; Pat Gilmour of the Print Department, the Tate Gallery; the Limited Editions Club, Avon, Connecticut; Jean Madison of the Lithography Workshop, London; the Galerie Maeght, Paris; Marlborough Graphics, London; the Petersburg Press, London; the Philadelphia Print Club, USA; Andrew Stasik, Director of the Pratt Graphics Center, New York; Soag Printing Machinery; W. J. Strachan; the Tamarind Institute, University of New Mexico, Albuquerque; Tatyana Grosman of Universal Limited Art Editions, Long Island; the Rector and staff of the Mukhina School of Art and Industry, Leningrad.

For research and help in more technical matters, I record my appreciation to W. S. Cowell Ltd of Ipswich; Anthony Ensink, Chicago; the Forrest Printing Ink Company, London; Jack Maisey of the Rubber and Plastics Research Association.

The work on paper plates, involving washes, transferring and colour printing, was carried out using an Alitho kit, generously supplied by Messrs E. J. Arnold and Son, of Leeds.

Finally, I again express my gratitude to Gerald Woods for the photographs of craft processes which he took at Camberwell School of Art, and also for his continuing interest in this project.

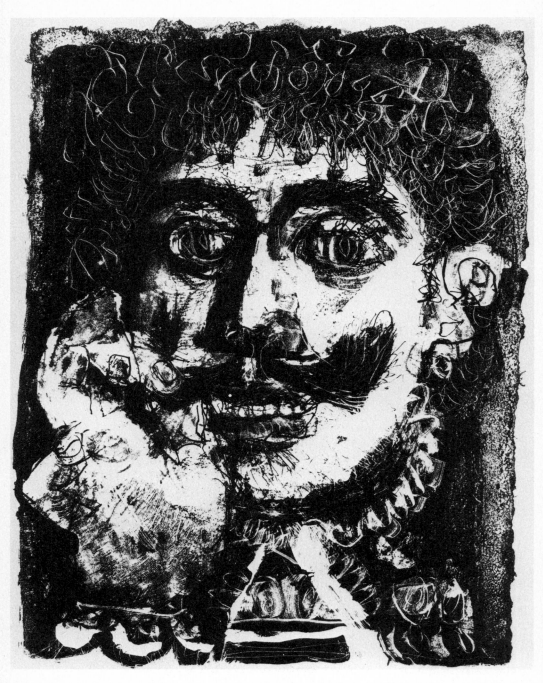

Antoni Clavé, *Baron Thunder ten Tronckh*, from Voltaire's *Candide*, Paris 1948. Black–and–white lithograph, 25 × 19 cm, using transferred handprints. Courtesy of W. J. Strachan.

Introduction

This volume deals mainly with those techniques which artists have embraced since 1950. This does not imply that these methods were not in existence before that date, but only that they have now become an accepted part of the lithographer's repertoire. While some of them are recent innovations made by artists, others are adaptations of commercial processes which have been in use for many years, and which, in some cases, have been discarded by industry. For example, transferring, which used to form a major part of the commercial lithographer's work, has largely been superseded by photographic methods of transfer and image multiplication, while autolithography is now rarely used as a commercial illustrative process. That the artist does not only borrow outdated processes is demonstrated by the employment of packaging techniques in the fabrication of three-dimensional prints, and the increasing use of photography as an image-making process.

This employment of readymade imagery has led to an intensification of the argument about what constitutes an original autographic print, and some say that lithographs which incorporate photographic processes are not eligible to be included in this category. This would seem to be a rather arbitrary decision, for similar pronouncements have been made in the past about artists whose work is now revered; a more equitable method of judgement might be based on whether the process has been used in a creative rather than a reproductive manner.

Many lithographers still find that direct autographic methods are more than sufficient for the realization of their ideas; it may be significant that for many of these artists lithography is a secondary means of expression, and their main efforts are used in other directions.

The tendency in contemporary printmaking is towards a more all-embracing concept of the various media involved; each method is regarded as being equally important, whether it is the humble linocut or the etching. This is very different from the atmosphere prevailing in Britain until the nineteen-thirties, when certain institutions would not allow lithography to be practised because etching was considered to be the only really acceptable printmaking craft. A logical and interesting development resulting from this more liberal

attitude has been the mixed-media print, in which the language of each method can make its own unique contribution.

Up to the nineteen-fifties, it was generally believed that letterpress printing would never be superseded. This belief was mainly due to the fact that the setting of metal type was still essential, and the transfer of its printed image to a litho plate necessitated the use of extra processes. The quality of reproductive colour printing by lithography was also much inferior to letterpress standards. However, within the space of five or six years, lithography was enriched by the developments of web-offset, photo-typesetting, and fine-grained and deep-etched plates capable of giving colour reproduction equal to the best that letterpress could offer. Thus, letterpress printing suffered a body-blow, and it now seems likely that its future may once again be in the hands of the artist-craftsman for the production of books in limited editions. It would seem that the artist-lithographer, similarly isolated from his commercial outlets, could find a promising future working within the disciplines of both crafts in the manner pioneered by Vollard at the turn of the century, which is being increasingly employed in printmaking workshops in France, Britain and America.

Oskar Kokoschka, *The Spirit of God came upon Saul*, from the portfolio *Saul and David*, 1968. Colour lithograph, 42.5 × 32.5 cm. Courtesy, Marlborough Graphics, London.

1 Basic chemistry

The principles of the lithographic craft are based on the natural phenomenon known as 'adsorption'. This is the ability of certain substances to form a close union with one another which is neither truly chemical nor truly physical. The most common example of this action is the effect of using soap in hard water, that is, water that contains limestone in solution. Instead of dissolving, the soap is adsorbed by the limestone to form a greasy insoluble precipitate. Similarly, when a drawing is made on a litho stone (limestone), using a crayon or ink composed mainly of soap, the fats combine with the stone to make an insoluble greasy image, which can only be totally removed by grinding away the surface. Since the stone is porous, the longer the fat remains in contact with it, the deeper it will penetrate, thus allowing more fat to be adsorbed.

If the undrawn areas are coated with gum arabic, they will be effectively sealed from any further contact with the grease. The gum will also penetrate into the pores of the undrawn stone, and because of its hygroscopic nature, will always be ready to take up water when it is applied. The gum is also adsorbed by the stone, and it is considered that the three main lithographic surfaces, stone, zinc and aluminium, adsorb it preferentially compared with the fat.

When both the image drawing and the gum have dried, it is possible to wash off the surplus gum with water and clean off the surplus ink with white spirit. It is only when this stage has been reached, that the division between the printing and non-printing areas can be appreciated. The image area is not only dry, but greasy and completely antipathetic to water; the non-printing areas are wet, and while in this state, it is impossible to deposit ink on them. When they are dry, they will accept ink or grease, but as soon as they are damped with a sponge, the grease is lifted away, leaving the areas clean.

This principle of adsorption operates to a lesser extent on marble, which is a harder form of limestone, and very efficiently on zinc or aluminium. It can also be applied to the paper plates, but it does not operate on other metals such as copper or iron. It is believed that the fat and the gum form mono-molecular layers on the limestone or metal, owing to some form of interlocking in the molecules, and

that these layers are sufficient to transform the quality of the surface to make lithographic printing possible.

Of the two areas, the gummed portion is the more easily removed. This can be done on stones or plates by dissolving the limestone or metal beneath the gum with a suitable solvent, exposing a clean, grease-sensitive surface once again.

Soap is a compound formed by treating sebaceous fats or tallow with either caustic soda or caustic potash. This alters the character of the fat so that it becomes equally soluble in water or spirit. The process of adsorption removes some of the insoluble fatty acid in order to make the image, and because this is in depth on the stone, it is more difficult to remove. Repeated applications of nitric acid will eventually dissolve the limestone from beneath the image, which will therefore become detached. Using these methods of erasure and resensitizing the background allows corrections and additions to be made to the image.

Because metal plates are not porous the image lies on the surface, and is therefore more vulnerable. It can be easily returned to a water-soluble state by the application of a caustic solution, and while in this condition it can be rinsed off with water.

Before any printing is carried out using the metal plate, the tenuous surface image left after washing out the drawing must be reinforced. The compound used for this purpose is made from asphaltum and turpentine, and is known as washout solution. It dries as a brown, greasy film which protects the image and also acts as an ideal base on which to roll up the ink.

If prolonged printing were undertaken either on the plate or the stone without any further preparation, both the printing and non-printing areas would deteriorate, leading to image coarsening or weakening, and scumming on the background. Therefore the further procedure of *etching* is necessary to establish these areas so that they can function efficiently over a long period. Etching is rather a misnomer, as no palpable erosion occurs on the surface, even though the dilute acids used affect both the image and the non-printing background.

These dilute acids – nitric acid for stones and tannic acid for plates – when they come into contact with the greasy ink, cause the fatty or stearic acid to be released, thus making it more readily available for adsorption by the metal or stone. Stearic acid forms the solid, insoluble part of soap or similar compounds. Thus, on the stone and the plate, etching produces a denser image, which can be seen by comparing a proof taken before etching with one taken after etching, using the same ink and paper, to keep the conditions constant. See the plates on p. 100.

When the stone is etched, the nitric acid also has the effect of very slightly enlarging the pores, which in turn increases the surface area, so that it is capable of adsorbing a greater amount of gum.

Henry Moore, *Two Reclining Figures in Yellow and Red*, 1967. Colour
lithograph, 79.5 × 56.5 cm. Courtesy, Marlborough Graphics, London.

The action of the plate etch is rather different, as it does not appear to react directly with the metal, but only on the adsorbed gum film. Tannic acid has a powerful astringent action, so that the gum would tend to be compacted into a denser and tougher layer. When the plate is damped, this mixture of gum and etch takes up the water, swelling slightly in the process, to form a damp, leathery grease-rejecting surface which is more resistant to wear and abrasion than the plain gum. Thus its effect on the gum is analogous to its effect on hide. Untreated, both substances become brittle, the gum when it is dry and the hide when it ages (unless it is tanned, when it will be turned into leather).

To prepare the plate for etching, after washing out the drawing and cleaning off the surplus gum, the image is rolled up with press black ink. In the case of the plate image, it is usually first coated with washout solution. Press black ink is a greasy, non-drying printing ink, rich in fatty acids, and designed for the purpose of preparing the lithographic image for the etching procedure. (It has other uses in the studio, which will be described in later chapters.) Etching takes place when the image is properly charged with this ink, and this stage is judged by the appearance of the proofs which are taken while rolling up.

Since this rolled-up image is now very greasy, any aqueous solution applied to it would be thrown off, and such are the natures of both substances that the water-borne etch would retreat to a position where it is not in contact with the image, leaving a dry, unetched strip surrounding each particle of ink. If proofing were to be undertaken while the plate was in this condition, the ink would spread to these areas. This factor also operates when gumming the original drawing, so that the aqueous gum solution would retreat in the same way. Thus with both the initial gumming and the etching of the rolled-up image, it must be ensured that these areas are efficiently desensitized, and will not react to grease. This is done by dusting the image with resin and french chalk, which has the effect of temporarily destroying the greasiness of the image, so that it is completely wettable. It is normal practice to use only french chalk when dusting the initial drawing. When etching, this dusting serves a twofold purpose. It allows the etch to act on the background right up to each part of the image perimeter and in the finest interstitial space in textured or chalked areas. At the same time, the etch can penetrate the ink to release the fatty acids. Unfortunately, if the etch is allowed to remain on the image for too long a period, it will begin to erode the basic adsorbed image, so that when proofing is resumed afterwards, ink will not be accepted from the roller. Therefore, both the strength of the etching solution used, and the time that it is allowed to remain on the plate are critical. Even so, the post-etching image, apart from the denser quality of its blacks, possesses a crispness and contrast that are lacking in proofs which were taken previously. Close inspection will reveal

John Selway, *Pot of Flowers*, 1973.
Black-and-white lithograph.
Courtesy, Newport College of Art
and Design.

that the white areas have acquired more brilliance because
the non-printing areas of the plate are cleaner and are re-
jecting the ink more efficiently. It will also be noticed that
the image itself has suffered a minute erosion which has
caused some of the very small particles of ink to disappear.
Naturally, this effect is more pronounced on textured areas
and on fine pen work. Solid tints are not affected to such
a degree.

When etching is complete, the plate or stone must be
gummed. At this stage, it might be expedient to consider
the nature and action of this substance.

Gum arabic is a true gum, that is, it is readily soluble in
water, but is untouched by spirit. Until the recent intro-
duction of cellulose gums, it was the only known substance
which would effectively desensitize the non-printing areas
of a litho stone or plate. It is obtained either in powder form,
or in the brittle, pebble-shaped lumps of its unrefined state.
These are added to water to dissolve, and the resulting
solution should be strained before use to remove any foreign
matter.

As the dry gum is added to water to form an increasingly
concentrated solution, its viscosity also increases, but for

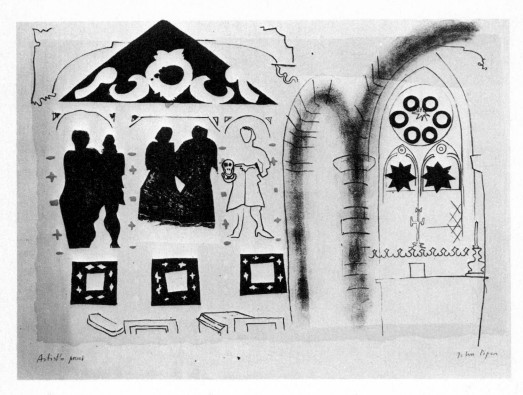

John Piper, *Rudbaxton, Pembrokeshire,*
from *A Retrospect of Churches,* 1964.
Colour lithograph, 59.4 × 81.9 cm.
Courtesy, Marlborough Graphics,
London.

concentrations between 0·4 per cent and 1·4 per cent, the
increase in viscosity is not linear. The nature of this difference
indicates that the small particles of gum start to aggregate
into larger particles at 0·4 per cent concentration, and that
the change is complete at 1·4 per cent concentration. These
changes apply to a solution of 7·6 pH value. At other pH
values, the onset of aggregation is delayed, and the period
over which the change takes place is longer. Thus the pH
value appears to be a controlling factor in these changes.
An adsorbed layer of gum arabic in its aggregated form is
more hydrophilic than a layer in particle form, and thus
produces a more efficient grease-rejecting surface. It would
seem that the relative concentration and pH values of the
gum solution are fairly critical to efficient lithography, so
that solutions of under about 2 per cent concentration (2 g
of dry gum arabic to 100 cc of water), should not be used.
Gum arabic is naturally acid, but this quality is so weak that
it does not appear to react with either the metal or the stone.

The gum is used during the process in a pure aqueous
solution, or with this solution combined with the appro-
priate etch, nitric acid for stones and plate etch for zinc or
aluminium. In this state it is known as gum/etch. Frequently,
these solutions are used for gumming up the original draw-
ing, either on the plate or the stone, as the case might be.
In fact, with regard to the plate image, it can be considered
as normal practice, and the occasions on which plain gum

is used as exceptions. Its use in this context usually ensures that the plate remains much cleaner during the rolling-up process, and that there is less tendency for the image to thicken. It may well be that with certain types of image an initial gumming with a gum/etch solution will render a full etch unnecessary. When gum/etch is used in this way it is known as 'giving a first etch'. The type of image which can become established without the aid of a full etch includes wash drawings, or similar drawings which involve the use of a thin, diluted litho writing ink.

Although tannic acid can be mixed in the studio from the fine crystalline powder, this is not an economic method. Certain proprietary makes are available, including Victory etch, which is based on tannic acid, and should be diluted to an appropriate strength, and Atzol, which is a ready-mixed gum/etch. This latter solution is made from gall nuts, a natural source of tannic acid. It, again, can be diluted to required strengths, usually with gum arabic. If required, a

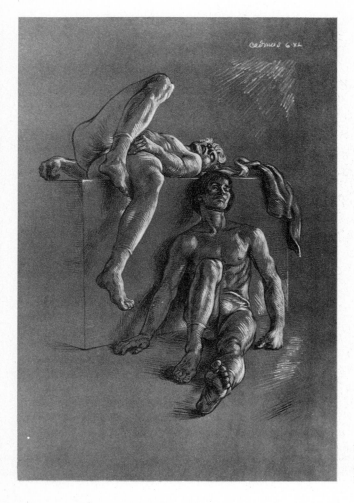

Paul Cadmus, *Dancers Resting*.
Colour lithograph, 63 × 45 cm.
Courtesy, Pratt Graphics Center,
New York.

17

gum/etch can be mixed using Victory etch and gum arabic, and this will have similar characteristics to Atzol.

With regard to the stone, the action of the nitric acid is more positive, and can be measured by the degree of effervescence which occurs after it has been applied. This reaction will continue until all the acid in the solution has been neutralized by the limestone. During this chemical reaction, carbon dioxide is released, and calcium nitrate is formed on the surface. Since this substance has no affinity for grease, its presence is helpful, and is another indication of the suitability of nitric acid as a stone etch.

Stones vary in colour from grey to pale buff, and this is an indication of their hardness, the darker grey stones being the hardest and the buff-coloured stones the softest. To achieve the same degree of effervescence on a hard stone that would occur on a soft stone, the acid would need to be more concentrated. The strength of the acid used for the different purposes is gauged by the degree of effervescence which is produced. These can be described as: a faint effervescence two or three seconds after applying the solution; a slow effervescence; and a brisk effervescence. Therefore, if a hard stone is being worked, these solutions would have to be adjusted, if they do not produce the reaction required. The weakest solution is normally used as a gum/etch for the initial gumming; the next can be used both as a gum/etch and as a dilute aqueous solution for the main etch, while the strongest solution, which contains no gum, is reserved for cleaning operations on the non-printing areas and the edges. This acid should never be allowed to touch the image. Because of the vigorous effervescence caused by this strength of acid, lithographers talk of 'boiling' the edges.

Thus, the major purposes of etching are to produce a stable image, and background areas which are resistant to scumming and durable under prolonged presswork. It must be borne in mind that, in a sense, the image is being constantly renewed by the addition of ink before each proof is taken, while the background is only kept functioning by the addition of water. From this, it could be expected that the grease-rejecting properties of the non-printing areas are more likely to break down than the image, and in practice, this is found to be true. One of the commonest troubles is the encroachment of the image on to the adjacent non-printing area. If unchecked, this alteration, which is at first only temporary, can become permanent and result in an image that is well removed from the artist's intentions.

Another manifestation of an inadequately prepared non-image area is the ease with which it will pick up ink from a roller. This is called 'scumming', and while initially of a temporary character, it can become established as the fat from the printing ink is gradually adsorbed by the plate surface to make the condition permanent.

2 Basic processes on stones and plates

The various stages in preparing a stone or plate for printing either in colour or monochrome may be summarized under the following headings.

1 Removing the old work from the stone and preparing its surface to receive the new (grinding, polishing and graining). Any analogous procedure that may have to be completed on the plate.

2 Applying the design to the surface. This may be by autographic means, by photography, by transfer, or by a combination of these methods.

3 Gumming the surface, to include both the image area and the non-printing background.

4 Proving the stone or plate. This consists of preparing the image to receive the press black, rolling up in press black, taking proofs to assess the state of the image, making any necessary corrections, etching and gumming up the plate or stone.

5 Proofing in colour or monochrome.

6 Washing out the coloured ink, rerolling with press black, and gumming the surface for storage.

Elfi Schuselka, *Landscape*. Colour lithograph, 36 × 33 cm. Courtesy, Pratt Graphics Center, New York.

WORK ON STONES

Stones may be used with either a polished or grained surface, depending on the character of the proposed work and the choice of the lithographer. The process is done in a graining trough which, by its nature, must be a fixture in the studio, as it has to be connected to running water, and also to a drainage system.

The old work is washed off with white spirit and water, and the surface is then ground away using a coarse grinding sand (about 80 grade), water, and another stone of similar size, or a levigator. During the process, the surface must be kept flat and as near as possible parallel to the bottom of the stone. This is frequently checked with a straight-edge and callipers. When the old image has been removed, the surface is smoothed with a pumice block, unless the very coarse grain left by this process is required, in which case, after the edges have been rounded, the stone is ready for use.

Ceri Richards, *And Death Shall Have
No Dominion*, from the *Dylan
Thomas Suite*, 1965. Colour
lithograph, 60.3 × 81.9 cm.
Courtesy, Marlborough Graphics,
London.

Polishing with the pumice block leaves the surface covered
with fine scratches, and to remove these it is polished with
a snakestone block. This must be continued until all the
scratches have been erased. When this is complete, if the
stone is required for fine line work or accepting transfers,
after the edges have been rounded and the stone washed
clear of grit it is ready for use.

An abrasive of the required grade of coarseness is sieved
on the wet surface of the stone, and the process of graining
is undertaken using a marble muller or a grainer made from
a piece of broken litho stone. The progress of this operation
must be closely watched in order to avoid under-graining,
or keeping the abrasive in use for too long a period, which
would result in a rounded grain of little character. A linen
prover is a helpful aid in checking this. When the graining
has been completed, the edges are rounded. Initially this is
done with a stone file, so that there is a gradual transition
between the working surface and the sides of the stone. This
process leaves grooves which must be removed with a file,
followed by a pumice block. Rounded edges discourage
chipping or fracturing, and keep themselves clean while the
stone is rolled. When this is complete the stone is ready.

Basic gumming

Gum arabic 50 parts, nitric acid 1 part by volume will give
a faint effervescence a few seconds after application. The

strength of this solution makes it suitable for most normal lithographs, comprising chalk work and solids. The gum must be dabbed on to the image, making sure that the smallest non-printing areas are coated. The stone should then be left for six hours before proceeding with the next process.

The following variation in the strength of the solution should be made for wash drawings or work which consists mainly of light chalking. This type of image should be left for six hours before gumming with a solution which should cause no effervescence. The 50:1 solution used previously can be gradually diluted with gum arabic, and tested on the edge of the stone until no effervescence occurs. If the drawing is particularly fine or delicate, plain gum should be used. Because they are more tenuous, drawings on polished stones are usually gummed with plain gum.

When mixing dilute solutions using concentrated acid, the acid should always be added drop by drop to the water or the gum arabic solution. Water should *never* be added to concentrated acid as an explosion is possible.

Proving stones

This takes place on the transfer press.

1 Wash the gum from the stone with a clean sponge and water.

2 Keeping the stone wet, wash out the drawing with white spirit and rag, until it appears as a grey image against the stone.

3 Wash the stone clean with water and rag, then take up the excess moisture with a clean sponge so that the surface is damp only.

4 Roll up with press black, keeping the stone damp, taking proofs until a good black proof has been obtained.

5 Roll up again to recharge the image.

6 Dust with resin and french chalk. Wipe off the surplus and clean the surface with water.

7 Make any alterations and corrections which may be necessary and, using a snakestone slip, clean away any marks from the non-printing areas.

8 With strong acid (water 5 parts, acid 1 part), boil the edges. A vigorous effervescence will result. On no account should this solution be allowed to touch the image.

9 Squeeze water all over the stone to clear the strong acid, taking care not to let it spread across the work.

10 Either with a solution of gum arabic 10 parts, nitric acid 1 part, cover the surface and allow it to dry, or, with a solution of water 10 parts, nitric acid 1 part, cover the surface and leave for one minute. Wash clean and gum with plain gum. These concentrations produce a slow effervescence.

11 Mix and roll out chosen colour.

12 Repeat numbers 1, 2 and 3.

13 Roll up in colour, taking proofs.

14 When colour printing is complete, repeat numbers 1, 2 and 3.

15 Roll up in press black, then gum the surface. When dry, the stone can be stored until it is needed again. Stones should never be stored when rolled up in colour, or while the gum is still wet.

Nitric acid etches should always be tested on the edge of the stone before applying them to the image. The proportions given should be regarded as guides, since different stones may require slightly different concentrations to produce the same degree of effervescence.

Processing wash drawings

Because this type of work is more tenuously held, even the process of washing it out may further weaken it. The following method should be adopted.

1 Wash off the gum with clean water.

2 Keeping the stone damp, roll up the press black directly over the drawn image. This will strengthen the work, allowing it better to withstand an etch.

3 Take proofs. As soon as the image shows signs of thickening, stop rolling.

4 Dust with resin and french chalk. Clean stone with water and fan dry.

5 Gum up the stone, rubbing it well into the image area.

6 When the gum is dry, the stone can be processed as for the average drawing.

WORK ON PLATES

Except as described in Chapter 9, metal plates are supplied by the makers ready grained, and are returned to the factory for regraining, or, if they are the thin variety which cannot be regrained, for exchange under the various arrangements which exist.

Graining is functionally more important to the plate than it is to the stone. While the stone's ability for holding damping water is unimpaired whether it is grained or polished, the plate is unable to retain sufficient water for printing unless its surface has been grained. The effect of graining is approximately to treble the surface area of the plate, so this increased surface allows more extensive adsorption of the fat and the gum than would be possible in the same linear area ungrained. This fact also explains why drawings on the polished stone are more tenuously held than they are on the grained stone.

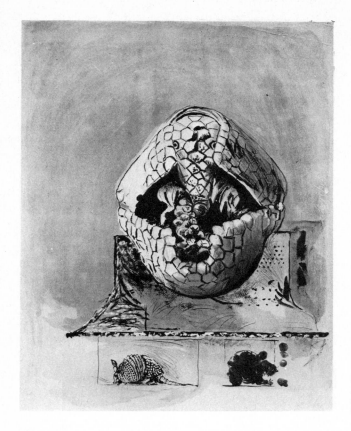

Graham Sutherland, *Armadillo*, from *A Bestiary*, 1968. Colour lithograph, 66 × 51 cm. Courtesy, Marlborough Graphics, London.

Basic gumming

Before commencing the drawing, it is normal practice to gum a margin round the edges of the plate, at least half an inch wide. Since corrections or deletions are more difficult to make on the plate, this margin prevents any transfer of grease from the hand. When a series of offsets are being made for a coloured print, this edge gumming is delayed until the registration marks have been drawn, when the gumming can be extended up to the image boundary.

The gum/etch can be made by mixing a small proportion of the plate etch with the plain gum. The recommended proportion varies with the authority. For wash drawings and light work, Atzol diluted with an equal volume of gum solution would be suitable. An alternative solution is provided by diluting Victory etch with six or seven times its own volume of gum solution. Both of these can be used on aluminium, although some lithographers may prefer a solution of gum arabic 50 parts, phosphoric acid 1 part.

Before gumming the plate, it is usual to dust the image with french chalk. This enables the gum to desensitize the background adjacent to each particle of image.

Proving plates

1 Using white spirit and rag, wash out as much as possible of the image, without removing the gum.

2 With a rag and water, wash off the gum, then, keeping the plate wet, continue to wash out the drawing until it appears as a dry, slightly discoloured area against the background.

3 Keeping the plate damp, gently wipe washout solution on to the image. Wipe the plate clean with a damp rag.

4 Keeping the plate damp, roll up in press black, taking proofs until a good black proof has been obtained.

5 Roll up again to recharge the image.

6 Dust with resin and french chalk. Wipe off the surplus and clean the plate with a damp rag.

7 Make any necessary alterations or corrections. Clean away marks from the non-printing area.

8 With a small sponge, liberally coat the marginal areas of the plate with etch, then recharge the sponge and coat the image area.

9 After the required length of time, clean off the etch with water and sponge. If the plate is very large, it may be expedient to etch it in sections.

10 Gum the surface with plain gum, rubbing it well into the image area with the palm of the hand. Allow gum to dry.

11 Mix and roll out chosen colour.

12 Repeat numbers 1, 2 and 3.

13 Roll up in colour, taking proofs.

14 When printing is complete, the colour must be washed out, washout solution applied and the image rolled up in press black, and the plate gummed. Alternatively, the plate can be gummed while it is still in colour, and when the gum is dry, the image is washed out with white spirit and washout solution applied all over the gummed-up plate. The place should never be stored rolled up in colour, or while the gum is wet. Wet gum causes the surface to oxidize, while coloured printing inks dry hard and will be difficult to remove when the plate is required again.

Gumming should never be too thick, especially if the plate or stone is to be stored. In time, as it dries, the gum curls back and flakes off. If this occurs on the image area, particularly on solids, it peels back the ink with it, leaving an anaemic grey patch, which might cause trouble by refusing ink, when the plate is next used. If left for too long, this change can become permanent.

ETCHING PLATES

When etching a stone, the quality of the resulting effervescence is an accurate guide to the strength of the acid, but with the plate, tannic acid-based etches give no obvious

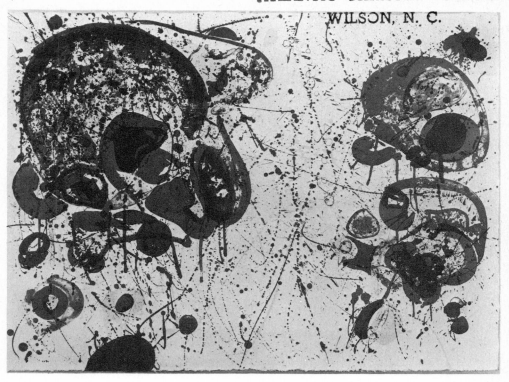

Sam Francis, *Untitled*, 1963. Colour lithograph. 67 × 92 cm. Courtesy, Tamarind Institute, University of New Mexico.

visual indication of the progress of the reaction, although full-strength Victory etch leaves brown streaks on the surface. Chromic acid also has a discernible effect on the plate, and for this reason was at one time widely used by commercial lithographers. Since its toxic effect on the skin became recognized, it is no longer used in the United Kingdom. Thus it is tempting for inexperienced lithographers to use solutions which are too strong, and to leave them on the plate for an excessive period.

Various factors govern the strength of etching solutions. While it is not unreasonable to expect that commercially produced etches should maintain constant standards so that their effect in any given situation would be predictable, variations do occur, and this may be through no fault in manufacture. All natural organic compounds vary in quality, depending on vagaries in climate and changes in local environment. This is certainly recognized with regard to the grape vine and the quality of its fruit, and there is no reason to believe that tree bark or gall nuts do not have vintage years. The recently introduced synthetic gums and etches would not, of course, be affected by this problem.

One other factor which affects the strength of etching solutions is the amount by which dry gum has been diluted with water before being mixed with the etch. The proportions for making a solution of gum arabic of creamy

consistency are, by weight, water 3 parts, dry gum arabic 1 part, although concentrations of the order of water 5 parts, gum arabic 1 part would be equally efficient. When mixing the gum/etch, the more concentrated solution should be used.

Some etching solutions

AGUM Z
A synthetic gum/etch for zinc and aluminium plates. It is a stable and safe compound, similar to Victory etch or Atzol. It is normally used in conjunction with Agum O.

AGUM O
This is a synthetic gum and can be used in place of gum arabic on both stones and plates.

ATZOL
A gum/etch made from gall nut decoction and gum arabic. It is a bland and safe etch, and can be diluted with gum arabic in equal quantities to form a weaker first etch.

HANCO
A cellulose-based etch, popular in the United States. It can be diluted with gum arabic and used as a first etch.

David Hockney, *Pacific Mutual Life Building with Palm Trees*, 1964. Colour lithograph, 51 × 62.5 cm. Courtesy, Tamarind Institute, University of New Mexico.

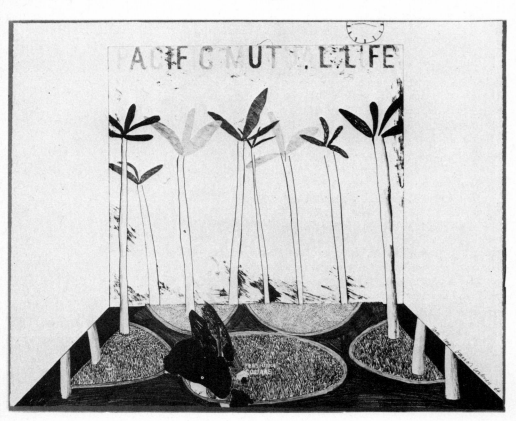

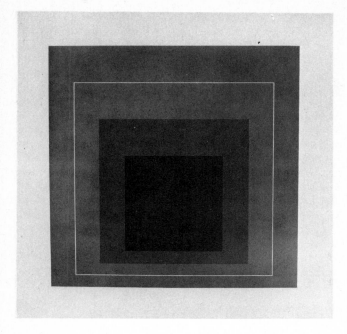

Joseph Albers, *White Line Square (II)
Gray Black IX*, 1966. Colour
lithograph, 53.5 × 53.5 cm.
Courtesy, Gemini G.E.L., Los
Angeles, California.

VICTORY ETCH
Mainly composed of tannic acid. Can be diluted with about
eight times its own volume of gum arabic to form a first
etch. Diluted with water, it is used as a main etch. The
proportions which would suit a strong drawing would be
Victory etch 2 parts, water 1 part. For lighter work and
washes, concentrations stronger than equal quantities of
water and etch would be unwise.

PHOSPHORIC ACID
In its concentrated form, this is a thick, almost colourless,
syrupy liquid. It is now almost exclusively used for alu-
minium. The concentrated acid must first be diluted with
four times its own volume of water. This solution is then
mixed with gum arabic solution in the proportion dilute
phosphoric acid 1 part, gum arabic 10 parts. Alternative
formula for both zinc and aluminium: gum arabic solution
30 oz. (850 g), phosphoric acid 10 oz. (283 g), tannic acid
powder $\frac{1}{2}$ oz. (14 g).

GALL NUT DECOCTION
Senefelder's recipe for making this is as follows. Steep $\frac{1}{2}$ lb.
of gall nuts in half gallon of water for 24 hours. Boil the
mixture for a short time. Cool and strain off the fluid.
This fluid is incorporated with the gum arabic in the
proportion gall nut decoction 20 parts, gum arabic solution
10 parts, phosphoric acid $\frac{1}{2}$ parts.

If the original drawing on the plate has been gummed with
Agum Z or Atzol, or a gum/etch made from Victory etch,

27

it is likely that a main etch will not be required. Used in the diluted strengths indicated above, Victory etch can be left on the work from one to two minutes. When it is diluted with gum in the same proportions and used as a main etch, it can be allowed to dry on the work. The Curwen studio in London use little else but Atzol in various strengths as their main etching compound for zinc and aluminium plates.

Generally speaking, it is better to under-etch rather than over-etch, and if the plate, when being printed, shows signs of under-etching (constant scumming and image spread), it can be put back into press black, dusted with resin and french chalk and re-etched. Since over-etching tends to destroy the basic image, its capacity for accepting ink from a roller will be impaired to a greater or lesser degree, depending on how much it has been damaged. If there is any doubt, it is safer to make several etchings of shorter duration, or with weaker solutions, rather than give a long one. See example on page 99.

DELETIONS AND ALTERATIONS

These processes become necessary when troublesome marks on the background are taking ink, or if some persistent scumming has become established. They are also necessary when the image is deemed unsatisfactory and parts of it have to be erased and redrawn.

The most favourable time for this work to be accomplished is when the image is fully rolled up with press black and dusted with resin and french chalk. This time is chosen so that the alterations can benefit from the etch which is about to follow, but in fact alterations can be made at any time; when making a coloured print, the need for such editing of the images may only be manifest after taking the trial proofs.

Alterations on stones

Non-printing areas of the stone can be cleared of extraneous marks by scraping them out, or by using a snakestone slip. This is done before etching. Scraping is not always advisable in the image area, especially if new drawing is to be made. Scraping, while not affecting the stone's capacity for adsorbing fat or forming a grease-rejecting surface, does ruin the grain, so that any major addition of work becomes obvious through the difference in texture.

Pure carbolic acid when applied to the washed-out image on the stone will prevent it from taking ink. As carbolic acid is not soluble in water, this process can be performed after the rest of the stone has been gummed.

1 Gum all the areas of the stone except the areas to be deleted.

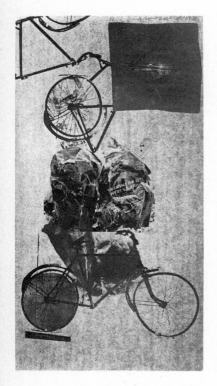

Robert Rauschenberg, *Kitty Hawk*, 1974. Colour lithograph, 200.5 × 101.5 cm, printed on brown wrapping paper. Courtesy, Universal Limited Art Editions, Long Island (Tatyana Grosman Collection).

Jim Dine, *Picabia I (Cheer)*. Colour lithograph. Courtesy, Petersburg Press, London.

2 When the gum has dried, wash out the appropriate areas with white spirit.

3 Apply a little carbolic and gently rub in with a pointed stick. A few drops of petrol can be added if desired.

4 Thoroughly wash stone with water to clear it of gum and carbolic.

5 When dry, dust with resin and french chalk.

6 If extra drawing is needed in these areas, resensitize them with the citric acid or acetic acid solutions (see below).

7 Thoroughly wash the surface to clear it of the resensitizing solution.

8 When dry, make the new drawing.

9 When this is dry, gum or gum/etch should be applied.

10 Wash out, roll up and etch in the normal manner.

11 If no extra drawing is to be made, resensitize the deleted areas, wash the stone to clear the solution and apply the gum/etch. Although the pattern of the previous work

will remain as a discoloration, it should not cause trouble by taking ink.

Additions on stones

When new drawing is needed on a previously desensitized non-printing area, it is necessary to dissolve away the film of gum which shields the stone from the ink, so that clean stone can be exposed. For this process, the lithographer has the choice of two organic acids, citric and acetic. Citric acid is supplied as crystals, indistinguishable from sugar. It is readily dissolved in cold water, and can be mixed as it is required. Acetic acid is a colourless liquid with choking fumes, but not considered toxic. It is used in the concentration of water 3 parts, acetic acid 1 part. The strengths of both these acids should be such that on application to the stone, only the faintest effervescence should occur – some authorities say none. Following their application, the stone should be thoroughly washed and allowed to dry before commencing the drawing.

Alterations on plates

The plate image, being superficial and therefore more vulnerable, is easier to erase than the image on the stone. The use of snakestone slips is sometimes advocated for erasing unwanted marks, but this should be done with care, as any damage to the grain will encourage scumming. It should be possible to erase any unwanted mark by chemical means.

Deletions on zinc

1 Wash plate with water to clear it of gum.
2 If the area to be removed is extensive, wash out the ink in these parts with petrol or white spirit. This will hasten the action of the caustic.
3 Dust area with french chalk.
4 Wash plate with water and thoroughly dry. This is essential as water will carry the caustic to other areas where it is not needed. Apply caustic with a stick which can be sharpened to a point.
5 After a minute or so, wash plate with plenty of water, taking care not to let the caustic touch the sound work.
6 If the erasing is insufficient, the plate must be dried and the process repeated. Note that the caustic spreads quite rapidly over areas which have been dusted with french chalk, so that if these join with work that is to be retained, it would be safer not to use the french chalk, though this will make the action of the caustic rather slower. When treating small spots in the image area, it would be better not to wash out the ink with white spirit, nor to apply the

Jasper Johns, *Decoy II*, 1971–73. Colour lithograph, 124 × 73.5 cm.
Courtesy, Universal Limited Art Editions, Long Island (Tatyana Grosman
Collection).

french chalk, as it will be difficult to contain the spread of the caustic.

7 After the erasing is complete, the areas are treated with a solution in the proportion nitric acid 30 cc, water 2,000 cc, potash/alum 50 g. This solution is known as a counter-etch or a resensitizing solution.

8 The plate is thoroughly washed with water. After it is dry, extra work may be added on these areas. If no extra work is to be added, the plate is gummed up.

Caustic soda and caustic potash have many properties in common. Although solid, being deliquescent they very quickly take up moisture and liquefy when exposed to the atmosphere. When they are being dissolved in water considerable heat is generated, and the same precautions as are observed when diluting acids must be observed here. Small pieces of caustic are added to the water, and these should be handled with tongs, as caustic dissolves human tissue. A saturated solution is made, and this in turn is diluted with four times its own volume of water to reduce it to a concentration suitable for erasing work on zinc. Of the two chemicals, caustic potash is to be preferred as its action is rather more gentle.

Additions on zinc

Non-printing areas which need to be resensitized for the receipt of new drawing are processed as follows.

1 Wash the gum from the plate. If the area to be counter-etched is large, while the plate is wet the nitric acid/potash alum solution is poured from the bottle on to its surface, and the plate tilted so that the water can carry it over the appropriate parts. The zinc will change in tone as this happens and this is an indication that the process is being effective.

2 Thoroughly wash the plate and allow it to dry. It is then ready for drawing. If the whole plate is to be resensitized, the solution may have to be applied in several places to achieve total coverage.

Treating the zinc with this solution slightly erodes the grain; too many applications on the same area, or using a solution which is too strong, will remove it completely. For small additions, it is always better to resensitize an area that is larger than that actually required. Very small areas such as spots do not resensitize very well, which may be due to the gum from neighbouring areas bleeding on to the newly counter-etched area when the solution is being washed off.

It is not always possible to predict the behaviour of added work. In theory, it should come up sufficiently strongly to be treated as part of the original image, but occasionally it is more tenuous in character. For this reason it is better to wait until it is being rolled up before deciding whether

Deborah Remington, *Ealing*, 1973.
Colour lithograph, 71 × 67 cm.
Courtesy, Tamarind Institute,
University of New Mexico.

Robert Gordy, *Night Clouds*, 1971. Colour lithograph, 81 × 67 cm.
Courtesy, Tamarind Institute, University of New Mexico.

Carol Summers, *Comet over the Lower Falls*, 1973. Colour lithograph with split duct inking, 104 × 73.6 cm. Courtesy, Tamarind Institute, University of New Mexico.

Rufino Tamayo, *Variations on a Man*, 1964. Black-and-white lithograph, 93 × 70 cm. Courtesy, Tamarind Institute, University of New Mexico.

to give it a full etch. However, the added work should be gummed using the gum/etch solution.

Alterations on aluminium

Although there are superficial similarities between zinc and aluminium, their chemical activity is different, and this necessitates different solutions for erasing work and for resensitizing the surface. Caustic solutions react vigorously with aluminium, very quickly dissolving it, while sulphuric and nitric acids have no effect on the metal. Instead of using a caustic solution, concentrated sulphuric acid is used to dissolve the image. This concentration of acid is highly corrosive and should be used with the greatest care, applied to the plate with either a glass rod or a fibre-glass brush. The plate must be thoroughly washed after treatment.

Counter-etching solutions act by dissolving a fine layer of metal beneath the gum arabic layer, so that a clean, fat-sensitive area of plate is exposed. Since nitric acid has no effect on aluminium, other preparations must be used. The lithographer has a choice. Oxalic acid, a highly irritant

35

crystalline powder, is poisonous if inhaled, and care must be exercised when dissolving it in warm water to make a saturated solution. This solution must in turn be diluted in the proportion water 40 parts, oxalic acid 1 part, to form a suitable counter-etch. An alternative solution would be: water 2,000 parts, nitric acid 140 parts, fluorsilicic acid 230 parts.

Aluminium, being slightly porous, holds both the greasy image and the film of gum arabic more firmly than does the zinc. Thus the incidence of scumming and related problems while rolling up and printing is less. At the same time, these characteristics can make the erasure and addition of work rather more difficult.

REGISTRATION

Any plate or stone which is to be used as one of a series involved in making a multi-colour print has to go through the process of proving and etching, as described above. Apart from this, to ensure that each colour will print in its appointed place on the finished proof, certain extra measures must be adopted. This discipline is known as 'registering' colours, and can be achieved by several methods.

The *wasted key* is probably the most efficient method, as it provides the most accurate guide for where the various colours should be drawn. It is most usefully applied to designs which have been fairly well worked out on paper beforehand, and therefore does not allow the artist as much latitude as other methods to use the medium creatively by modifying his design while he is drawing the plates.

The wasted key plate can be made by one of two methods, and is only used for registration. It is not normally used in the final print. A tracing is made of the complete design, showing the boundaries of the shapes. If desired, colour changes can be drawn in. This drawing should be of a linear character. Using greasy carbon paper, this is traced down to the plate. The design will be more accurate if a ball point pen is used for tracing. Registration crosses are added at each end of the plate, allowing as wide a margin as possible. The plate is gummed and proofed in press black in the normal way, on to the rough side of MG paper. As many proofs as may be needed to make the colour plates should be taken. After the paper has been left to dry for an hour, the proofs are dusted with offset powder. These 'offsets' are then printed down to clean plates so that a drawing identical with the original, together with the crosses, appears in a non-printing purple line on each plate. The crosses are then drawn in with litho writing ink, and when this is dry the plate margins are gummed.

An alternative method of preparing this type of plate involves the use of french transfer paper and is described in Chapter 5.

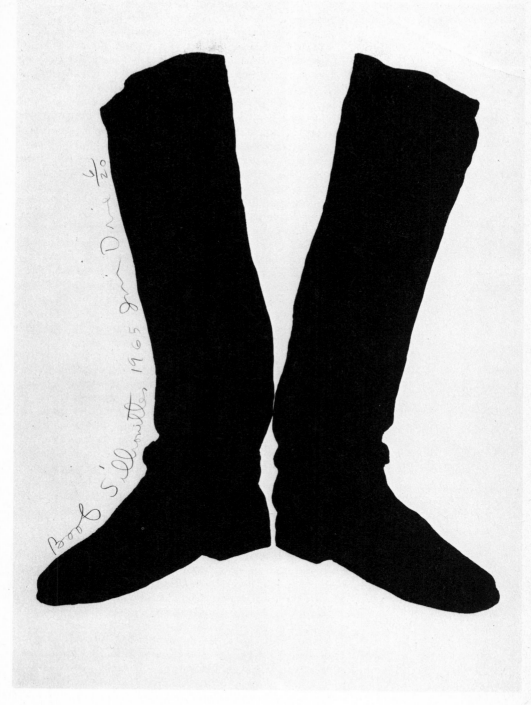

Jim Dine, *Boot Silhouettes*, 1965. Black-and-white lithograph,
124 × 73.5 cm. Courtesy, Universal Limited Art Editions, Long Island.

A more direct method is to prepare a tracing of the original, and on this to draw in the registration crosses. This tracing is used to trace down the design on to as many plates as are needed, using red set-off paper. The disadvantage of this method is that the tracing paper gradually becomes distorted with repeated use; this, together with the risk of it moving in relation to each plate while being traced, increases the likelihood of introducing inaccuracies.

Another method which allows more freedom for experimentation is to draw the plate which makes the largest contribution to the finished design, and while proving it, to print on to the rough side of M G paper; these prints can then be used as offsets for the other colours. It is possible with this method to add extra drawing in line on this plate, indicating the position of other elements. After taking the offset proofs, they can be deleted and etched out. This plate is not necessarily printed first in the final sequence.

When printing in colour, registration is effected by accurately placing the proof on to each plate, so that the registration crosses coincide. This can be achieved in two ways. After the first colour has been printed, registration needles are pushed into each proof from the back, at the intersection of the lines forming the crosses. The needles are then orientated to the corresponding points on the plate, and the proof allowed to drop down to the plate surface. If the crosses have been drawn accurately, the second colour will register with the first. This process is repeated for the other colours in the sequence. In the alternative method, after printing the first colour, windows are cut in the centre of each cross, so that the ends of the arms are left on the print, or alternatively a small triangular window is cut in one of the angles of each cross. When laying the proof down to the plate, it is orientated so that these windows coincide with the crosses on the plate. One point which should be considered when preparing offsets, is whether the print is to be printed direct, on the transfer press, or by offset, as this will affect the decision to reverse the design when tracing it.

For making offsets M G paper is chosen, because with most other papers there is a tendency for the offset powder to stick to non-image areas, which can be confusing. This does not happen on the rough side of M G paper.

Registration is effected on the offset press in the following way. After the first colour has been printed, and the second plate is in the press, the image from the second plate is printed down on to the impression bed. Windows are cut in one of the proofs of the first colour. These should be rectangular, and should remove the middle of each cross, but leave a short length of each arm remaining on the paper. The proof is then laid on the impression bed, and its position adjusted until the crosses on the bed can be seen in the windows and are accurately completing the crosses on the paper. The grippers are then opened, and without

altering the position of the proof, its bottom edge is tucked
under the grippers, which are then allowed to close. The
paper is now held sufficiently tightly for the front and side
lays to be adjusted so that they align with the appropriate
edges of the paper. If the first colour has been accurately
laid on each proof, then all the proofs should be in accurate
registration with the second colour. This procedure is
adopted for all the ensuing colours.

When drawing plates for a colour print, it is normal
practice to proof each plate in colour before proceeding
with the drawing on the next plate. By this means, the
creative nature of the work can be maintained. If all the
plates were drawn with reference to some preconceived
paper idea, the craft would be reduced to the status of a
reproductive medium, giving little scope for an experi-
mental approach. It is inevitable that the first colour will
be drawn with reference to some idea which may be on
paper, but as each colour succeeds the previous one, the
print itself will exercise more control over the direction in
which it is moving. Thus the lithographer can draw each
plate while continuously assessing the textural and over-
printing possibilities displayed by the unfinished print.

Antonio Tapiès, *Deux pieds sur ocre*,
1972. Colour lithograph, 53.5 ×
67.5 cm. Courtesy, Galerie Maeght,
Paris.

PRINTING IN COLOUR

Generally, this should present fewer problems than when
rolling up in press black. If the plate has been properly

39

Joan Miró, *Défilé de mannequins
à Istanbul*, 1969. Colour lithograph,
125.5 × 86.5 cm. Courtesy, Galerie
Maeght, Paris.

etched, and as the coloured inks are less viscous than the
press black, the image should accept them more easily.
At the same time, their inferior viscosity is more liable to
produce background scumming and image thickening,
unless adequate precautions are taken. Certain inks, includ-
ing the lakes and the range of blues known as bronze or
prussian, are particularly prone to causing this effect. Ferric
ferrocyanide, the pigmentation used in these blues, is a
naturally greasy pigment, while the lakes, because of their
natural lack of body, cannot absorb as much vehicle as
true pigments can. This gives an imbalance between the
vehicle and the solid part of the ink, which usually has to
be redressed by the addition, in the studio, of an additive
such as light magnesium carbonate.

This tendency to scumming can be lessened by keeping
the ink film to a minimum, and the plate as dry as possible,
while rolling up. When these lakes are reduced to make
transparent tints by the addition of reducing white, the

extra viscosity possessed by this additive reduces the tendency of lakes to scum.

Certain true pigments, such as the range of chrome colours and flake white, can absorb large quantities of the vehicle, so the ratio between the pigment and the vehicle in litho printing inks varies in each colour between these two extremes.

As a broad classification, true pigments incline to the opaque, while lakes are nearer to the transparent, and it is this basic difference which has been so well exploited by lithographers since the turn of the century, both in the juxtaposing and in the overprinting which these colours allow.

Inks that have been mixed with flake white to make an opaque or semi-opaque tint can also give trouble when rolling up and printing. This ink has a tendency to mottle in flat areas of tint, and also to build up into a ridge on the edges. Again, one cure is to keep the film as thin as possible, but a better solution would be to use titanium white.

To roll up a large area of tint, particularly a transparent one, without the darker-toned lines made by the roller overlapping previously inked areas demands some skill, especially when a small roller is being used. The recently introduced large-diameter rollers are designed to prevent this trouble.

Scumming and image thickening can also be caused on the zinc plate when printing a colour (most commonly grey) which has the same tone as the metal background. Extra vigilance should be taken when rolling up this type of colour, especially if close-textured work is involved; the same trouble can occur on the grey rubber blanket of

Raoul Ubac, *Rythme ascendant*, 1972. Colour lithograph, 48 × 65 cm. Courtesy, Galerie Maeght, Paris.

the offset press. Another problem encountered when printing from plates is the way in which the washout solution can contaminate pale colours or tints. It is frequently advised that, in these cases, the washout solution need not be applied, but rolling up being carried out on the basic image only. This is a risky procedure, and can be avoided by using the white washout solution which has been developed for this purpose.

INK ADDITIVES

These are necessary in some contexts to modify the viscosity of an ink, to decrease its greasiness, or to hasten or retard the drying. Since the majority of inks now available to the hand lithographer are offset inks, and designed to operate in the extreme conditions of high-speed printing, they are less viscous than the direct inks and, in general, tend to dry more quickly and with a higher gloss than is acceptable for printmaking.

Ideally, the hand printer needs a good-bodied ink with good viscosity. High-speed drying is not essential so long as at least one or two colours can be printed (on the same print) within the 24 hours.

Drying is achieved in printing inks by oxidation of the vehicle, which turns it into a polymer. The oxygen for this task can come from the atmosphere, from the pigment or from *driers* which are added to the ink. Certain pigments are rich in available oxygen, so that any inks containing them are generally good drying inks. These include the earth colours, chrome colours and flake white. Non-drying colours include the lake colours and blacks, so these have driers incorporated with them during manufacture.

The two driers available to the lithographer are the liquid driers, which are based on cobalt and cause the ink to dry hard with a gloss, and the paste driers based on manganese and lead, which allow the ink to dry in a supple film with a semi-matt finish. The latter are more suited to the printmakers' needs. The proportions in which these compounds should be used is approximately 130 of ink to 1 of drier. For the average amount of ink used in printing one colour, this would be little more than a spot on the end of the palette knife.

Another problem is the formation of gloss, which can accompany extensive overprinting, especially when the first colour to go down is a quick-drying ink. It was noted above that inks dry through oxidation. When this happens, their surface becomes impervious, so if the first colour in a sequence is allowed to dry, all the subsequent colours will have to dry on the surface. This will encourage the formation of gloss. If possible, the inks printed early in the sequence should be kept sufficiently open for some of the vehicle from the later colours to penetrate to the paper. A quick-

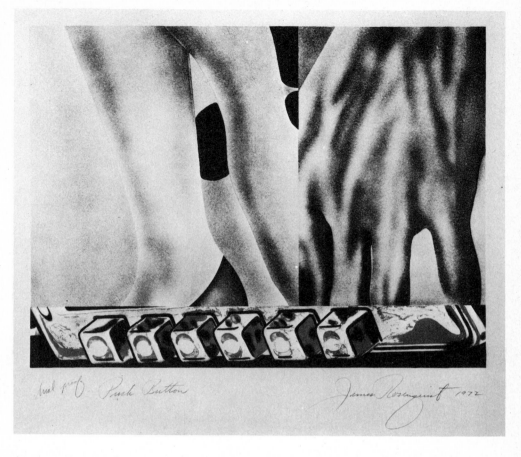

trial proof Push Buttons James Rosenquist 1972

James Rosenquist, *Push Buttons*, 1973. Colour lithograph with airbrush, 72 × 88 cm. Courtesy, Petersburg Press, London.

drying ink, printed first, will effectively seal the pores of the paper, thus preventing any penetration. Gloss is usually associated with lake colours, where the vehicle content is high in relation to the solid content.

To redress the balance, it is usual to add alumina hydrate or light magnesium carbonate to the ink. These fine white powders add body and, of the two, magnesium carbonate is the more widely used. Adding this compound to a greasy ink, or one lacking body, transforms it into an ink of more workable consistency. However, it has one disadvantage if used in excess quantities. Like limestone, it is capable of adsorbing fat, so that as increasing quantities are mixed into the ink, its consistency becomes short and crumbly, until it is incapable of being rolled out into a film. Furthermore, excess amounts in the ink will also destroy the basic adsorbed image on the plate, so that it will become incapable of accepting ink from a roller.

Magnesium carbonate is also used to reduce the gloss on a finished print before the final colour to go down has completely dried. In this case, it is lightly dusted across the surface of the print, so that it adheres to the tacky ink. This

Drying rack made from cord, screw
eyelets and spring pegs, secured to
a batten on the ceiling.

treatment is not recommended in all cases as, particularly
when transparent colours form the final printing, the
magnesium carbonate imparts a milky quality to the ink,
and causes a tonal change. With light-toned and opaque
colours, this effect is less marked. So the use of this additive,
in either context, should be regarded with considerable
circumspection.

As far as possible, colour printing should be completed
without the use of additives, as they are not always necessary.
In many cases gloss can be avoided by exercising a stricter
control over the thickness of the ink film, and printing it
when the previous colour is in the most receptive condition,
that is, when there is little tendency for it to offset on the
plate that is being printed, and yet at the same time it is
sufficiently open for the vehicle of the newly printed ink
to penetrate.

Gloss caused by surface ink drying is commoner on sized or hot-pressed papers, as they are less absorbent than water-leaf or unsized varieties. While it is desirable for dark-toned colours to dry with a slight gloss or sheen to enhance their luminosity, light-toned and opaque tints have more character if they dry with a matt surface.

Certain compounds when added to the ink will retard the drying, and their use may be indicated if the first colour to be printed is an opaque, quick-drying ink, which will seal the pores of the paper before the second colour can be printed. A non-drying oil such as paraffin (which will encourage the formation of a matt surface), is an example of this type of additive, and so is vaseline, or one of the various patent gel compounds. Their tendency to decrease viscosity can be counteracted by adding some reducing white.

Reducing white, in a sense, falls into the same category as litho varnishes, being composed mainly of boiled linseed oil, but with the addition of a faint white pigmentation. It can also be known as tinting medium, for its primary function is to reduce colours to the form of transparent tints. It is a viscous compound, and when mixed with slack inks, transmits some of this quality to them. When used in this way, the reducing white is added to the ink, as it has little effect on either the tone or the colour. When it is being used to make a tint, colours are added in small amounts to the reducing white or the opaque white until the required tone is reached.

Litho varnishes vary in viscosity, depending on how long the raw linseed oil has been allowed to boil. The thinnest varnishes are tapped after about an hour, and the thickest after about 24 hours. Boiling reduces the natural greasiness of the oil at the same time as the viscosity is increased. Thus, adding raw oil or thin varnish to an ink to reduce its viscosity may introduce the problems of scumming, which will have to be countered by the addition of magnesium carbonate.

The compatibility of inks

Certain pigments and lakes should not be used in close proximity to one another because chemical reactions are possible between them. As a general rule, pigments containing copper or lead should not be mixed with, nor overprinted on, pigments containing sulphur, otherwise black sulphides of copper or lead will be formed. Colours containing sulphur include the range of blues known as ultramarine, royal blue, oriental blue and ultramarine green. Genuine vermilion (mercuric sulphide) also comes into this category. Colours containing copper or lead include the range of chrome colours and flake white. Although the cadmium colours contain sulphur, they are not normally made in the form of printing inks as they are expensive pigments.

Among the lakes, reactions in the form of oxidation can take place between titanium white and iron blue or phthalo blue, when either of these colours is used to make opaque tints. Reactions are also possible between any vehicle containing hydroxyl groups and pigments containing salts of barium, calcium or sodium, although this is rare with the modern methods of making inks.

SAFETY IN THE STUDIO

At this stage it might be as well to include some notes on safety and the avoidance of accidents. Unfortunately, these can occur – especially if the studio is used on a communal basis, as in a school or college – through mismanagement of presses, through carelessness in the storage of inflammable liquids or by exposing them to heat or a naked flame, and from the toxic or corrosive nature of some of the chemicals used.

Thus, some care should be exercised in planning the studio, to minimize the likelihood of accidents. All powered presses should have their gears and moving parts protected by guards, and at some easily accessible point in the room there should be an overriding switch that will at once stop any press which is working. Guillotines, either powered or hand-operated, should be adequately protected, and when not in use should be locked with the blade on the bed. The presses should be regularly serviced, and their safety devices checked for signs of wear or inefficient operation: fingers can be trapped in the runners of the transfer press and between the gears and the rack of the offset press.

All toxic and corrosive solutions and powders in their concentrated state should be stored in a locked cupboard, and strict control exercised over the process of diluting them to working strength. A chart should be displayed showing the appropriate action to take should they be splashed on the skin or in the eyes, or inhaled or swallowed. Generally, with caustic solutions and concentrated acids, water is the best initial treatment.

With regard to the fire risk, advice should be sought from the local fire service as to the correct type of fire extinguisher to use, and it is best for them to instal and maintain it.

Inflammable liquids should never be decanted near a naked flame, so when mixing the litho writing ink from the stick over a spirit lamp or bunsen burner, these solutions should be removed from the vicinity.

It would be advisable for these potential hazards to be pointed out to each new student when he joins the class.

3 Presses

The flatbed offset proof press is an altogether more sophisticated construction than the average transfer press, being in every sense a precision machine. In its simplest form, it consists of an open rigid steel frame, rectangular in construction, with two short cross frames and two long side frames. This supports two accurately ground steel beds which are adjustable in height. The plate bed is located at the front end of the press, while the impression bed, that is, the bed which holds the paper, is located exactly the circumference of one cylinder farther along the frame. The cylinder itself is suspended between two large gears which travel on accurately cut racks running along the top of each side frame. This method of construction ensures that any given part of the surface of the cylinder will always bear against the same part of the plate bed and against the corresponding part of the impression bed. This allows great accuracy in the registration of a multi-plate print. Some of the older types of press can accommodate stones, but normally these presses are only designed for plate work.

Mailander offset proof press. Courtesy, Soag Printing Machinery Ltd, publicity department.

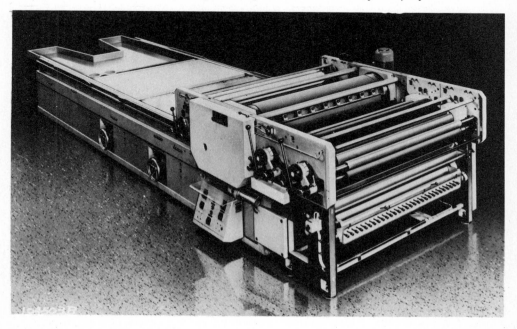

A plate ready for printing is fixed to the plate clamping bar, which is situated just in front of the plate bed. This usually takes the form of two narrow strips of steel running across the press, between which the edge of the plate can be gripped, and then secured with small knurled bolts. The paper is held by grippers located on the front edge of the impression bed, and its position is governed by the micrometer-controlled front and side lays.

The cylinder, which is covered by a heavy, resilient rubber blanket, is brought to the front end of the press. On this journey (the non-printing stroke), the cylinder does not rotate, as the gears are freewheeling along the racks. When the printing stroke is commenced, that is, on its journey to the rear of the press, a pawl is dropped inside the cylinder, mechanically connecting it to the gears so that it can rotate twice before the end of the press is reached. At this point, the gears are automatically disengaged, allowing them to freewheel during the next non-printing stroke. During its first revolution, the cylinder picks up the image from the plate. This revolution is completed in the space between the two beds, so that the second revolution commences with the onset of the impression bed; during this, the cylinder prints down the image on the paper. The plate is re-inked, fresh paper is fixed, and the sequence repeated.

Among the more obvious advantages which this type of press possesses, is that laterally reversing the image on to the plate is unnecessary, as whatever is on the plate will appear in the same phase on the paper. The press can be used for direct printing, in which the cylinder is used purely as a means of applying pressure, and also for the process of transferring from transfer paper to plate, or from plate to plate, when a clean plate is fixed on to the impression bed to receive the image.

With regard to effecting close registration, both the paper and the plate can be moved laterally or longitudinally by means of the micrometer screws. The heights of the two beds are also adjustable, either partially or wholly. The means by which this is done varies with the make of the press. On the simplest machine, a fine-threaded screw fitted with a locknut is located at each corner on both beds. These have to be altered individually when levelling the press on instalment, and also whenever the bed height needs to be changed, for example when changing from a thin paper to card. Since this type of adjustment can be irritating, especially if it has to be done frequently, it can be avoided by initially adjusting both beds to the height required by the thickest paper or plate that is likely to be used. When using thinner materials, both the plate and paper can have compensating packing inserted under them.

A refinement in some presses is an extra mechanism which enables the height of each bed to be adjusted by means of a handle after the adjustments to level the beds have been made.

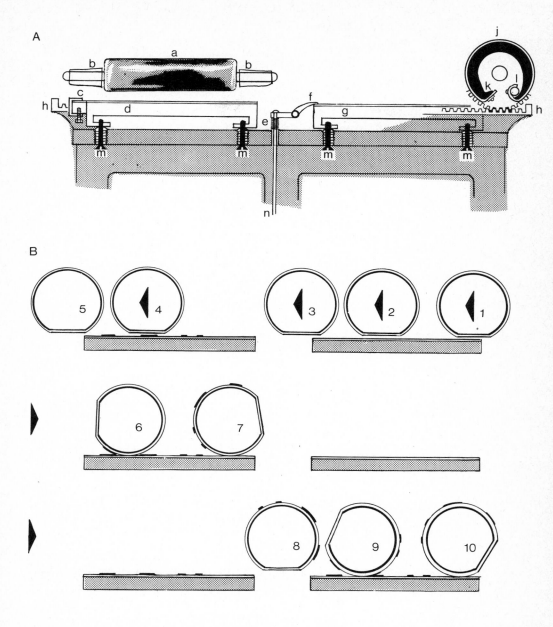

A. The offset press. The screw adjustment for altering the position of the plate after it has been locked has not been indicated. The front and side lays on the impression bed have not been indicated. *a* Hand roller; *b* roller grips; *c* plate locking bar; *d* plate bed; *e* gripper tension spring; *f* paper gripper; *g* impression bed; *h* rack and cylinder gear wheel; *j* cylinder and rubber blanket; *k* blanket securing bar; *l* blanket tension rod with ratchet; *m* bed levelling screws (four to each bed); *n* connecting rod to gripper operating pedal.

B. Method of operation. *1, 2, 3, 4, 5* The return or non-printing stroke. Note that the cylinder does not rotate on this journey. *6, 7* Transfer of image from plate to cylinder blanket. *8* The cylinder at rest. (Note: at this point, it is possible to roll up the plate again, and recharge the blanket. The cylinder can be returned to position between the beds.) *9, 10* Transfer of ink from blanket to paper.

Drying the plate after rolling up and before proofing on the offset press. Courtesy, Camberwell School of Arts and Crafts. London.

The offset press must be set up with the greatest care as any inaccuracy in level will seriously impair its efficiency.

With the aid of a spirit level, preferably a long one as used by bricklayers, or failing this, using the edge of a straight-edge on which a small spirit level has been laid, the frame is positioned on the floor. Levelness is tested across the racks and along them. If there is any inaccuracy here, efficient transfer of ink cannot occur. Blocking up under the feet may be necessary, and for this purpose some thin pieces of wood and some pieces of zinc cut from an old plate can be used. This will provide fine adjustment. When the press is level, the packing can be secured by a screw through the holes in the feet. Should the press have to be moved to a new position in the studio, it will have to be relevelled in the same way.

Next, attention must be paid to the beds. Even though the frame may be level, inaccurate beds will produce poor printing. A clean plate, of the maximum thickness that is likely to be used, is clamped to the plate bed. It should also be the largest plate that the bed can accommodate. A piece of smooth card or paper, the same size as the impression bed, is also fixed in position. Using coloured blackboard chalk, lines are drawn in each dimension of the plate, to form a wide grid.

The cylinder is then brought to the front of the press and taken on the first half of its printing stroke, that is, to a position between the two beds. The quality of the transferred chalk lines on the blanket is compared with that of the chalk lines on the plate. If they are stronger and the cylinder is difficult to turn, then the plate bed is too high. Identical adjustments are made to the plate bed adjusting screws, which are normally situated underneath the bed, where they are attached to cross members joining the two side frames. The blanket is cleaned and the chalk lines on the plate strengthened. Another print is made on to the blanket. If the transferred image is light on one side, then that side

Lifting a proof from the offset press. Courtesy, Camberwell School of Arts and Crafts, London.

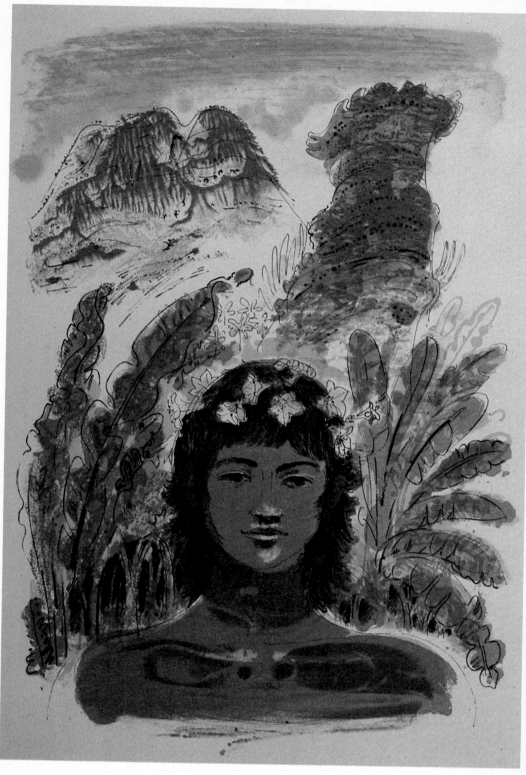

David Gentleman, *In the Rukh*. One of a series of lithographs made by this artist for
an edition of *The Jungle Books* issued by the Limited Editions Club, © 1968;
reproduced by permission of the Heritage Club, Avon, Connecticut.

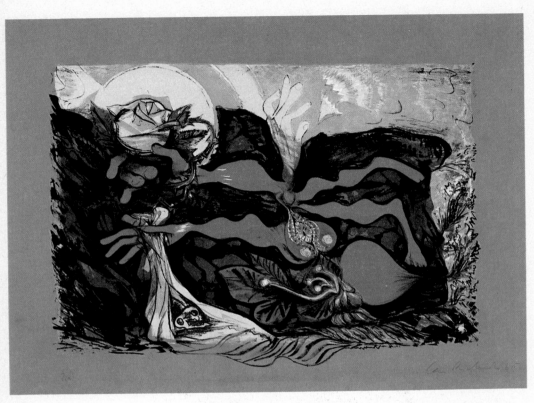

Ceri Richards, *The Force that through the Green Fuse Drives the Flower*,
from the *Dylan Thomas Suite*, 1965. Colour lithograph, 81.9 × 60.3 cm.
Courtesy, Marlborough Graphics, London.

of the bed must be raised. This sequence is repeated until perfect transfer has been achieved. When the bed is properly adjusted, there should be accurate transfer of the whole of the chalk image, and no measurable effort should be needed to turn the cylinder along. After the operation is complete, the locknuts are tightened, care being taken not to alter the setting of the height-adjusting screws in the process.

The blanket is again cleaned and the chalk lines strengthened. The image on the plate is printed on to the cylinder, and then printed down to the paper. Using the same technique, adjustments are made to the impression bed, and proofs are taken until the press is printing true. When the locknuts of this bed have been tightened, the press should be ready for operation.

Several points may be noticed here. Over the course of a few weeks, the ink transference may deteriorate. This can be caused by the bed screws becoming loose (which is unlikely), or by a build-up of printing ink on the plate bed through incomplete cleaning at the end of each working session. This will cause the plate to be fractionally higher in places, which can drastically interfere with the smooth and easy action of this type of press. With a new press, or if a new blanket has been fitted, difficulty may also be encountered by the blanket becoming stretched. This makes it slightly thinner and also causes it to bunch as it goes over the beds, making the cylinder momentarily difficult to turn. The blanket can be tightened by winding the blanket tension bar up a notch or two on its ratchet, using a tommy bar. This adjustment is made inside the cylinder, which can be turned until the opening in its surface is facing upwards.

Although both the paper and plate can be built up by inserting a thin sheet of paper beneath them, care must be taken that this does not protrude beyond the edges of the plate, as it will absorb water from the damping sponge and also take ink from the roller, causing unnecessary mess. The packing on the impression bed must be changed the moment it appears to be getting dirty, otherwise dirt will be transferred to the edition paper.

The messy tasks of washing out, rolling up or etching a plate should never be carried out on the offset press. These procedures, together with deleting and resensitizing, should be carried out on the transfer press or the bench. These can be risky activities, particularly when being done by a beginner, and the various chemicals and solutions are frequently splashed, causing staining and sometimes corrosion. Expensive and sophisticated presses should never be put at risk in this way.

The type of press described here is the simplest of its kind, although the principles are general. Most offset proof presses, especially those designed for commercial use, employ a more sophisticated design, being fully motorized and possessing such refinements as an automatic ink mill,

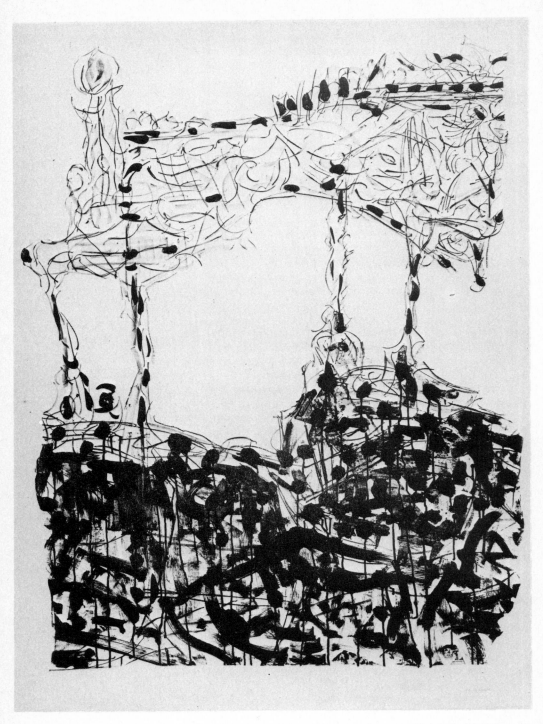

Jean-Paul Riopelle, *Suite Caribou*, 1972. Black-and-white lithograph,
160 × 116 cm. Courtesy, Galerie Maeght, Paris.

automatic inking and damping. Receptacles for holding gum, sponges etc. are also built in.

The relative merits of direct and offset printing in the printmaking context have often been debated, and the main criticism of offset presses is that inherent in their mode of operation is the inability to transfer a film of ink to the paper which is as thick as that possible using the direct method. While this is not denied, the difference can be minimized by modifying the ink and keeping the press, particularly the blanket and beds, at the peak of their operating efficiency. Other factors favouring the offset press are the ease with which it is operated compared with an ungeared hand-operated transfer press, and easier printing of multi-plate prints which rely on close registration.

Problems of offset printing

PROBLEM	POSSIBLE CAUSE
Light inking on the print	If transference of ink to the blanket is satisfactory, the impression bed is too low, or the paper is too thin. Poor transfer of ink to the blanket indicates similar faults on the plate or plate bed
Lightly inked areas on the print	Check that the plate is inking properly. If the pattern of areas is constant on a series of prints, this may be caused by thin areas on the blanket, and this will have to be replaced. If the light areas vary from print to print, this may mean that one or other of the beds is loose, so that the bed tilts under the cylinder. Check both beds and relevel if necessary
Dirty background on the print	Unnoticed scumming on the plate which is also missed on the blanket. The culprit is usually a grey-tinted ink, roughly the same tone as the plate and blanket Clean the blanket with blanket wash and roll up the plate with greater care. If scumming persists, remove the plate from the press, put it into press black and carry on investigations from there
Irregular badly inked streaks on the print, running in the direction of the press	Usually caused by trying to print a plate that is too damp. The cylinder blanket picks up water from the plate and, during its

passage over the paper, acts like a squeegee, pushing the water along the face of the paper and preventing total contact between paper and ink. Use less damping water and wait for the plate to dry before printing

Light impression on the print down either side or across the top or bottom

Faulty adjustment of the beds, the low area corresponding to the light areas on the print. If the plate bed is at fault, the lightly inked areas will also show on the blanket. If the fault is in the impression bed, the light inking will only be apparent on the print. The beds would have to be re-adjusted

LETTERPRESS PROOFING MACHINES

The types of relief presses most likely to be of use in a printmaking studio would be the traditional hand-operated platen press of the Albion or Columbia pattern, which are the direct descendants of the wooden hand press used by Gutenberg and the other early printers, and the cylinder proofing press which, in its essentials, is a very similar structure to the offset proofing press described above. This is obtainable in as many sizes and grades of sophistication as its offset counterpart.

An ideal press for the printmaker would be the Wharfedale type of machine. As its name implies, it was first manufactured in Wharfedale, Yorkshire, but now, instead of the name being applied to a particular make (Dawson, Payne & Elliot), it is a general description of any flatbed letterpress machine which uses the stop cylinder principle. These presses were manufactured from the middle of the nineteenth century until shortly after the Second World War, and were virtually unchanged in design, but because of their relative slowness, and the decline of letterpress printing, their commercial use has rapidly dwindled. At the moment of writing they are easily obtainable on the secondhand market, and offer an economically attractive alternative to a new proofing press. Being robust in construction, they remain unsurpassed for bookwork. The three types of press will now be examined in more detail.

THE HAND-OPERATED PLATEN

A platen press works on the simple principle of two opposing, accurately ground steel surfaces, on one of which

is fixed the type, and on the other the paper, so that as they come together the paper is impressed.

In the Columbia and Albion presses, these surfaces are in a horizontal plane, the type forme being locked on to the lower or type bed. Hinged to this surface is the tympan, on to which the paper is placed. After hand inking the type, the tympan is lowered so that the paper is in contact with the type. Impression is made by bringing down the platen.

In the early models of this press, the platen was lowered by a large central screw, whose action was similar to that in a bookbinder's iron nipping press. The major advance in the design of platens occurred at the end of the eighteenth century when Lord Stanhope devised a system of lever-operated knuckle joints which replaced the screw. This made printing much simpler and quicker as impression could be achieved by turning a bar through a few degrees. When this was released, a spring returned the platen to its original position. An alternative method, which also uses a bar or lever to operate it, consists of two wedge-shaped pieces of iron, one sliding over the other when the bar is turned, causing the platen to be depressed. In both cases, the lever or bar travels through an angle of only 30° to 45°, and a stop is usually incorporated so that the bar cannot travel so far as to cause excessive pressure and crush the type.

Several different designs of this press exist, but these differences are only matters of detail. The best-known are the Columbia, which was originally made in America, and the Albion and the Stanhope which were made in England, although the latter is usually regarded as being of French design. They were made in a wide range of sizes from crown quarto up to double crown or even double demy.

In the United Kingdom at least, some local printers still have these presses in operation and they are mostly used in conjunction with wooden type for printing auctioneers' posters and other short-run ephemera of local interest. It is possible that this method of printing is still the most economic for the large format but small editions required for this class of work. These presses have not been made for many years and they command a high price in the secondhand market, out of all proportion to their functional capabilities, as they are now valued as antiques. The Columbia press, with its cast-iron eagle at the top of the cross member, is especially coveted.

The press consists of a cast-iron frame standing on ball-and-claw legs; at the top, a cross member connects the two side castings, and from this is suspended the platen with the pressure bar and its associated mechanism. Beneath this are located two runners which extend outwards, and on which the type bed runs. This system enables the bed to be withdrawn from beneath the platen, so that the type can be inked, the paper laid on the tympan and other necessary processes performed. Underneath the runners is fitted the winding handle, or *rounce*, which turns a wooden drum to

Gardy-Artigas, *Enchevêtrement*, 1972. Colour lithograph, 65 × 50 cm. Courtesy, Galerie Maeght, Paris.

Le Yaouanc, *Mois de Mars*, 1971. Colour lithograph, 75 × 55 cm. Courtesy, Galerie Maeght, Paris.

which three lengths of webbing or leather straps are fixed. These are attached to the bed, the two outside ones to one end, and the middle one to the other, enabling it to be wound in and out of the press.

In essence, the type bed is a tray with shallow sides, so that the chase of type can be locked into position with the quoins. At the end of the bed, farthest from the press, is the hinged tympan. This consists of two hollow iron frames, one fitting inside the other, both of which are covered with manilla or parchment; thus the tympan is a double one, to allow extra packing to be inserted between the two layers. Hinged to the outer end of the tympan is the frisket. This again is a light hollow frame which is covered with stiff paper. Its purpose is twofold. After the printing paper has been laid, the frisket folds over it to hold it firmly against the tympan. So it must have a rectangular shape cut into it, corresponding in size and position to the area of type. When two-colour printing is being carried out, it is used as a mask to prevent the paper from being printed. When the first colour is being printed, a frisket is cut to allow only those areas of paper which are to be printed in this colour to be impressed. When the second colour is being printed, a new frisket is cut to mask the areas of the paper which have been printed in the first colour. In this way, splitting the forme into two parts and printing them separately, and thus becoming involved in registration problems, can be avoided. If the type is lightly printed on to the frisket, the areas to be cut out will be apparent.

To cover the tympan, the tympan frames are removed from the press and laid over the material with which they are to be covered. This should be $1\frac{1}{2}$ in. (4 cm) larger than the frame in each dimension. The corners are sheared diagonally, and provision must be made for the several projections on the frame. A pencil line is drawn on the covering, marking the inside edge of the frame. If parchment is being used, it must be soaked in water for a minute or two, but manilla need only be damped with a sponge. The purpose of this is to make these materials expand, so that when they have been fixed they contract, giving a drumlike covering. Paste is rubbed into the edges up to the pencil line and then the frame is replaced. The edges are then folded in and tucked round the frame with a bone folder or palette knife so that they do not go across the impression area. This dressing should be regarded as permanent, and care should be taken not to print on it or to spoil it in any other way. The inside of the tympan is protected by a sheet of smooth paper, which is secured to it by a spot of paste at each corner, care being taken to avoid the impression area. To this sheet the lay pins or gauges are fixed, on which rests the paper being printed. This inner tympan is held in place by several hooks attached to the main tympan frame.

The type of packing inserted between the layers of tympan is governed by the character of the relief matter being

impressed. This packing can be hard or soft depending on the area of type. Small areas require hard packing (hard, thin card), while larger areas of text or solid tints need the softer quality provided by newsprint or similar paper.

To avoid crushing the type, before proofing is started, the stop should be screwed in to ensure that only minimum pressure can be exerted. As proofing continues, the pressure can be adjusted until the correct impression has been achieved.

Inking is done by hand with a brayer and should be repeated in several directions across the type. Generally the best results are obtained with a much thinner film than is used in lithography. Traditionally, patches of over-inking and filling in are known as 'monks', while areas of grey or under-inking are called 'friars'.

Related to this problem of even inking is the question of adjusting the platen so that it is parallel with the type. On the ribbed top surface of the platen four bolts are symmetrically arranged round the hemispherical hollow at its centre. An equivalent hemispherical casting fits into this hollow, attached to the framework holding the pressure mechanism and bar. The four bolts, when tight, hold the platen firmly against the casting. When one of them is loosened, the bolt diametrically opposite can be tightened by the same number of turns, thus changing the inclination of the platen in relation to the type bed.

To set up the press, it is necessary to fit a chase, containing a number of 6-point or 12-point rules, on to the bed. Rolling and proofing are pursued simultaneously, with small adjustments to these bolts, until an even impression has been achieved.

THE CYLINDER PROOF PRESS

In basic construction this is similar to the flatbed offset press. In place of the impression and plate beds, there is just the one bed for holding the type. This can normally be adjusted in height to cope with type locked in a chase, or in the galley. The impression cylinder runs between two large gears which travel in racks situated on the top of the side castings.

The main differences occur in the manner of feeding the paper to the press. Instead of the impression bed, there is a wooden feed board at one end, to which the adjustable side lays are fixed. The leading edge of the paper is placed against the adjustable front lays which, on this type of press, are located on the cylinder. Thus, before printing, the cylinder, its lays and the grippers are in position against the front edge of the feed board. After the paper has been positioned, the grippers are lowered by a lever in the cylinder carriage. The cylinder can then be wound along the press in the same way as that operating on the offset

press, except that in this case it carries the paper with it. As the cylinder rotates, the paper is gradually brought into contact with the type so that impression can take place. At the end of this printing stroke, the grippers are automatically opened so that the paper can be removed. On its return to the feed board (the non-printing stroke), a trip in the cylinder carriage raises the cylinder so that it is clear of the type. When it arrives at the feed board, it is automatically lowered ready for taking the next proof.

The advantages of this type of machine lie in the extreme accuracy of registration and in the greater control which can be exercised over the pressure. Because only a little more than a knife edge is being printed at a time, a proportionally greater pressure can be exerted than is possible with the platen, where the pressure is dispersed over a rectangular area.

Provisions can be made for automatic inking, and fully motorized versions of this press are available. They are frequently advertised, either new or secondhand, by dealers in printers' machinery. Some makes are: the Soldan Proofmaster, the Vandercook No. 4, the Caslon Lightning Press, the Verax by Harrild, and the Littlejohn Press. Some of these are no longer made and are only obtainable on the secondhand market.

THE WHARFEDALE PRESS

The proof press relies on a stationary bed and a cylinder that is able to travel the length of the machine. The Wharfedale relies on the principle of a cylinder rotating in a fixed position while the bed reciprocates beneath it.

The main drive to the press is connected to the bed, which is made to reciprocate by a crank geared to the flywheel shaft. All the other mechanical processes on the press are timed to this action and are operated by cams or trips which function at the appropriate stages. When setting up this type of press, therefore, the services of a skilled printer's engineer will usually be needed.

The bed, apart from holding the type and ink slab, has racks along its edges which engage with the gears situated on each side of the cylinder. As the bed reciprocates, the racks cause these gears to rotate backwards and forwards, while the cylinder, unless it has been engaged by a lever, does not rotate. At one end of the press is the wooden feed board, and the printing stroke commences when the bed has travelled to a position underneath it. When printing is required, the operator moves a lever to raise a trip in the side frame, which in turn engages the gears with the cylinder, so that as the bed moves down to the other end of the press the cylinder makes one revolution before automatically becoming disengaged for the non-printing stroke – that is, while the bed moves up to the position under the feed board.

This sequence is repeated for as long as the lever is in the printing position. This principle of the cylinder being stationary on the non-printing stroke has led to this type of machine being called the stop cylinder press.

If, after taking each proof, the lever is moved to its non-printing position, misprinting on the cylinder dressing can be avoided. This safeguard, combined with the stop cylinder principle, makes the press ideal for taking single proofs, and is doubly valuable to the printmaker, not only for printing type, but for making relief or mixed-media prints. Since the construction of these presses is so robust, they are able to print large areas of solid tint without difficulty. The press may be used either with hand inking or with the built-in automatic system. Registration provisions vary with the make, but most machines possess adjustable front and side lays, and in some, these are micrometer-controlled. If they are absent, it is a simple matter to add some form of screw-controlled lays.

On this type of press, the paper is fed to the bottom of the cylinder, which means that it must be fed face downwards on the feed board.

When used commercially, these presses, while being hand fed, have automatic delivery units driven by the cylinder gears. When used in the printmaking context, or for taking single proofs, the delivery system, or fliers, can be lifted clear of the press, giving easy access to the type or blocks being printed. If no long editions are planned, this overhead system can be removed altogether.

CYLINDER PACKING

This takes the same form, whatever type of cylinder press is being used. If the bare steel cylinder is inspected, it will be found that all of it except for about an inch at each end has been recessed by a small amount. This varies with the press but may range from 40 to 70 thousandths of an inch (0.1 to 0.18 mm). This is to take the packing necessary for good printing. The machines are so designed that the high edges of the cylinder act as bearers and rest on steel flanges on each side of the bed. (This is the case both in proofing presses and in the stop cylinder model.) The height of these flanges approximates to type height, so that when the cylinder is dressed, its diameter should not be measurably greater than the unrecessed or bearing part of the cylinder, otherwise slurring of the image and excess depth of impression would result.

It can be seen that the total diameter of the cylinder is critical. As the cylinder moves in relation to the bed, the distance of rotation of the circumference must be equal to the distance travelled by the type. Too much packing increases the circumference so that this will travel a longer distance compared with the bed.

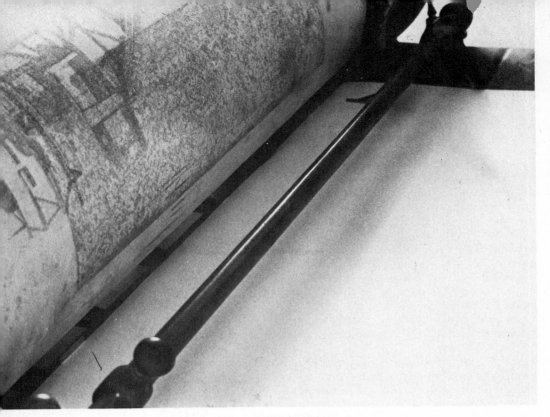

The Wharfedale press (*1*). The paper on the feed board. Note the side lay and two front lays.

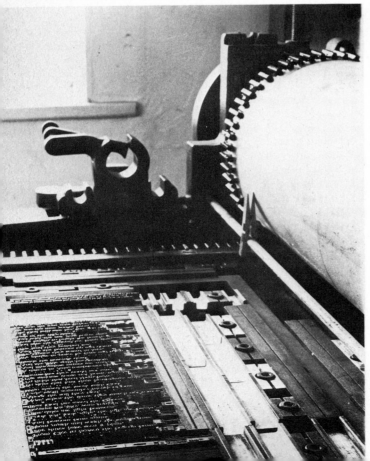

The Wharfedale press (*2*). The type and bed are moving towards the cylinder on the non-printing stroke. The cylinder is stationary.

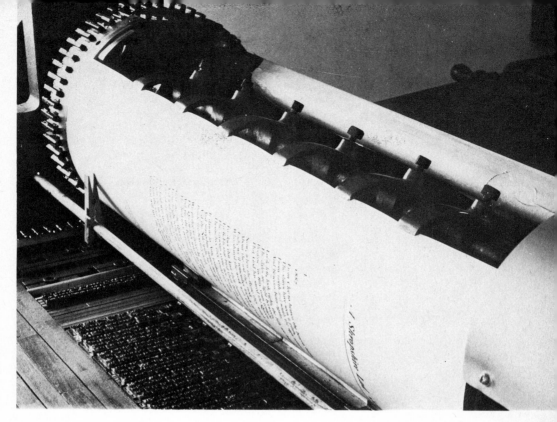

The Wharfedale press (3). The bed
with the type is now moving away
from the cylinder on the printing
stroke. The cylinder is revolving
in a clockwise direction.

The Wharfedale press (4). View of
open segment of the cylinder during
the printing stroke. The end of the
paper is still on the feed board while
the front edge is held by the grippers
on the cylinder.

As with the platen, the packing is composed of permanent and temporary dressing, the permanent dressing corresponding to the tympan and usually taking the form of one or two sheets of oiled manilla. This is to keep it stable in humid conditions. These sheets should be the maximum size that the recess in the cylinder will allow. Methods of fixing them vary slightly from machine to machine, but the following description is broadly applicable.

The cylinder is hollow, and entry to the inside is made in that part of the circumference which has been cut away. This space is bordered by two lips which extend across the cylinder. On one of the lips will be found a line of grippers and behind them, on the inside of the cylinder wall, are a series of small hooks. Inside the other lip will be found a spindle about an inch in diameter, which can be rotated in bearings at each end of the cylinder. One of the bearings incorporates a ratchet so that the spindle can only be rotated in one direction, unless the ratchet is lifted.

The ends of the sheets of manilla are pasted round a thin steel rod of suitable length, holes being left to coincide with the positions of the hooks under the grippers. The cylinder is rotated until the grippers are open and the manilla and steel rod are then secured behind the hooks. The free end of the manilla is eased under the grippers and passed round the cylinder to be pulled tight and pasted just inside the other lip of the opening. A similar piece of manilla is prepared on another steel rod in the same way and passed round the cylinder to be wrapped round the spindle, where it can be pulled tight with a tommy bar and held in position by the ratchet. Any other dressing which may be necessary must be inserted underneath this outer sheet of manilla. This packing can be varied to suit the type of work which is being done. Large areas of solid tints, such as a linocut, would require a fairly soft packing, while small amounts of type would require less packing of a harder nature. As far as possible, packing should be of a generalized sort so that most types of work will be suited. Modifications for small-scale work, or other variations, can be made afterwards by patching thin sheets of dressing on to the outer covering, or using other methods of applying localized extra pressure. These may take the form of interlays or underlays on the actual block.

4 Transfer papers and transferring

Senefelder, during the course of his many experiments, devised a method whereby writing could be drawn on paper with the greasy writing ink, and afterwards transferred down to the stone. This technique has the obvious advantage that any work transferred in this way is automatically laterally reversed during the process, so that when the stone is printed, the image on the paper is in the same phase as the original drawing on the transfer paper. As a result of his efforts, papers designed for transferring were developed, each with its own characteristics to suit different types of work. They consist of a paper base which must remain stable when wet, on one side of which has been applied a thin, water-soluble layer consisting of some of the following ingredients: gamboge, thin glue, starch, whiting, plaster of paris, flour, flake white, glycerine and gelatine. The selection and proportion of these substances depends on the type of work for which the paper is intended.

The main requirements of transfer papers are that the coating should be capable of sticking to the surface of the stone or plate after it has been damped. The coating should not be so absorbent that the grease from the ink will soak right in, leaving none on the surface to be transferred. The paper base must be sufficiently absorbent so that, when a damp sponge is applied to it during the transferring process, the water can penetrate through to the coating, activating the adhesives which it contains, detaching it from the base and sticking it, and the greasy image drawn or printed on it, to the plate.

The methods of transferring are similar for each type of paper, but vary in detail. The process itself is very simple. A drawing in litho ink or chalk, or an image obtained in some other way, for example by printing, is made on the coating of the appropriate paper. The paper is then placed face down on a clean plate or stone. After being damped from the back of the sheet, it is taken several times through the transfer press, under firm pressure. The paper is then exposed and damped again. If it is considered necessary, it can go through the press again. When the transfer has been satisfactorily made, the paper base can be peeled back, leaving the coating and the drawing adhering to the surface of the plate. After any necessary repair to a poor transfer, or

any additional drawing, the plate is gummed and proved in the normal way.

An indispensable aid to transferring is the damping book. In fact, it is an essential item in the printmaking workshop if intaglio methods are practised, and its other main use in lithography is to damp rough papers, and some handmade papers, evenly to make them more sympathetic for printing. The book consists of sheets of blotting paper (the unfolded variety is best), sandwiched between two sheets of zinc or other non-absorbent, rigid material such as a plastic laminate. Moderate pressure can be supplied by a crown-size litho stone. This rests on an old drawing board cut to size, which is laid over the top piece of zinc. The pressure helps to prevent the transfer paper from cockling when it becomes damp. The blotting paper should be kept as nearly as possible in a constant and even state of dampness, which usually means some attention about once a day. It will be found that there is a tendency for the book to become mouldy, but this can be prevented by adding a few drops of oil of cloves or carbolic to the water which is used to damp it.

The transfer paper is inserted between the sheets of blotting paper a few minutes before transferring is due to start, and is left until it has become limp. It is advisable to place the transfer in the book face upwards, with the drawing protected from the top piece of blotting paper by a piece of MG paper, the rough side of which lies on the drawing. Apart from preventing the ink from offsetting on to the blotting paper, this will prevent the coating from becoming prematurely damp, which would make it come away from its paper backing.

When the book is used for damping printing papers, these can be left for longer periods, and if the paper is very thick, several hours may be necessary for it to be properly prepared.

The main types of transfer paper which have a use in the printmaking studio are:

> Writing transfer paper
> French transfer paper
> Everdamp paper
> Chalk transfer paper

There is one more paper, known as Decalcomania, and this has a specialized use which will be described at the end of the chapter.

Writing transfer paper

This has a smooth hard surface, which makes it ideal for work involving litho writing ink, pen and brush. It is made in two qualities, one using gamboge gum, which gives it a bright yellow colour; this is known as 'yellow transfer paper'. The other, which uses thin glue instead of the

gamboge, is white. This type also possesses more substance and is more suitable for work which contains large areas of solid. It is known as 'Scotch transfer paper'. The hard surface which both these papers possess makes them suitable for taking transfers from relief objects such as type or relief blocks. This operation should be done with a cylinder proofing press or an Albion press.

French transfer paper

This has a surface similar to Scotch transfer paper, but the coating is thinner and is laid on a very fine transparent tissue. It is normally used for preparing wasted keys for multi-plate prints. Although it will take very sharp transfers from type, because of its fragile nature it is difficult to handle and is not often used for this purpose.

Everdamp paper

This paper has a coating similar to the preceding papers, but with the addition of glycerine. Being hygroscopic, this substance keeps the paper permanently damp and limp. It should always be stored in a waterproof container or wrapped in polythene. It is recommended for transferring type or for transferring an image from one plate to another. However, its major use to the printmaker is its capacity for quickly taking transfers from random objects for later incorporation into a print.

Chalk transfer paper

This paper possesses a very thick grained coating whose surface approximates to a 100-grain litho stone. It is laid on a heavy cartridge of about 250 gsm. Its granular quality is achieved by the introduction of plaster of paris into its composition. This paper was originally made to Joseph Pennell's specifications by Cornelissens of London, for drawing his series recording the building of the Panama Canal. It is often referred to as Pennell paper.

Since the coating is thick, it is possible to scrape into the image with a knife or point. As it is very absorbent, the chalk drawing must be equally heavy to compensate for this loss of surface fat. It should be used for transferring to a polished stone, as any pronounced grain on the receiving surface will break up the granular quality of the drawing. Failing a stone with this surface, a grained plate, about 200, could be substituted, though this will add difficulty to an already critical operation. By their nature, chalk transfer papers cannot make the close contact with the stone or plate that could be desired, so that the chances of it moving in relation to the receiving surface are increased. Using a heavy pressure on this type of paper will break down its grain and coarsen the image.

With this type of transfer it must be accepted that extra chalking cannot be added once the transfer has been made, as any addition will have a very different character because of the disparity of the two grained surfaces, those of the paper and the plate. Chalk additions on the plate are very obvious although work with ink, brush and pen can be safely added.

DRAWN TRANSFERS

These are images made with brush, pen and chalk. Depending on the needs of the finished print, it is possible to use all of the above papers for images formed in this way.

At present, it is the fashion for transferred images to form only a part of the finished print. This makes it possible for directly drawn matter, transferred drawing and, for example, transferred printed matter taken from old line blocks or halftones to be combined in one design.

Both types of writing transfer paper will allow drawing using the finest line, while the Scotch paper will also give the opportunity to use heavy solids. In this case, the ink should not be applied in too thick a film as under pressure it will squash and cause image spread on the plate. Scraping with a knife is not satisfactory, though it is possible to tear the transfer, and this technique has been used when a ragged edge is required or when making a collage. Thin washes can be made on writing paper, but the final result is unpredictable. It is likely that some of the lighter halftone passages will disappear.

Another form of drawn transfer is employed for collecting random textures from objects which cannot be brought into the studio. Examples could be walls, pavements and textures found on rusting iron in the council rubbish dump. The method employed is the same as that used for taking brass rubbings and is known as *frottage*. The most suitable paper for this would be Everdamp: because of its built-in limpness, it readily conforms to the contours of the surface over which it has been laid. After it has been placed in position, the desired areas are worked with a 2- or 3-grade litho crayon. If possible, to avoid moving the transfer and thus making a slurred image, it should be taped to the surface.

When a design for a lithograph has reached the stage when any future development must be carried out on the plate, transfers involving French transfer paper can form a vital link between the paper work and the actual process of image drawing. The transfer paper is pinned down firmly over the design, and the tracing carefully made in litho writing ink. The main areas of colour change and the various elements in the design should be indicated. If desired, a fairly free approach can be used. To obtain a fine line, the ink must be mixed quite thinly so that it can flow easily from

Robert Rauschenberg, *Bait*, from the *Stoned Moon* series, 1969. Colour
lithograph, 89 × 66 cm. Courtesy, Gemini G.E.L., Los Angeles,
California.

Richard Vicary, *Coast Scene*, 1975. Colour lithograph and linocut,
24 × 46 cm.

the nib. However, in spite of this precaution, it will regularly clog and will have to be cleaned with water. Since the paper is very flimsy, drawing pressure will have to be minimal if the paper is not to be torn by the nib.

For the limited method of book production which can be practised in the studio, this paper is invaluable. When preparing a design of this nature, the drawing must take the form of a completed page, showing the disposition of illustrations and text, apart from any colour changes which may be needed within the illustrations. Also indicated on the transfer would be the various indications for trimming, and the registration marks.

PRINTED TRANSFERS

By this is meant all transfers which have been prepared using transfer ink or press black, either applied directly to the transfer paper by roller, or by taking a transfer from suitable materials or surfaces which have themselves been inked.

Using Everdamp paper, it is possible to ink up a textured surface and to lay the paper down upon it. The paper is secured with tape and, when firm, it is burnished from the back to transfer the press black or transfer ink to the coating. A small rubber roller can also be used for this purpose.

A variation of the frottage method is to lay the transfer paper face upwards on the texture and to press a small roller charged with transfer ink across it. The high parts of the underlying texture will cause the paper to take the ink at these points. The area of transferred texture is limited by the length and circumference of the roller because, to avoid moving the paper, the roller can be rolled over only once.

Using a larger roller, it is possible to make other types of transfer. The paper, which can be Scotch or Everdamp, is fixed by its edges to an ink slab or large litho stone. Shapes cut or torn from thin paper (a bank or bond will do) are secured to its surface by gum arabic to act as stencils. The roller, charged with press black, is rolled across them once.

Taking transfers from type is a more precise operation and is best performed on a cylinder proofing press or an Albion press. The pressure is a critical factor and must be exact. Light pressure will give an incompletely inked image, while excess pressure will over-ink the type image, at the same time indenting it too much into the paper. This will cause thickening of the letters. To avoid slurring, the transfer paper must be held by grippers and the heavier substance of writing transfer paper is better able to withstand this, than the lighter substance of French paper. Random surfaces, provided that they can be accurately built up to type height, can be well printed on to transfer paper using the cylinder press, and will give a much crisper image than that obtained using the frottage method. When

using any letterpress machine the object is to achieve the best proof with minimum indentation, and this is especially important when making transfers. To assist in attaining this, the dressing on the cylinder (or platen, as the case may be) should be fairly hard and the inking should be kept to a minimum to avoid image spread.

Transfers from some materials can be made directly on to the plate. The fact that this kind of transfer is possible indicates that the material possesses yielding and flexible qualities. There are two main methods for making the transfer. An ink slab can be rolled up with transfer ink or press black and the material laid on it: materials such as embossed papers, woven fabrics and buckram are ideal for this purpose. Pressure is then applied from the back with a small roller or brayer, and this causes the material to pick up the ink. Hand burnishing can be used if the material is first covered with a sheet of blotting paper. Alternatively, if the material is suitable, it can be directly inked with the roller, laid on the plate and taken through the press under moderate pressure. Materials which contain loose fibres or hairs should be avoided for this second method and the first method used, otherwise the roller will strip these fibres from the material rather than deposit ink on them.

TRANSFERRING

With the heavier-bodied papers, the procedure is similar, although the circumstances may dictate small modifications.

The stone or plate on which the transfer is to be made is placed on the bed of the press and the pressure screw adjusted to give a light pressure. It is important that the pressure is even all over the receiving surface. This can be checked in a similar way to that used when the beds on the offset press are being levelled. Two sheets of smooth process cartridge paper are needed, and on the bottom one a grid is drawn in coloured blackboard chalk. The second sheet is laid over it and then they are both taken through the press. Any weak transference of the image will indicate areas of insufficient pressure. These, if they are excessive, can be remedied by appropriate packing under the stone or plate bed.

The transfer, with the drawing on it, is placed in the damping book until it has become limp (not forgetting to protect the image with a sheet of rough paper). If the transfer is in the form of a complete drawing, it should be laid on the plate so that the margins are even. When the transfer is lying face down on the stone or plate, it is covered with a sheet of damp blotting paper. The backing papers and the tympan are lowered. Some authorities recommend laying a waterproof sheet over the transfer to prevent the moisture from travelling upwards into the backing rather than downwards through the coating to the plate; in fact, very little seems to get into the backing sheets.

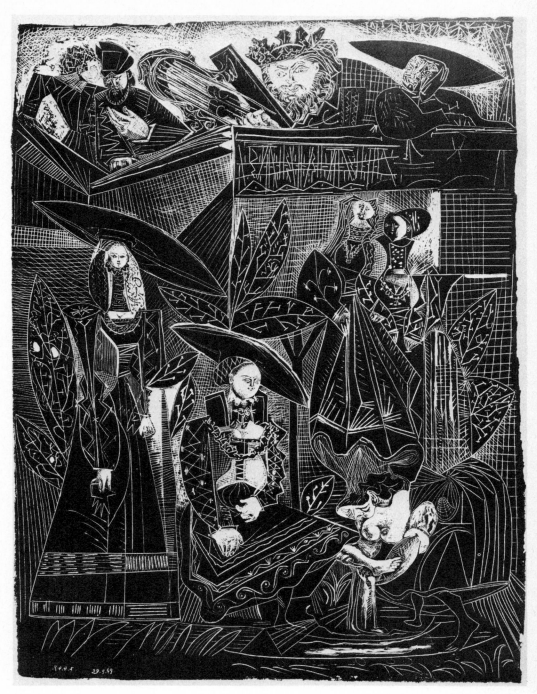

Pablo Picasso, *David et Bathsabée*, 1949. Black–and–white lithograph and transfer, 64 × 49 cm.
The original lithograph on zinc (based on the painting by Cranach) was developed in March 1947,
and five states were proved. A sixth state was proved in March 1948, after extensive modification
with a scraper. In April 1949, this state was transferred to stone, and the design was again modified
to produce this print. In all, nine states were made on the original zinc. Courtesy, Courtauld
Institute of Art, London.

Sidney Nolan, *Rinder, Subject 1*,
1969. Black-and-white lithograph,
50.5×65.5 cm. Courtesy,
Marlborough Graphics, London.

The bed is run through the press once in each direction
without releasing the pressure. The light pressure which
has been used for this part of the operation should be suffi-
cient to make the coating stick to the plate. The pressure is
increased and the bed run through as before.

The transfer is then exposed and its back damped with
clean water from a sponge. It will be found that this moisture
is readily taken up by the transfer backing. If the drawing
or image has been made by writing ink dissolved in water,
this will spread in a disastrous manner should the damping
at any stage of transferring be too generous. It is better to
take longer over transferring rather than hastening the
process by too much damping. The pressure is increased
once more, and the bed taken through the press.

The transfer is again exposed, and in case the pressure is
uneven across the bed, the plate, with the transfer sticking
to it, is turned through an angle of 180°. It is damped once
more and sent through the press.

After this, one corner of the transfer can be lifted. If it
comes away easily, the remainder can be carefully stripped
from the plate. If any areas are difficult to lift, these should
be damped on a local basis. If this is followed by gentle
rubbing, the problem is usually solved.

Chalk transfer paper is put down in a similar way, but because of the extra thickness of the paper and coating, the water will take longer to penetrate. If transferring to a stone, this should be gently warmed for an hour or so previously, by standing it in front of a fire. It must be *warm*, not hot. Alternatively, the stone may be kept damp with hot water until the transfer is ready. Any transfer which is likely to prove difficult will go down more easily if warm water is used for damping the back. Care must be taken to ensure that the transfer does not become hot, as this will melt the ink or chalk, causing the image to spread.

Everdamp papers do not normally require damping, and will adhere quite easily to the plate surface without it. However, if they have been stored for any length of time without adequate protection, or if chalk forms part of the image (as in frottage), damping may be necessary to help

Sidney Nolan, *Rinder, Subject 2*, 1969. Black-and-white lithograph and transfer, 50.5 × 65.5 cm. Courtesy, Marlborough Graphics, London.

the fat to stick to the plate. If transfer ink or press black in a thin film forms the image on this type of paper, heavy pressure can be used to make the transfer without danger of the image spreading.

Because of their substance, the writing and chalk transfer papers do not readily cockle when subjected to damp, so that French transfer paper, which unfortunately possesses this quality in good measure, requires a different treatment. It is not placed in the damping book prior to transferring. When the plate is ready, the dry French paper is laid on it and then covered with a sheet of damp paper. Since the transfer will begin to cockle the moment it touches the damp paper, the operation of laying it and bringing down the backing and tympan is more easily and quickly performed with the aid of an assistant. The mode of operation is as follows.

The transfer is carefully laid on the plate in the required position and held firm, while the assistant, on the non-working side of the press, holds the damp paper in readiness. He carefully lays this over the hand which is holding the transfer still. Immediately it is down, it is held firm by the operator's other hand while he withdraws the first one. Meanwhile the assistant is bringing down the backing, which is laid, as before, over the hand of the operator. While the operator is holding the backing steady and withdrawing the other hand, the assistant is lowering the tympan. The bed is then passed once through the press in each direction, under firm but not excessive pressure. The transfer is then inspected. It will be seen that the areas of the transfer paper which have successfully transferred have become almost invisible except for the lines of the drawing. In these areas the moisture from the damp paper has penetrated to the plate surface. If necessary, the back of the transfer is lightly damped with a well squeezed out sponge, and after the plate has been turned through 180° the bed is run through the press once more. After exposing the transfer, it can be tested by lifting one corner. Thereafter, it may be peeled off, carefully damping if necessary.

When the plate is dry, any strengthening of the image can be carried out before gumming the plate with gum/etch. It is not necessary to etch this type of transfer as so few prints will be required from it.

When several different transfers are used to build up an image on the same plate, in the form of a collage or montage, a different method must be adopted. It is not practicable to transfer images in sequence, as the first ones to go down would offset on to the later ones as they are being transferred. Having made the various images on transfer paper, which may include pieces of texture, transfers from old blocks or direct drawing, and may be made using transfer ink or press black and the direct graphic media of crayon or writing ink, they can be cut or torn to the sizes and shapes required. After a period in the damping book, they are then assembled

Sidney Nolan, *Leda Suite No. 2.*
Black-and-white lithograph.
Courtesy, Ganymed Original
Editions Ltd, London.

in their respective positions on a piece of damp cartridge paper of adequate size. They can be secured to this by a few spots of gum arabic on their backs, but the traditional method is to use black treacle in the same discreet way. The treacle is to be preferred as it is non-drying and its natural viscosity makes it a good temporary adhesive. A further advantage is that as it is neutral in its action on the plate, should any find its way there it will cause no problem.

This method of assembling small transfers was widely practised in commercial printing before the development of the 'step and repeat' camera, mainly for printing labels or similar ephemera in quantity. It was known as *patching up*.

The patched-up sheet is applied to the plate in the normal manner, and being damp, no sheet of damp paper is interposed between it and the backing sheets on the press. The pressure should be firm, and the bed run forwards and backwards once before exposing the transfer. The individual transfers should have adhered sufficiently strongly to the plate for the patching sheet to be removed. If this is not possible, this sheet should be carefully damped without altering its position, and then run through the press again. After the patching sheet has been removed, careful damping is continued on the backs of the different transfers and the bed run through the press as before.

It is advisable to turn the plate through 180° and to run the bed through again. The sequence of damping and

putting the transfers through the press is repeated until they can be peeled off with the help of a damp sponge. It is better to combine only Everdamp and writing transfer papers in this way.

Certain variations can be adopted in the making of this type of multiple image. With care, it is possible to mount a smaller transfer on to a larger one after the latter has been patched up to the sheet, so that after transferring, no gap exists between the boundaries of the images. It is also possible to mask, with clean paper, areas or parts of the individual transfers after they have been patched up. In both these cases, spots of treacle are used to secure the extra transfers or pieces of paper. Masking with paper allows exact drawing to be added to the plate after the transfer has been put down.

After any weak transfers have been strengthened, and registration marks added, if they are necessary, the plate can be gummed and proved in the normal way.

Although transfer ink is the recommended medium for taking printed transfers, it will be found that press black, used in a thin but adequate film, will be perfectly satisfactory. Transfer ink is rather closer to the writing ink in composition, and usually possesses quite weak pigmentation. Thus it is tempting to use too generous a film when inking the various surfaces from which transfers are required. It is a very stiff and intractable ink, and needs to be reduced with a medium varnish to a good working consistency.

Some transfer coatings seem to have a marginal desensitizing action on the plate, and it sometimes happens that drawing added after transferring fails to take. In such a case, it is better to gum the plate after making good any weak transfer, and then roll up the plate with press black in the normal way. The plate can then be resensitized and any necessary drawing added at this stage. Processing can then continue.

If there is any doubt about the strength of a transferred image, plain gum rather than gum/etch should be used before washing out and rolling up. After a proof has been taken, a decision can be made about resensitizing and strengthening the transferred design.

Transfers can be laid on to plates which have been partially gummed out to form white areas, or to protect some drawing which has already been made. No special technique is involved in this form of transferring, though the gum on the plate should be as thin as possible, and contain some etch, to give added protection to the drawing.

Most transfers, after being put down to the plate, can be processed in the normal way, that is, gummed with gum/etch solution, washed out and rolled up and proved.

When an isolated area of transferred texture is added to an existing, but uncompleted, plate drawing, e.g. a transfer obtained by rolling up a piece of coarse muslin and either burnishing it down to the plate by hand or running it

through the press, it need not be subject to any special treatment but can be processed in the same way as the rest of the drawing. Most printed transfers involving transfer ink or press black produce very sharp and strong images which present little difficulty in becoming established on the plate.

Certain transferring techniques developed by Picasso involve the use of gouache paint. This paint, since it contains gum arabic, has a completely desensitizing effect on the plate when used in anything more than a thin wash. Also, white gouache colour contains chalk, which, as lithographers know, will adsorb fat. Several methods have been employed. A drawing is made on writing transfer paper, which might take the form of bold solid areas. A gouache drawing is made over this, and when it is dry the whole is transferred down to the plate. The second method involves working directly on the plate with gouache, using it very thinly, and then transferring the drawing on top of it. Alternatively, a gouache drawing can be made on the transfer paper, and when this is dry, a second drawing is made with litho ink. When ready, the whole is transferred to the plate.

Without some fairly prolonged experimenting on the part of the artist who wishes to use these methods, the results cannot be accurately predicted.

In 1895, in the *Saturday Review*, Sickert made a thinly veiled attack on Whistler because he had used transfer paper in making certain of his lithographs, and accused him of obtaining money by false pretences as his prints could not honestly be described as lithographs. In the ensuing libel action, Whistler was completely vindicated and the court judged that his accusers were ignorant of the lithographic process. In this use of technical innovation the only real criterion which operates is that the process must have been used creatively, and that it was indispensable in achieving a particular quality of image.

TRANSFERS AND CERAMICS

For many years, lithography was the medium used for duplicating designs to be applied to glazed china. While its place in the industry has now been taken by the screen printing process, the original method may have some attractions for the lithographer who has access to a pottery and kiln. This technique can be practised satisfactorily on most glazed surfaces such as tiles or white china. The method relies on a certain type of transfer paper known as *Decalcomania*. This consists of a heavyweight cartridge paper, to one side of which is applied a strong, thin, semi-transparent paper coated with gum.

The method used is as follows. The design is prepared and the plates drawn and proofed in colour in the normal

way. After making any necessary corrections, and establishing the printing order, the transfers can be printed. For this, instead of colour a very thick litho varnish is used. The image is printed on to the gum coating of the transfer paper and is then dusted with the appropriate enamel powder. In a multi-colour design, the order of printing which was established when proofing the plates must be reversed when printing the transfers. The colour which goes down first on the transfer will be the uppermost colour on the finished piece of ceramic. It should be stressed that the raw powdered enamels bear no resemblance to their colour after being fired.

Each printing on the transfer can only be done when the previous colour has dried. Therefore the sequence is: printing with varnish, dusting it with enamel (carried out in a manner similar to dusting offsets), allowing the varnish to dry, printing the second colour over the first, dusting this with the second colour, allowing this to dry and so on, until all the plates have been printed. It must be stressed that after inking the plate the damping water must be fanned dry before laying the transfer, otherwise the gum surface will be activated and stick to the plate.

Surplus transfer paper is trimmed from the design and the area on the pot which is to receive it is damped with a clean sponge. When the decalcomania is applied to this, the exposed gum will be activated by the moisture so that the transfer will stick to the surface. With a small sponge, the back of the transfer is gently rubbed with a solution of soft soap so that it can be separated, leaving the thin paper and enamel design sticking to the pot.

The pot is fired to a critical temperature at which the enamel and glaze begin to melt so that they become fused together. During firing, the paper and varnish are burnt away and the enamels, after fusing, change into their true colours, becoming an integral part of the glaze.

5 Paper plates

This is the brainchild of Anthony Ensink of Chicago,
developed during the Second World War primarily as an
immediate and economic method of printing, under field
conditions, the endless quantities of ephemera needed by
the various services. Initially, it was conceived as a simple
wipe-on plate, that is, it could be coated with a light-
sensitive solution without the use of bulky and sophisticated
equipment, and afterwards exposed through a negative to
a light source to form a lithographic printing surface.

Its commercial use spread rapidly after the war and, in
the UK at least, led to the formation of many in-plant
printing departments by firms and public bodies, with
predictable effect on the local jobbing and letterpress printer.
The fact that untrained staff could operate the system, and
that it could be successfully married to the electric type-
writer or Varityper, with its wide range of type faces and
capacity for justification, is an indication of its directness
and simplicity.

During the nineteen-fifties, Anthony Ensink introduced
a modified system relying on autographic methods, mainly
intended for use in an educational context. This received
widespread recognition throughout the United States and
Europe, as a simple and economic method of introducing
lithography to children in secondary schools. For this, it
has many advantages, not the least being that the process
is immediate and does not involve the rather technical and
precise disciplines of rolling up and etching, and – possibly
more important – that no toxic materials or solutions are
used.

Since then, paper plates have been invading the field
of higher education and are now frequently used in art
schools and colleges of education. In Britain, economic
factors have had some influence on their adoption, these
being mainly the increased initial cost of zinc or aluminium
plates and the heavy expense of regraining them.

The plate consists of a coating laid on a paper base, similarly
to the way transfer paper is made. The layer immediately
adjacent to the paper is made from a waterproof compound
and this is overlaid with a grease-sensitive coating com-
prising alginates, china clay, barium sulphate, calcium
carbonate and titanium dioxide. The surface and working

characteristics which this coating gives can be compared to that of one of the lighter-coloured litho stones, but experienced lithographers will find it rather more absorbent, and less sensitive to thin washes. These points will be dealt with later.

A further development by Anthony Ensink is the interposition of a hydrophilic barrier between the waterproof coating and the working surface. This allows the use of a scraper or point to make white-line images or texture. At the time of writing, these plates are not available in Britain.

Although drawing media designed specifically for these plates can be supplied, the standard litho media, including crayon, writing ink and tusche, apart from ordinary colour wax crayons, can be used for image-making.

Because of the pronounced absorbent quality of this type of plate, the drawing or other image-making media must have a strong and active grease content. The plate does not appear to react very sensitively to the use of minimal quantities of ink, for instance, as used in making certain washes, and this quality produces images which are well contrasted in tone. The explanation may be that any application of thin ink is totally absorbed into the plate, leaving insufficient on the surface to form a printable image. Although areas worked in this way remain visible, they do not accept ink from a roller.

Chalking, lines drawn with a ball point pen (used with a light pressure to avoid indenting the paper), areas painted with writing ink, and gumming out with the desensitizing fluid, are techniques which can be confidently employed.

In addition, the plate's flexible structure makes it suitable for taking transfers from highly textured surfaces, using the frottage method (p. 68). It can also be used for taking proofs from stones or metal plates, or from type and various relief blocks. Using a lithographic ribbon, it can be used in a typewriter. Its lightness and portability make it ideal for use as an extension to the sketchbook. It can be pinned to a drawing board, or clipped to a sheet of hardboard to give it stability as it is being worked.

The plate is capable of providing characteristic washes, some of which resemble those obtainable from metal plates (discussed in Chapter 6). However, it will be found that using the generous amounts of water needed for some of these tends to make the plate cockle. This can be minimized by pinning the plate to a board all round the edges. A slight distortion also occurs when the desensitizing fluid is applied. Because of this tendency to warp, it is better to wait until the expansion has stopped before sticking the plate to a rigid surface for processing and printing. If the image is large in relation to the size of the plate, and there is little non-printing area, the distortion will be minimal, so that the plate can be permanently mounted before drawing.

Any lithographer used to the rocklike stability of stones, who has tried to roll out colour on to a thin aluminium

Frottage texture taken from wood, by litho crayon, directly on to
a paper plate.

The hand roller or brayer.

plate without first securing it, will have experienced the frustrating problem of the plate wrapping itself round the roller. Unless fixed to a rigid base, paper plates behave in the same way. The plate can easily be fixed, with gum arabic, to a polished litho stone or to the smooth and cleaned non-working side of a zinc plate. When secured in this way, it can be satisfactorily proofed on the transfer press or the offset proof press. One of the double-sided adhesive sheets used by letterpress printers for mounting line and halftone blocks to a base is also useful, though it has one major disadvantage in that if white spirit is used in quantity on the plate, it will strike through the paper and dissolve the adhesive, which will cause the plate to crease while going through the press.

While it is recommended that a polyurethane hand roller or brayer should be used for rolling up the plate, if the image contains large areas of solid flat tint roller marks may be difficult to avoid. Once the plate has been secured to a rigid base, the normal litho roller can be used, with a corresponding improvement in the quality of the inking.

DRAWING AND PROCESSING

As previously stated, direct traditional methods can be used on the plate, with the exception that with some plates scraping out is not recommended. Since the plate has the flexible quality of transfer paper, frottage images can be made directly on to the drawing, in the way described in Chapter 4. If required, transfers can also be made on to the paper plates from relief surfaces, using the letterpress machine. The desensitizing fluid, because it is so thin, allows the finest white line to be drawn with the pen. This equivalent of gumming out is also possible using the brush; in both these cases the fluid must be allowed to dry before continuing the drawing.

The plate will also receive a good contrasted image from a metal litho plate or stone, although if the image contains halftone passages associated with certain washes, these will not transfer well, if at all.

When the drawing is complete and dry, it should be left for an hour before coating the plate with the desensitizing fluid. This is done in the same manner as gumming a stone or plate with gum arabic. Rolling up the image can proceed immediately, while this fluid is still wet. Washing out, as practised on the stone or metal plate, is not done on this type of plate. It is recommended that the concentrated solution should be used for the initial coating, but for keeping the plate damp while rolling up, it can be diluted with its own volume of water. In some way, the non-printing areas need to be fed with the desensitizing fluid, so that it is unwise to rely on pure water as the damping medium. It will also be discovered that this fluid is much more efficient than water at clearing any scumming which might form.

After about six proofs – that is, when a good proof has been obtained, and the plate image is fully charged with ink – it should be laid aside for an hour or so before proceeding with the printing. According to Anthony Ensink, if these procedures are followed paper plates should be capable of providing an edition of about seventy without any real deterioration.

PRINTING IN COLOUR

The plates for a multi-coloured print can be prepared by any one of the methods usually employed on metal plates or stones, including tracing, wasted keys and so on.

Because of their rather fragile nature, paper plates cannot take the amount of punishment sometimes accorded to the more traditional surfaces, particularly in making frequent changes of colour, as washing out on this type of plate nearly always causes some damage to the image, either by weakening it so that it will afterwards tend to reject the ink, or, paradoxically, by making it spread, causing chalkwork to become coarse or even fill in. Therefore, the transitional stages which follow the black, rolled up drawing, before its use as a printing area for colour, must be completed with great care.

Firstly, several proofs should be taken without rolling up the image, to clear it of surplus black ink. The plate is then generously coated with the desensitizing fluid, and the level of this must be maintained while the image is being washed out with rag and as little white spirit as will do the work – that is, the rag should never be more than damp. When the image appears as a grey or blue-grey shadow, the plate can then be cleaned of the white spirit with a rag or tissue soaked with the desensitizing fluid. This type of image appears to reject completely any application of washout solution, so that rolling up takes place as soon as the plate is clean. Any areas which are rejecting the printing ink can be restored by allowing the plate to dry, and should then be rubbed with a piece of wax candle sharpened to a point.

If any of this is deposited on the non-printing surface, it can be cleared by gently rubbing the area with desensitizing fluid.

The coloured printing inks should be lithographic in quality, that is, they should possess good body and viscosity. If the ink lacks these, image spread is almost inevitable. Also, since the film of ink seems to be rather thinner than that on metal plates, care should be taken to avoid over-inking which, again, will cause the image to spread.

To some degree, the necessity for washing out can be avoided by using wax crayons for drawing the image. Since the plate reacts quite satisfactorily to these, if a pale-toned crayon were used, pale colours or tints made with reducing white can be rolled up directly over the drawing.

One method of working which is not practicable with metal plates or stones, is one favoured by intaglio printers when making coloured prints. This takes advantage of the fact that paper plates can be easily cut with a knife or a pair of scissors. The design can be drawn on the complete plate and then individual parts can be cut out for separate inking with different colours and then reassembled for printing.

DELETIONS AND ADDITIONS

No caustic preparations are needed for erasing unwanted marks or images, for a special eraser is supplied by the makers. To avoid smudging, it is better not to erase until as much ink as possible has been removed from the image by taking proofs without rolling up. The operation is best completed while the plate is dry, but it can be done when the plate is wet. Desensitizing fluid must, of course, be applied to these areas afterwards.

Vinegar seems to act as a satisfactory counter-etch or resensitizing solution. It can be left on the plate for up to an hour, and then washed off with water. After the plate is dry, extra work may be added, but rolling up should be delayed for an hour in order to allow the image to become established. After applying the desensitizing fluid, rolling up can proceed.

TRANSFERRING

It would seem that in a lithography workshop the major role of paper plates lies in this field. The plate can be used to make the image for transfer, either directly drawn or by frottage, or by printing on to it from some other independent image source; it can also be used as the transferring vehicle to print images down to other plates or stones. It can be seen that in this sphere, it has a great advantage over the traditional forms of transfer paper, not only in its ability to take the transfer, but because the image it has acquired

Peter Escott, detail from *Tuileries*, 1962. Colour lithograph with
transferred textures, 38 × 30.5 cm. Courtesy of the artist.

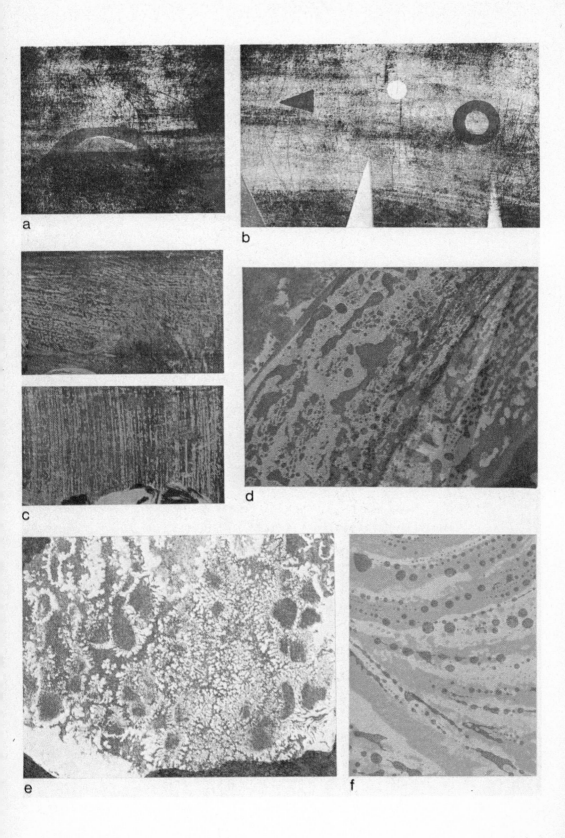

can be modified or strengthened before being re-transferred to the metal or the stone. It can easily provide both phases of image, the first by printing directly from it on to the metal plate, and the second, or mirror image, by first printing on to an intermediate surface such as transfer paper or another paper plate.

Its tendency to eliminate halftones can be exploited to reproduce an existing image from a metal plate or stone. The result will have the same relationship to the original that a tone-separated photographic print bears to the original camera image.

Transferring is easily achieved. Whether it is from metal plate to paper plate or vice versa, the metal plate should always be lying on the plate bed of the press, while the paper plate is uppermost. When rolling up the paper plate for transferring to the stone or metal, it should be secured to a flat board with drawing pins. A smooth sheet of rigid material – plastic laminate or the non-working side of a zinc plate – should be inserted under the plate. The image needs to be sufficiently charged with ink, but not over-inked. When this has been done, the plate can be unpinned and laid face down on the stone or metal plate, and then taken once through the press under firm pressure, in the same way as taking a normal proof. When transferring the other way, that is, from the metal to the paper, no special procedures are necessary. The image is inked with press black and proofed on the paper plate in the same manner as when taking a simple proof. Care should be taken that the image is properly inked. The normal precautions of gumming the metal or applying desensitizing fluid to the paper plate after the transfer has been completed, must be taken.

In his writings on the invention, Anthony Ensink emphasizes that these plates cannot usurp the functions of the traditional media in producing original prints, but it can be seen that they are capable of making a positive contribution to the work of the printmaker.

Opposite: Details of washes taken from coloured prints. *a, b* Texture resulting from zinc plate grained with pumice powder using a piece of cork as a grainer. This gives characteristic scratches which print intaglio. *c* Fine-grained plate where the washed-out solid tint had been worked into with Victory etch, giving a characteristic mottled texture. *d, f* Textures obtained from stones. Diluted writing ink was painted over the surface which had been previously damped with white spirit. *e* Texture of wash using writing ink dissolved in white spirit.

Wash texture using press black diluted with white spirit and floated on
to a well–damped zinc plate, which had been grained in the studio.
After etching, this plate was proofed directly on to a paper plate.

Proof taken from the paper plate after it had been desensitized and rolled
up. Note the extreme contrast of the image.

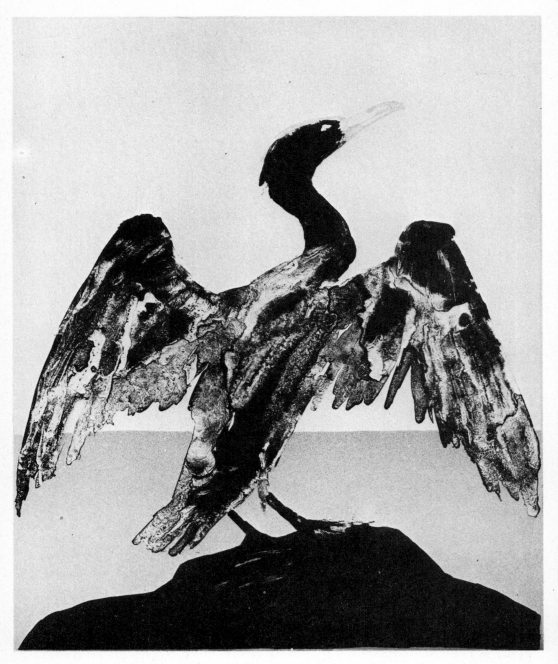

Elisabeth Frink, *Cormorant*, from the *Sea Birds Suite*, 1974. Colour lithograph with wash, 54.5 × 46 cm.
This lithograph was printed in dark brown and pale turquoise green. The wash was achieved by
flooding the appropriate area with water and working into it with writing ink. Lithographed at the
Curwen Studio, London. Courtesy of the artist.

6 Washes and wash textures

Drawing a solid area on the plate for eventual printing in a transparent colour is akin to laying a wash in painting: generally, though not necessarily, lithographic washes are laid with a dilute ink rather than a concentrated mix. Because of their final appearance, a more suitable description would be wash textures. In a painting medium, whether oil, gouache or water colour, the end results are completely predictable, but although some measure of control can be exercised in laying a lithographic wash, it would be rash to predict its exact outcome because of the intermediate stages. These wash textures should be regarded as a means of securing effects unobtainable by any other method. Although some broad idea of the over-all character of the finished texture might be anticipated, its precise quality depends on a number of variables. These factors include the different natures of the stone, metal or paper plate, the relative fineness of the grain, the different solutions used to make the wash, the amount of movement that is allowed the wash when it is on the plate, and the strength of the ink being used. Therefore, to secure a more predictable outcome to his activities, the lithographer should record in his note-book each formula used and each procedure adopted.

The one common factor in making these washes is that the particles of fatty ink, from microscopic to visible size, must be able to disperse over the plate in a solution which has to evaporate completely without leaving a printable trace of its presence on the surface. When this function is complete, the fatty particles can settle so that adsorption can take place between them and the metal, stone or paper plate. This is an ideal situation, but with some washes there may be some bleeding into the solution by the fat and this will be manifested by a film of tone when rolling up. Frequently this can be etched out at a later stage if needed, but sometimes it can be left to give extra quality to the texture.

The particles of fatty ink may be widely or closely dispersed, and this degree of aggregation will depend on the amount of movement in the solution. Thus the variation of tone is also dependent on this movement, though another major factor would be the strength of the ink being used. Since these washes are composed of minute and often

individual particles of adsorbed fat, their treatment must ensure that their unique character is preserved. The non-printing areas surrounding each particle must be desensitized without damaging the capacity of these small image areas to receive the printing ink.

The fatty solutions used for producing the printing areas can include litho writing ink or tusche in liquid form, diluted with distilled or natural water, stick writing ink dissolved in distilled or natural water, or white spirit, washout solution, and press black dissolved in white spirit. Other solvents for these materials can include methylated spirits, petrol and carbon tetrachloride. In some ways, petrol is to be preferred to white spirit as a solvent, since occasionally white spirit seems to contain residual traces of grease which may cause the plate to roll up as a solid.

Liquids which may be used by themselves to control the dispersal of the fat, but which do not act as solvents in the context in which they are used, include those listed above – water, white spirit, petrol, methylated spirit and carbon tetrachloride. Gouache may also be used, either on the plate or in conjunction with transfer paper, to produce characteristic textures.

Thus the wash may be composed of three parts, the ink, the fluid in which the ink is dissolved, and for some washes, a contrasting fluid which can retain its separate identity without mixing with the fatty solution of ink which it supports and disperse across the surface of the plate.

The characteristic which most distinguishes the metal plate from either the stone or the paper plate is its lack of porosity. Because of this, the wash can be kept in a plastic state for much longer than is possible on the absorbent surfaces of the stone or the paper coating. It is mainly for this reason that washes made on zinc or aluminium are so diverse in character.

WATER WASHES

These can be defined as either liquid writing ink, or the stick form dissolved in distilled water and applied to the plate. There is a critical stage in the dilution of this ink, above which it will roll up as a solid, and below which it will roll up as a halftone. This must be discovered empirically by drawing a plate with trial areas of different concentrations and, after gumming the plate, rolling them up, to study their behaviour when being inked.

Plain diluted writing ink applied directly to the plate surface gives a halftone quality. It is not a flat tone, but varied within moderate limits, and is characterized by irregular lines of deposited fat, left by the water as it evaporates. Layers can be built up one over the other to form an additive tonal change. It is important when working in this way to allow each layer of wash to dry before applying

the next. Variations occur if hard water is used, and this gives a more speckled quality to the wash. An example of this technique can be seen in Sam Francis's print, *Speck*.

An alternative method of applying this type of wash consists of first damping the surface of the plate with water and then dropping the diluted ink into this. The ink will percolate through this coating in a random way, a generously damped surface encouraging more flow than would be achieved on a moderately damp surface. The textures arising from this method generally possess organic characteristics, with a wide variation of tone combined with solids and textures. This type of wash has been well exploited by Elizabeth Frink in many of her lithographs. *The Cormorant*, from her *Sea Birds*, is a good example (p. 92).

When this water-diluted writing ink is used over a plate damped with petrol, white spirit or carbon tetrachloride, textures of very different quality are formed. Since the water solution will not mix with the spirit, the ink collects into globules across the surface, the character of these varying according to the strength of the writing ink and the amount of petrol or white spirit that has been used to damp the plate. The more fluid, and therefore weaker, ink will collect into smaller spots while a thicker ink, especially if the white spirit has dried to a thin or patchy layer, will produce larger spots and irregular shapes. This technique can be used to

Sam Francis, *Speck*, 1971. Colour lithograph with wash, 86.5 × 118 cm. Courtesy, Gemini G.E.L., Los Angeles, California.

Wash texture made by brushing
a solution of writing ink on to
the surface of a zinc plate (120 grain)
which had previously been damped
with carbon tetrachloride.

make rhythmic sweeping patterns, and operates equally successfully on metal or paper plates and stones. The brush used for applying the writing ink quickly becomes contaminated with the petrol or white spirit, which will be transferred to the container or writing ink. If this is allowed to continue unchecked, a solid will result. The brush should be wiped clean each time, after applying the ink to the plate, and only one stroke should be made before cleaning it. When used on zinc or aluminium, the spots occasionally bleed into the white spirit, so that when the plate is rolled up, they appear with blurred edges. These can give a very atmospheric quality to the print.

A variation of this method is to use a diluted writing ink in water, and apply it directly to the plate by a brush that has been dipped in white spirit.

When the plate has been damped with carbon tetrachloride before applying the ink, the texture assumes strong linear and rhythmic qualities, and the background and ink areas are more evenly balanced than when using petrol or white spirit, when there is usually more background than image.

One difficulty which may be encountered when using this method is that because spirit solutions are generally

lighter than aqueous solutions, the ink in the brush tends to penetrate the film of spirit and make image marks directly on the plate surface. The lightest touch is all that is required.

SPIRIT-BASED WASHES

These can be defined as writing ink in stick form, or press black dissolved in petrol or white spirit. These offer many possibilities for the lithographer as they are capable of a wide range of textures. They possess one advantage over water washes, in that the area on which they are to be laid can be isolated by gumming out the rest of the plate. Shapes within the area can also be gummed out, and will thus appear white against the texture. A water wash will tend to dissolve a gum film and deposit ink where it is not needed. Thus, water washes are more easily made while the plate is in the process of being drawn, while spirit washes can be made after the rest of the drawing has been finished, dusted with french chalk and gummed up. This will protect the rest of the plate from any encroachment of the spirit wash.

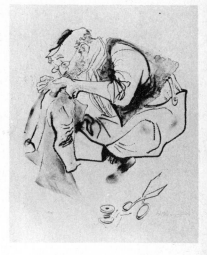

William Gropper, *Tailor*. Black-and-white lithograph with washes, 44 × 35 cm. Courtesy, Pratt Graphics Center, New York.

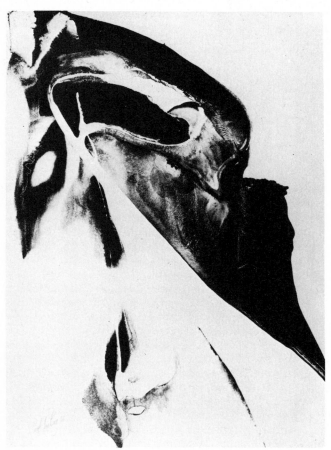

Paul Jenkins, *Untitled*. Black-and-white lithograph with wash, 76 × 56 cm. Courtesy, Pratt Graphics Center, New York.

Wash texture using litho writing ink dissolved in white spirit. The shape and several areas were gummed out before the wash was applied. Zinc plate, 120 grain.

These washes can be applied to the plate in the same way as water washes, directly to the surface, or on to a surface which has previously been damped with turps, or on to a surface which has been flooded with water. Each method produces its own characteristic wash, and many variations exist in each method. Variations are also caused by the use of press black or writing ink, the latter generally giving a more granular quality. These washes, again, can appear to be very organic and create a three-dimensional effect, but they can also assume quite flat and textured characteristics.

Using writing ink dissolved in white spirit possibly affords the most interesting washes, with fewer halftones and wider textural variations. If petrol, instead of white spirit, is used to dissolve the ink the granulation becomes more pronounced.

After gumming round the area to be covered, ink/spirit solution can be flooded directly on to the plate and encouraged to flow across the area by tilting. The liquid component of the wash carries the ink over the area, allowing the particles to fall out of suspension. Alternatively, the ink/spirit is fed into the white spirit which has been used to

damp the surface. The particles of ink settle, leaving the clear spirit above, to evaporate. Once the particles have come to rest, the plates should be kept still, in a horizontal position, until all the spirit has evaporated. Any movement in the plate will cause the particles to go back into suspension, so that the granular quality associated with the spirit/writing ink wash is destroyed: the granulation seems to break down to form an all-over solid tint. It is possible to obtain some interesting results while the particles are still in suspension, by adding pure white spirit or methylated spirits from a brush. This action appears to alter the surface tension of the solution, so that quite violent but short-lived movement is given to the ink. A characteristic 'cratering' results where each drop has been added.

Applying the ink/spirit solution directly to the plate usually makes a more compact texture, as the granules of ink do not have as much room to spread. If this solution is too concentrated, the area will roll up as a solid. The different textures produced by this method depend on the different grades of concentration, the weaker solutions

Wash texture using litho writing ink dissolved in white spirit. White spirit was dropped on to the wash while the particles of ink were still in suspension. This image, because of persistent scumming, was etched three times (as described on p. 28). Zinc plate, 120 grain.

Wash texture using writing ink dissolved in distilled water and floated on to a previously damped fine-grain aluminium plate. This shows the state of the image after being rolled up, following the initial gumming with gum/etch.

The same area proofed with the same ink, after etching for 30 seconds with a 50 per cent solution of Victory etch.

providing more open textures. Some of these washes tend to produce effects which are almost cellular and organic, while some have the quality of wrinkled skin. The more compact washes are dark in tone, and contain very little white unless laid across areas which have been gummed out.

Washes composed of press black and white spirit are not altogether satisfactory when laid directly on to the plate surface. The fine division of fat and pigment in this ink tends to produce an all-over halftone, which frequently rolls up as a solid. However, if the plate is first damped with water or methylated spirits, the results are more encouraging. The ink, which should be quite fluid, floats easily on the water and can be moved around the plate to form the texture. The water holds the ink away from the surface so that any contact is prevented until it has evaporated. The resulting texture is rich in halftones and frequently has a veined marble quality. After the texture has formed, the plate must be allowed to dry in a horizontal position.

Washout solution can be used in a similar manner but the textures it forms are quite different in character. The plate is generously damped with water and the washout solution dropped on to it from a brush. Movement can be imparted to it by tilting the plate, or disturbing the water with a small stick or a feather. Because of its quick drying speed, it tends to form into plaques with rivers of the water showing between them. The washout solution is quite dry before the water has evaporated, so that frequently there is little adhesion between the solution and the plate. If this appears to be the case, the area should be gummed and when this is dry, a mixture of press black and turps can be rubbed over the area to secure the image. Washing out normally can then take place. An alternative method involves floating the solution, or a solution of press black and white spirit, on water contained in a photographic dish. The fatty layer can be moved around on the surface of the water until the required texture is formed. The working surface of the plate can then be lowered on to this to pick up the texture. When it is dry, it can be gummed up. If the texture needs to be more contained within the image on the plate, transfer paper can be used for lifting it from the surface of the water, for later transference to the plate. In this case, the transfer paper can be cut to the required shape. This method is basically the same as that used for preparing marbled end-papers for ledgers and other books during the nineteenth century.

THE USE OF GOUACHE

Gouache is generally considered to have been introduced into lithography by Picasso, who used it in conjunction with transfer paper for the production of a series of prints which exploit the characteristic texture the method provides.

Texture on zinc plate. The plate was damped with carbon tetrachloride and this was over-painted with gouache. As the CTC dried, the gouache sank to the plate to dry. The ink, press black slightly diluted with white spirit, can either be painted directly over, or applied by rolling out a film of ink on to a sheet of smooth paper and then running it through the press as a transfer. In this example, the ink was applied by rolling out the press black directly over the plate.

Gouache, because of its composition, has two effects on lithographic materials. Most paints of this sort contain gum arabic, so that gouache has a very efficient desensitizing action on the plate. In white gouache, finely powdered chalk is often present as part of the pigmentation, so that, to some degree, it will adsorb fat.

Two examples of wash textures in which gouache has been used are shown here. In the first, the plate was first given a light damping of carbon tetrachloride, and this was overpainted with white gouache to form a similar, but negative, texture to that made by painting water-diluted writing ink over carbon tetrachloride. The gouache forms itself into a series of smaller or larger spots and because the carbon tetrachloride evaporates very quickly, these are able to settle on the surface of the plate before the water which they contain has evaporated. It is possible to work quickly to give sweeping and rhythmic textures. When the gouache has dried, alternative procedures can be adopted to coat the background with ink, so that a white texture against a dark background results. The adhesion between the gouache and the plate is not very strong, and the spots of gouache can be knocked off quite easily. The plate is laid on the press, and

a polyurethane roller charged with slightly diluted press black is rolled once over the area. This will lift some of the spots from the plate. It can be seen that this technique is only practicable if the area to be treated is smaller than the surface area of the roller. The area can then be gummed up.

Alternatively, using a fairly stiff mixture of press black, the background can be painted in, gently working right over the spots of gouache. This method carries a slight risk that the ink creeps marginally under each spot. Again, when the area has been treated, it can be gummed up. The third method involves a simple transferring technique. A sheet of smooth paper is pinned to a board, with the smooth side of a zinc plate inserted under it, and is then rolled up with press black, to form an even film. Either this, or a suitable shape cut from it, is laid on the plate and the whole run

Texture on zinc plate. A piece of yellow writing transfer paper was drawn with a mixture of press black and white spirit, and a gouache drawing was made over this greasy image. When it was dry, the whole was transferred to the plate in the normal way.

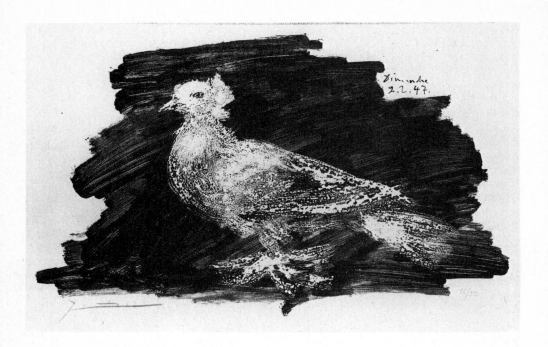

through the transfer press. As the paper is peeled from the
plate after impressing, it will pull most of the spots of
gouache with it. Using this wash technique, the areas to be
treated can be isolated by gumming out the rest of the
drawing before applying the carbon tetrachloride.

This type of texture (minute areas of white on a solid
background) requires the greatest care in processing, in order
to prevent the whites from filling in. When the texture is
complete, and the plate gummed up, it is better to omit this
area when washing out the drawing. When the rest of the
image has been coated with washout solution, these parts
can be strengthened by gently rubbing them with press black
diluted with a little white spirit, and keeping the plate damp.
When this has been done, the plate must be generously
coated with water and the wash texture gently rubbed with
a clean sponge to remove the spots of gouache which have
been covered with the ink. When this has been completed,
the whole image is dusted with french chalk and gummed
with gum/etch solution. It can then be processed normally.

The second texture involving gouache is made on yellow
or Scotch transfer paper, but paper plates are equally
efficient. Firstly, the transfer paper is broadly drawn with
an area, using either writing ink or press black diluted with
white spirit. The image is then drawn over this area, using
gouache. The possible textures, though similar in general
characteristics, vary in scale from the delicate to the bold.
When the gouache is dry, the transfer can be made in the
normal manner. When working at Mourlot's atelier, Picasso
used this method for many lithographs, including *Pigeon*

Jean Carzou, colour lithograph for the cover of Jacques Audiberti's
La Lagune hérissée (Paris, 1958). Courtesy of W. J. Strachan.

Richard Vicary, *Wasteland*, 1970. Colour lithograph with photographic imagery and transfer, 51 × 38 cm. See pp. 131–3.

au fond gris. One speculates on Mourlot's reaction when first confronted with this type of image.

In both these methods, the relative coarseness of the texture depends on the thickness of the gouache, more dilute mixtures producing finer textures, while the thicker paint can extend into larger shapes.

In more ways than one, preparing and using washes are occasions for extreme restraint on the part of the lithographer. Because they are so rewarding to make, there is the temptation to exploit them for their own sake. Used with discretion, they can make a valid and pointed contribution to a print. The other cause for restraint is a matter of lithographic chemistry. When preparing these washes, in most cases, the area may appear very weak, but in almost every case, the wash will roll up into a well-contrasted texture, tonally ranging from black to white. It is very tempting to mix washes too strongly to compensate for their anaemic appearance, and this will almost certainly mean that a solid area of black will result.

PROCESSING THE IMAGE

It must be understood that lithographic washes, even though they may give the appearance of halftones, are composed of minute specks of ink, each one having been adsorbed by the plate, and because of their size, they are extremely vulnerable to the encroachment of the etch after they have been dusted with resin and french chalk. Thus many of the granules disappear, leaving the image much more contrasted than either the original drawing, or the inked-up image prior to etching. This is demonstrated in the washes on page 100. The various tones of a wash are secured by the clumping together of the ink granules to form larger or smaller areas, and by the lesser and greater distances over which they have been dispersed. Thus, once the image has been established, the greatest threat is posed by image thickening, and various methods have been suggested to deal with the special problems relating to washes.

Normally, whichever method is followed, it is better to dust the original wash drawing with french chalk before gumming the plate and proceeding with the proving stages. When the drawing has been dusted, it will better resist any tendency to smudge when the plate is being gummed up. Also, since both the image and the non-printing areas can be so minute, and any spreading of the ink can damage this type of image more seriously than most others, the addition of french chalk to the image will temporarily remove its greasy quality, thus allowing the gum to desensitize the background immediately adjacent to each image speck (see p. 14). This initial gumming can be carried out using a gum/etch solution either with equal parts of gum arabic and Aztol, or with 2 parts of gum arabic to 1 of Victory etch.

This fairly strong initial gumming will do more to ensure a clean working background than a strong second etch, with its attendant risks of etching some of the image away.

Some authorities recommend allowing the finished wash to stand for at least six hours to enable the image to become properly established on the plate, before performing the initial gumming.

After the gum is dry, the image can be washed out, but it may be found advisable to use a solution of washout diluted with white spirit, rather than the full strength mixture. Sometimes, this solution can be very thick and over greasy, which would tend to coarsen the image. Rolling up should be carried out with a sparely inked roller, and it is better to build up the ink gradually rather than use a thick film, which would also encourage image coarsening. If the initial gumming, or to give it its other title, the first etch, has been made using the strong gum/etch solution, it may well be that the plate will be printing satisfactorily and will need no further etch. This can only be judged on the behaviour of the image and background while rolling up, and the quality of the proofs which are taken.

An alternative method uses the principle of rolling up directly over the original drawing. In this case, it is not dusted with french chalk before the first etch. This must be carried out with great care to avoid smudging the image, and at the same time to ensure that the gum coats the background right up to the boundaries of each particle of ink.

The gum is washed off, and rolling up with a sparely inked roller is performed directly on the drawing. When the image is taking ink, but before it begins to thicken, rolling is suspended. It is then dusted with resin and french chalk and given an etch of 30 seconds with a 50 per cent solution of Victory etch. The plate is then gummed with plain gum. When this is dry, the image can be washed out in the normal manner and rolled up.

The method used at the Curwen Studio has proved consistently successful in stabilizing washes to withstand long editions. When the drawing is finished, it is dusted with french chalk and thinly gummed with either a solution of gum arabic 50 parts, phosphoric acid 1 part, for aluminium plates, or equal parts of gum arabic and Atzol for zinc plates. When the gum has dried, it is washed from the plate by gentle hosing. (Using a sponge would smear the ink.) When the plate is dry, diluted Prepasol (1 part Prepasol to 5 parts water) is applied to the plate three times. Finally, the plate is dried and gummed with plain gum arabic. It must then be left for an hour before washing out and proofing. Normally no further etching treatment would be required.

WASH TEXTURES ON PAPER PLATES

Compared with zinc or aluminium, paper plates are much more absorbent, and this characteristic alters the quality of

the wash, so that even with the same solutions and techniques the results will be different from those achieved on metal. Generally, this change is manifested by a more positive granularity and a more enhanced contrast, there usually being an absence of halftones, and a more general coarseness of texture. Those washes which mostly resemble metal plate washes are obtained when the paper plate has been damped with carbon tetrachloride. Their characteristics are almost identical.

This wash (made with an aqueous solution of writing ink) appears to be the most successful which can be obtained using this type of ink, as when the wash is laid on the plate without the carbon tetrachloride, although initially it possesses the character associated with the method, when rolling up is commenced, the halftone areas do not respond, so that the over-all appearance of the wash is one of irregular fully inked shapes. Washes involving press black, or stick writing ink dissolved in white spirit, while not possessing halftones, are still full of interest.

Wash texture using press black diluted with white spirit floated on to a paper plate which had previously been well damped with water.

Wash texture using washout solution floated on to a thoroughly wet paper plate.

To compare three wash textures made with diluted press black, look at one made on zinc, on page 90, and a wash made on a paper plate, on page 109. The third example (p. 91) is a print taken from a paper plate which had been directly printed from the press black wash texture on the zinc plate. It will be seen that there is a greater affinity between the two impressions from the paper plate than there is between the original wash texture on zinc and its transferred image on the paper plate. Apart from the broad outline of the pattern being similar, the textural relationship is very small.

Opposite above: Wash texture on paper plate. The plate was first lightly damped with white spirit; litho writing ink dissolved in water was then painted over it. When the white spirit evaporated, the writing ink settled on to the surface of the plate. The larger areas of black arise in places where the film of white spirit is thinner.

Opposite below: Wash texture on paper plate. The plate was first lightly damped with white spirit, and writing ink dissolved in water was painted across it. The size of the spots is governed partly by the thickness of the ink and the thickness of the film of white spirit.

7 Photographically prepared images

Apart from directly drawn and transferred images, there is a third method, one which involves photography.

During the last half of the nineteenth century, in the field of commercial printing, most of the work now done by the camera was carried out by the lithographic artist, who was an indispensable member of the litho workshop. Through his work evolved the methods we now use of drawing keys and making offsets for drawing the various coloured plates or stones. His skills included the assessment of original colour work – which may have been anything from a popular Academy painting to the illustrations for Mrs Beeton's cookery book – and deciding how many stones would have to be drawn and in what colours they would have to be printed, if the work was to be accurately reproduced. His profession was at its peak during the heyday of chrome-lithography, when as many as 14 stones might be drawn and overprinted for a single illustration. It was a protracted business, but with the invention of the photographic half-tone and its employment in lithography the need for the lithographic artist diminished. Occasionally, however, his services are still required in the more expensive methods of reproducing paintings, more especially modern ones. In cases where the camera's filters are unable to separate a particular colour accurately, the areas in question are drawn on another plate and printed with a special mix of colour to match the original used by the painter.

The use of photography in preparing litho plates or stones occurred rather later than its introduction to intaglio or relief methods of printing. A light-sensitive coating for the production of intaglio plates was developed as early as 1829 by Niepce, who was involved with Daguerre in the pioneering of photography. Similar methods were also developed to transfer the artist's design to wood blocks for the engraver to cut, but the first purely photo-engraved relief plate was made by Fox Talbot in 1852. He used a fine silk gauze as a screen to break up the halftones. The application of simple photographic principles to lithography was achieved in 1857, when Poitevin patented a method of coating a zinc plate with bichromated albumen. At this time, lithography was mainly used for the highly technical business of reproductive colour work; it could not compete

with reproductive wood engraving for small-scale mono-chrome work, mainly because of the registration difficulties of incorporating small-scale lithographs in the text. The medium was not then ready for this innovation, which was only useful in a black and white context. The first commer-cially viable halftone screen, in its present form of two closely ruled glass sheets cemented together at right angles, was perfected by Frederick Ives of Philadelphia, in 1885. The three-colour or trichromatic halftone process followed in 1893, mainly due to the efforts of William Kurtz of New York.

During the last decade of the nineteenth century, photo-graphy was used in conjunction with hand-drawn methods for the production of chrome-lithographs. Although not fully employing trichromatic principles, some form of colour separation was involved, enabling the number of stones used for each print to be greatly reduced.

Photographic methods, as well as being widely used for reproductive purposes over the past decade, have been employed by artists in the making of prints. Images pro-duced by this means now have a secure place in the print-maker's repertoire, and many studios have facilities for making them.

It must be understood, first of all, that photo-litho does not always employ true lithographic principles. As we have seen with drawn and transferred images, the process works because of the adsorption of fat by the plate, the ink and the metal or stone being in direct contact. Many photographic-ally made images, however, are not in contact with the plate at all, being built up on the light-sensitive albumen with which the plate is coated.

Photographic methods are possible through the odd be-haviour of certain substances when exposed to light, and also because of their capacity to affect the behaviour of others radically when they are mixed together. Among other chromic acid salts, ammonium bichromate, while normally easily soluble in water, loses this property after being exposed to light, so that when mixed with solutions of egg albumen, glues or gums, it either completely or partially transmits this property to them. Thus, when a plate which has been coated with a solution of bichromated egg albumen is exposed to a strong light source with the interposition of a photographic negative, the transparent areas of the film allow the light to shine through on the albumen, rendering it insoluble in water and at the same time making it adhere strongly to the plate. In this case, these areas would eventually become the printing surface.

The behaviour of a dilute solution of bichromated fish glue is such that the exposed areas eventually become the non-printing surface. Thus, in this case, the printing image on the plate would be in the same phase as the film; that is, if a positive film is used, a positive image results on the plate, while in the case of bichromated albumen, the printing

image would be in the opposite phase to the film, so, to produce a positive printing image, a negative film must be used.

The normal equipment for coating and exposing the plate would be a plate whirler and a vacuum frame with a light source. Since the introduction of pre-sensitized and wipe-on plates and printing-down units, the older type of equipment has tended to go the way of the transfer press. Arc lamps, plate whirlers and vacuum frames are becoming quite rare and, depending on the circumstances, one might have to pay a lot for a secondhand set of equipment, or one may be sufficiently lucky to find a printer who is anxious to give it away.

PRINTING-DOWN UNITS

These are obtainable in various sizes to accommodate the different sizes of plate. In essence, a lightproof cabinet standing about three feet high has, for its top, a frame faced with a plate-glass front on one side and a metal lid for the other. The litho plate and the photographic copy are fixed into this frame and the air extracted by an attached pump.

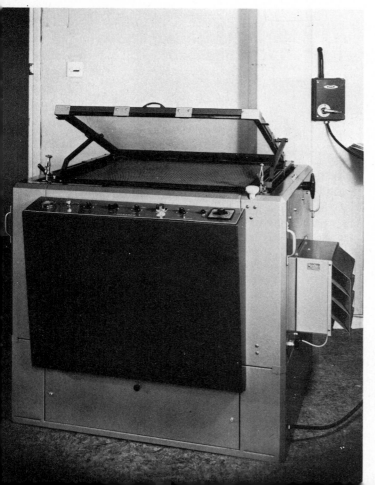

Swing-top or flip-top printing-down cabinet. With this model there is a pre-set timing device. When the frame has been loaded, it is turned inwards and automatically switches on the lamps for exposure. Courtesy, Messrs Hawthorne Baker Ltd, Dunstable.

This ensures absolute contact between the plate surface and the film, as they are forced against the glass. The light source is situated on the floor of the cabinet. In an alternative design, known as the *flip-top* or *swing-top* cabinet, the vacuum unit is pivoted so that it can swing through 180°. This allows easier loading and more accurate positioning of the film in relation to the plate. In the first model, the film is laid down first and the plate laid face downwards on it. In the second, the plate is laid face upwards and the film laid over it. When they are in position the frame is closed and the air extracted. The vacuum top can then be turned so that the film and plate face inwards to the cabinet and light source.

The plate whirler

This consists of a circular, semi-lightproof cabinet containing a horizontal platform which is rotated by an electric motor. On this platform are small screw-in pegs, the position of which can be altered to fit the various sizes and shapes of plates. This must be managed so that the plate is positioned as nearly as possible about the centre of rotation, to ensure even distribution of the coating when it is applied.

On top of the cabinet is a lid which carries an electric heater so that when the lid is closed, the heat is directed on to the plate. The heater can be switched on only when the platform is rotating. Under the platform is a sump to catch the surplus water and coating which is thrown off while the platform is revolving. A pipe collects this and leads it outside where it can be drained into a bucket.

The arc lamp

The ultraviolet light given by the arc lamp has been the activating light source in photo-engraving for many years. In printing-down frames its place has been taken by alternative methods, including tungsten and quartz halogen lamps. Ultraviolet light can damage the eyes and, in prolonged and excessive exposure, cause lesions on the skin, so care should be exercised in its use.

The lamp consists of two vertical carbon rods in line, with their ends touching. A current is fed to them by a transformer, and as the carbons form a virtual short circuit, the current is heavy. The rods separate, causing a brilliant arc to form between them. This separation is automatically controlled by the amount of current. As the rods separate, the current is reduced, so that the gap once again begins to close. Thus the process is self-adjusting, and after a few seconds the carbons reach a position of equilibrium. Sometimes starting can be difficult, but this can usually be overcome by slightly altering the position of the bottom carbon.

The whole assembly hangs from the ceiling and its height is adjusted so that the arc is centrally placed in relation to the vacuum frame when it is in the upright position.

The arc lamp. *a* Electrical input terminals; *b* coil; *c* metal casing; *d* soft iron rod and holder for top carbon; *e* reflector; *f* securing screw for bottom carbon.

When voltage is applied across the terminals (*left*) to complete the circuit, current flows through the coil and the carbon rods. Initially this is high, as there is very little resistance in the circuit. A strong magnetic field is formed by the coil, which causes the soft iron rod to be drawn upwards into the coil-former. The carbons are thus separated (*right*) and a brilliant arc is formed between their ends. This has the effect of reducing the current, so that the iron rod then drops, bringing the tips of the carbons closer again. Once warmed up and running properly, the whole system is self-adjusting. Starting can be difficult, when the lamp can run for several seconds and stop. This can normally be cured by slightly raising the bottom carbon.

The construction of this is similar to the lid of the flip-top cabinet. A heavy piece of plate glass is sealed into the hinged lid of a shallow steel box. This, in turn, is hinged to an underframe which is screwed to the bench so that its position relative to the arc lamp is fixed. The floor of the box is lined with an embossed rubber sheet on which the plate and photo-copy are laid. The air is extracted via a narrow pipe by a vacuum pump, after which the frame can be turned to its vertical position ready for exposure.

COATING THE PLATE

Concentrated light-sensitive solutions for plate-making, ready to be diluted to working strength, can be easily bought, but they have the disadvantage that they deteriorate in storage. A bottle of solution will normally provide about three times its own volume of working-strength solution and unless it is being constantly used by more than one person, will deteriorate before it has been finished. Similar solutions can be very easily and quickly made up from locally purchased ingredients, and this is cheaper, too.

Dried egg albumen is supplied in glass-like flakes and the required amount is soaked in sufficient water to make a watery syrup. A more basic method is to separate the white from a fresh egg, and to dilute this with from three to four times its own volume of water, again to make a very thin syrup. Both solutions must then be strained to remove any strings or other particles.

Ammonium bichromate is supplied in the form of brilliant orange-coloured crystals, easily dissolved in water. A saturated solution should be made and enough of this is added to the diluted albumen or fish glue to turn the solution lemon yellow. This solution is gently stirred while adding a few drops of cloudy ammonia. The addition of this retards the action of the light, thus allowing a little more leeway in positioning the films. When preparing this mixture, care should be taken to avoid the formation of any bubbles as these are difficult to eliminate and, in the case of the albumen, can cause trouble if they occur over the image area. They tend to dry as small craters and when printing they appear as pock marks. If bubbles do form, a suggested remedy is to pour the solution on to the plate from a container such as a teapot, in which the base of the spout is situated halfway down the vessel. This will allow solution to be poured out from the centre of the container rather than from the bottom, where there may be some sediment, or from its surface, where any bubbles will collect.

This mixture should be stored in a brown glass bottle, and if possible, in a lightproof cupboard. As an added precaution the bottle can be wrapped in foil. In time, however, light will always penetrate, causing the solution to become gelatinous and unfit for use.

The plate is washed under the tap and fixed, while still very wet, to the platform of the whirler. When the machine is switched on, the surplus water is thrown off by centrifugal force. Before too much has been lost, the sensitized albumen or fish glue is poured on, as near to the centre of rotation as possible. Approximately one tablespoonful would be sufficient for a 20 in. × 15 in. (51 × 38 cm) plate. The rotation gradually forces the coating to spread outwards across the surface of the water until the whole plate is covered.

There are some points to notice here. As the plate is rotating, its grain appears to make concentric circles, the diameters of which decrease as the centre of rotation is reached.

It is at this point that the solution is poured on. The aim must be to use as thin a layer of coating as possible. If it is too thick, the light will not penetrate sufficiently deeply to make it all insoluble in water. The underneath will be left in a spongy condition, and in the case of the albumen, after a short while, encouraged by the action of printing, the image will become detached from the plate.

It is sound practice to close the lid of the whirler once it has been seen that the surface of the plate is completely covered. The heater in the lid is switched on, and its warmth spreads over the plate to assist with the drying. As long as the solution is in a liquid state, it will continue to spread from the centre, forcing the surplus over the edges and at the same time coating the plate more thinly. As soon as the heater has warmed up, the solution becomes viscous and remains static. The plate should dry in from five to ten minutes.

EXPOSING THE PLATE

Although the sensitized plate is very slow, compared with photographic film, it does not pay to be dilatory about processing it. The available light in a studio, even if the plate is wrapped, is enough to start activating the coating after an hour or so.

The plate is laid face upward on the rubber mat in the vacuum frame, and the film placed over it in the required position. It is usually possible to place the film against the plate with the emulsion either up or down, without loss of definition, whenever a lateral reversal of the image is needed. This may be important if the job is to be printed on the transfer press, where the image has to be reversed on the plate in order to print the right way on the paper. All non-image areas must be masked from the light by thick black paper, metal foil or other photo-opaque material. It is useful to keep a selection of such material near the frame so that cutting different-shaped masks for specific images will be unnecessary.

When the plate and film have been correctly positioned, the glass front is brought down and screwed up tight. The

tap on the air extracting pipe should be closed and then the extractor pump switched on. When both plate and film are forced tightly against the glass, the frame can be turned to its vertical position. If the frame were to be turned before the air was extracted, the plate would not be held sufficiently tightly and would slip down to the bottom edge.

A distance of about 18 in. (46 cm) is recommended between the arc and the image. At this distance, the exposure would be of the order of one to two minutes. A few trial plates should be exposed when the equipment is first installed, using different times; the period giving the best development, with a crisp image and clean background, should be used as the normal exposure time. Exposures that are too long encourage the disappearance of fine work. The intensity of the light decreases rapidly as the distance from the light source increases, so longer distances necessitate longer exposures, thus increasing the likelihood of inferior definition.

After exposure, which should be accurately timed, the arc is switched off, the vacuum frame returned to the horizontal and the pump switched off. The tap on the air extraction pipe can be opened to allow the air to enter the frame more quickly.

It will be found useful to have a smooth working surface next to the frame so that the exposed plate can be placed on it for the first stage of developing the image. A large litho stone is ideal.

Until this point, the processing of plates sensitized with either albumen or fish glue follows the same course; from now onwards, each type will be dealt with separately.

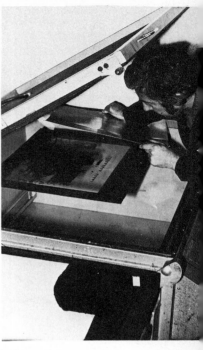

Printing-down unit. Laying the sensitized plate on to the negative. Note that the negative is resting on the plate glass. When everything is in position, the lid is brought down and clamped, the air is extracted from the vacuum frame, and this is followed by exposure to the lights in the base of the unit. Courtesy, Camberwell School of Arts and Crafts, London.

DEVELOPING THE IMAGE

Bichromated albumen

The first stage of this procedure is a critical one, as failure to perform it will mean losing the image and having to start again with a clean plate.

When the exposed plate has been removed from the frame, the difference which the light has made can be quite easily seen: the exposed (and therefore the image) areas will have turned a brownish colour, while the areas which will be washed away retain their pale lemon-yellow colour.

The developing solution is gently rubbed over the image and allowed to dry. This solution is a refined form of washout solution, composed of genuine turpentine, asphaltum and lamp black. Failure to coat the image with this solution at this stage will seriously impair its ability to accept ink from a roller later on. The image must be given a greasy, water-rejecting surface before commencing to wash off the unexposed part of the albumen. Once the image has become wet, even though it can be dried out again, it will not accept a stable film of the greasy developing solution.

119

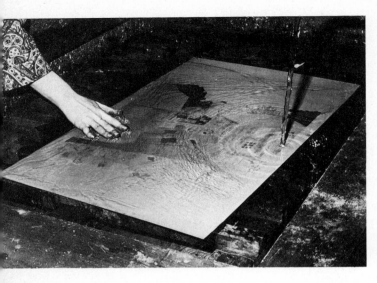

Developing the photographic image
on the plate, under running water.
Courtesy, Camberwell School of
Arts and Crafts, London.

It is easier, when putting on the developer, to work first
round the perimeter of the image, and then to coat every-
thing within that line. Although the difference between the
exposed and unexpected albumen is quite apparent, once the
very dark-toned developer is applied to the plate the two
areas become almost indistinguishable, and to be certain of
covering the image, the whole plate would have to be
coated, which is more messy as well as being less economic.

After the developer has dried, which should only take
a few minutes and can be hastened with an electric drier,
the plate is washed under the tap and at the same time care-
fully rubbed with a pad of cotton wool. The water washes
away all the unexposed albumen, leaving the image crisply
showing in black against the clean background of the plate.
The surplus water is allowed to drain off and the plate
gummed with gum/etch.

When the gum has dried, it is washed off, and press black
rolled up directly over the dried developing solution.
Proofing and etching the plate can be carried out in the
normal way. When this type of plate (an albumen-coated
plate with a photographically produced image) is washed
out prior to rolling it up in colour, the normal method of
using white spirit followed by washout solution can be
adopted.

Bichromated fish glue

Originally this method was used for duplicating plans and
diagrams, mainly of a linear character, and was known as
the Vandyke process. The process is possible because bi-
chromated fish glue does not become as insoluble in water,
after exposure to light, as does the albumen.

After removing the plate from the vacuum frame, it is
immediately developed under running water without add-

ing the developing solution. The unexposed (image) areas are washed away, leaving the exposed bichromated fish glue, which is temporarily insoluble in water, on the plate.

These areas are then stained by coating them with a solution of methyl violet, after which the plate should be dried and slightly warmed. Following this, resensitizing solution is flooded over the plate to restore the fat-sensitivity of the unexposed areas which may have become impaired by the action of the fish glue. The plate is now thoroughly washed and dried. The design is filled with transfer ink or press black, which can be slightly reduced with white spirit. The plate should then be allowed to lie in a warm place for several hours.

The next stage is the removal of the stained, exposed film of fish glue. If the plate is left covered with water for twelve hours, this will be sufficient to remove the coating, but it may be removed more speedily by immersing it for a short period in a solution of 1 part of hydrochloric acid in 160 parts of water. This should clear the background fairly quickly. The progress can be checked by lightly rubbing the coating. Although it may be tempting to hasten the action by making the solution stronger, it is better to immerse the plate for a long period in a weak solution rather than give it a short immersion in a stronger solution.

After the image has been cleared, the plate is thoroughly washed, gummed up and treated as a normal autographic drawing.

COMBINED IMAGES

The unexposed bichromate albumen seems to be almost neutral in its effect on the plate, so that when the image has been developed and washed under the tap, but before gumming up, extra work can be drawn in by chalk or ink, and the plate then gummed. When the drawing is washed out, it is preferable to avoid the photographic image, but if this is not possible, and the photographic image has to be included, to avoid weakening it washout solution should be used instead of white spirit. The plate can then be rolled up, etched and proved normally. Full-strength drawings can be added in this way, but if the drawing is to be light, or will involve the use of washes, after developing the image the plate should be resensitized, washed and dried before adding the work.

If extra work is to be added by transfer, a slight variation of procedure becomes necessary in order to protect the photographic image during the transferring process. The plate is exposed and developing solution applied in the manner described. This can then be reinforced by adding a coating of washout solution. If the image is composed of fine lines, the addition of a little press black might be advisable; it should not be so thick that it is sticky, otherwise

it will build up on the image, coarsening all the fine work and filling in the interstices of the design. This would be manifested during the process of clearing the unexposed albumen under the running water, as the action of rubbing the image with cotton wool would tend to wipe any excess mixture on to the non-printing background.

When the developing has been completed, the plate can be resensitized, washed and dried, and the transferring can then be carried out. Both writing and Everdamp papers can be used. After any necessary repair to a poor transfer, the plate is gummed. When this is dry, the image is washed out with washout solution as in the previous case. The normal processes of rolling up and proving ensue.

It is possible to combine all the three methods of image-making on the same plate, as long as this order is followed. First, the photographic image is put down and strengthened with the developing solution and washout solution. The transferred work is added after developing and resensitizing the plate. This is followed by any direct drawing which may be required. The plate is gummed up and when this is dry, the combined image is washed out with washout solution. The normal processes of rolling, proving and etching follow.

Although it was stated earlier that egg albumen appears to be neutral in its action on the plate, and therefore it is theoretically possible to wash it off and to add extra work without any further preparation, in practice the plate does sometimes appear to be reluctant to give a stable printable image, and this most frequently occurs when adding a thin wash. Full-strength additions do not cause so much trouble. Resensitizing the plate is generally a guarantee that additions can be made with reasonable confidence that a stable image will result.

In the case of plates on which fish glue has been used, when the image has been developed in the manner described, extra work can be added in a similar way to that described for albumen plates. After the exposed and therefore light-hardened coating has been removed by the hydrochloric acid bath, and the plate has been thoroughly washed, it can be resensitized with the appropriate solution, washed and dried. It will then be ready to receive extra work in the form of drawing or transfer.

PREPARATION OF FILM

So far, reference has been made only to photographic negatives or film in a general sense, but before these can be used for making lithographic images, they will have to be modified to some degree.

It must be supposed that the artist has some specific idea which may involve the use of an existing photographic image, either whole or in part, or that a special one will have to be made. Thus the initial image will probably be in the

I

Expecting your arrival tomorrow, I find myself
thinking *I love You*; then comes the thought—
*I should like to write a poem which would express
exactly what I mean when I think these words.*

II

Of any poem written by someone else, my first
demand is that it be good (who wrote it is of
secondary importance); of any poem written by
myself, my first demand is that it be genuine,
recognisable, like my handwriting, as having been
written, for better or worse, by me. (When it comes
to his own poems, a poet's preferences and those of
his readers often overlap but seldom coincide.)

VI

If I were a painter, I believe I could paint a portrait
that would express to an onlooker what I mean when
I think the word *You* (beautiful, lovable, etc.), but it
would be impossible for me to paint it in such a way
that he would know that *I* loved You. The language
of painting lacks, as it were, the Active Voice, and it
is just this objectivity which makes it meaningless for
an onlooker to ask:— 'Is this really a portrait of *N*
(not of a young boy, a judge or a locomotive in
disguise)?'

IX

First I write *I was born in York*; then, *I was born in
New York*: to discover which statement is true and
which false, it is no use studying my handwriting.

Henry Moore, illustration to W. H. Auden's poems, 1973. Colour
lithograph. Courtesy, Petersburg Press, London.

Richard Smith, *Edward Gordon Craig II*. Colour lithograph, three-dimensional. Courtesy, Petersburg Press, London.

form of a black and white negative film, of 35 mm or some other size. It will usually possess a range of halftones between the extremes of black and white.

Before it can be used on the plate, it must be enlarged to the size that is required, and either transformed into a half-tone negative, or modified in some other way which will substitute a pure black and white for the various and con-tinuous tones of grey in the original.

The use of a halftone screen interposed between the original negative and the transparent film on which it is being enlarged will break up the continuous tones of the original into a series of larger or smaller dots, closely or widely spaced, combined with flat areas of black and white, echoing the varied tones of the camera negative, but in a form which is suited to make a lithographic image. If the negative is screened before being enlarged, the screen will be enlarged to the same degree, and the result would be a very coarse halftone print. If this were to be enlarged even more, the halftone screen would dominate the subject-matter and become a pattern in its own right, almost abstract in character. This has been a popular graphic image for a number of years.

Alternatively, the negative can be enlarged first, and then screened to make a fine halftone film before being put down on the plate. The fineness of the screen is a matter

Gerald Laing, *The United States Pyramid*, 1973. Colour lithograph with photographic imagery, 38 × 53 cm. Courtesy, Tamarind Institute, University of New Mexico.

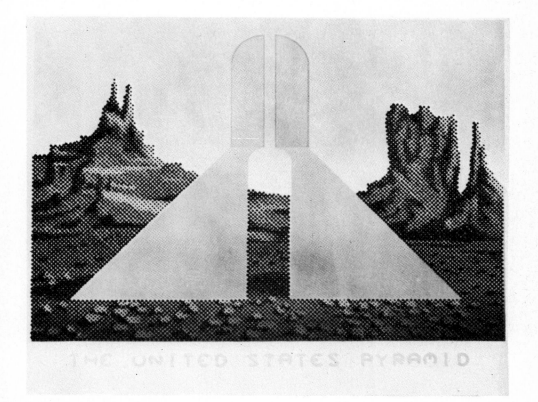

Penny Varney, detail of portrait,
1969. Black-and-white lithograph
with photographic imagery, 25.5 ×
20.5 cm. Original photograph taken
on Ilford FP4 through a sheet of
patterned glass. The film was
tone-separated and photographed
down to a zinc plate. Courtesy,
Shrewsbury School of Art.

of choice, and film is now available in which the screen is
incorporated, so that enlarging a negative or positive on to
this screened film will automatically produce an image
suitable for immediate printing down to the plate. For
normal purposes in the printmaking studio, a screen of
about 120 (dots per inch) would be perfectly adequate and
provide an accurate interpretation of the original without
presenting too many difficulties in rolling up and printing.

Another method of modifying a camera negative so that
it can be used on a litho plate is the well-tried darkroom
technique known as tone separation. Subjecting a film to
this process has the effect of eliminating all the halftone
passages, leaving a simplified image in crisp black and
white. This technique is frequently employed for cinemato-
graph images in television graphics. The camera negative
is printed on a piece of high-contrast or litho film, which is
developed and fixed in the normal way. The resulting
transparent positive is now printed on to another piece of
the same type of film, producing another negative. It will
be noticed that each time this transfer is made some of the
halftones are lost. Usually several transfers are necessary
before a satisfactory image is obtained. The final image
must be in the correct positive or negative phase, and the
right size, in order to produce an image of the correct
phase and size on the plate. That is to say, if a positive
image is needed for printing on an albumen-coated plate,
then the final enlarged film must be in the form of a negative;
on a plate coated with fish glue, the image will be in the
same phase as the final enlarged film.

If needed, colour transparencies can also be used to provide
black and white film, which can be modified in the same

way. These processes naturally belong to the darkroom and are only given in outline. There are other methods of altering the character of a negative to make lithographic images, each one giving a different over-all quality, which ranges from the poetic to the dramatic. These include masking, solarization and reticulation.*

FURTHER METHODS

It must not be assumed that all photographic images are obtained with camera and film. Any image that can be made by altering the pattern of light falling on to a sensitized surface is truly a photographic one. Any reasonably flat shape that is opaque, or a combination of opaque and transparent, can be laid over a coated plate and exposed to light. The image which it gives will depend on the degree of transparency and texture which it possesses. Many natural forms lend themselves to this end, including leaves, feathers, different grasses and insects, as well as a wide range of artefacts.

If no vacuum frame is available, this type of object can be used if the plate is laid on a flat surface and the objects arranged on it, and the whole covered by a thick sheet of plate glass. It would be better for the plate to rest on a layer of foam rubber or similar substance, to make it slightly resilient. If a vacuum frame is being used for this purpose, objects that are too thick will put a great strain on the glass when the vacuum is formed, and may crack it. Small twigs such as heathers can be used quite safely, but anything very much thicker should be avoided. Also, when using objects which have a measurable thickness, it is advisable not to use the very thin type of aluminium plate, as when the vacuum is formed, the pressure forces the object into the plate, causing it to buckle.

This technique can be highly successful, particularly as an introductory exercise in lithography, if materials like cut paper, lace or string cloth are used. These objects, on an albumen plate, will give textures in their negative form while a direct transfer from them would give a positive image.

Material to be used as photographic images can be assembled as a collage on thin, transparent acetate film; this includes photographic positives and negatives – processed as previously described – other flat textured materials and adhesive textures and letters such as the range of Letraset products. Any drawn image to be combined with this type of image would have to be done on the plate after exposing and developing, as acetate has a high gloss and is not very sympathetic to drawing. The various objects and

* The student is referred to Philip Gotlop's *Manual of Professional Photography* in this series.

Gerald Woods, *Cinquecento*, 1974.
Black-and-white lithograph with
photographic imagery, 57 × 44.5 cm.
Photographic collage with Letratone
textures. Courtesy of the artist.

films could be secured with adhesive tape to allow any
alteration in their positions that may be needed.

A more versatile surface for working is Plastocowell, a
semi-transparent plastic sheeting, obtainable in rolls, one
side of which is glossy while the other possesses a grain
almost identical to that of a medium-grained plate. Plasto-
cowell is the registered name, and it was developed by
W. S. Cowell of Ipswich, the lithographers, as a graphic
aid for artists working on the plate. Drawings are made
on its rough side with any photo-opaque medium, including
litho chalk, gouache, Photopake, line, solid tints, adhesive
textures and lettering. The drawn textures which are possible
are more varied than can be obtained by working directly
on to the plate, and range from those achieved by using
wax and water colour, to those made by scraping into
solids with a knife or point.

Plastocowell is most suitable for multi-colour prints and
for use with positive working plates. The rough side is also
sympathetic to the printed image, so that a litho image
printed on it can itself be used as a negative in the preparation
of another plate. Thus it can be used for transposing a
negative to positive, or vice versa, or in preparing a second
plate where the image is to be a negative of the first plate,
so that when overprinting occurs, exact registration can be
achieved.

The plate whose image is to be transposed is rolled up with a stiff black ink: a good mixture is chalk black with some press black added to strengthen the consistency. Neither varnish nor reducing white should be used to make it thicker as it is necessary to preserve the natural opacity of the ink. The surface of Plastocowell, being plastic, is non-absorbent, so if the image on the plate is over-inked, or if the ink is too sloppy, it will spread during printing. The thinnest film consistent with a good crisp proof should be the aim. It will be found that the offset press is very much more efficient for this type of work than the transfer press.

When a satisfactory print has been obtained, it should be inspected for imperfect solids and broken lines, which can be repaired by drawing them in with some of the printing ink diluted with a little white spirit. Rejected prints on the Plastocowell do not mean that this material has to be thrown away. Before the ink has dried, it can be cleaned off with petrol, and the plastic sheet washed with soap or detergent and water. Unless permanently damaged by scraping, it will last for many years.

If possible, the work of repairing the image should be carried out on a revising or light table, as the light shining upwards through the image will at once reveal any weakness in the inking. After this has been completed, the image must be dusted with either aluminium or bronze metallic powder to render it wholly opaque. The surplus powder is

Dieter Rot, *Goodbye Sharpie*, 1972. Black-and-white lithograph with photographic imagery, 113 × 138 cm. Courtesy, Petersburg Press, London.

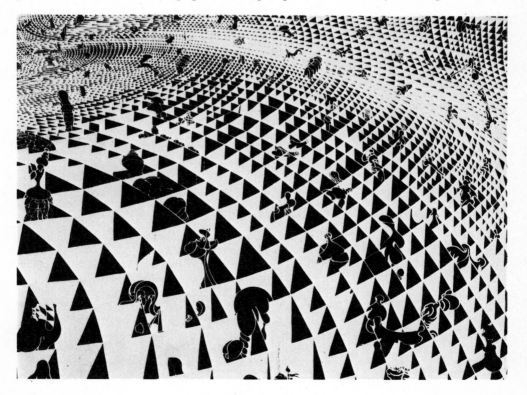

Light table or revising table. The lamps shown are of the cold fluorescent type, but if tungsten lamps are fitted, holes about 1 in. in diameter must be drilled in the base and along the top of the cabinet in order to provide a current of air. A rectangular sectioned beading (*a*) should be used to secure the glass, and to provide a firm surface for the edges of the paper when checking registration. The ground plate glass (*b*) should be bedded in putty, Seelastic or similar material.

carefully brushed from the transparent areas of the print, as any residue, being opaque, will prevent the light from activating the coating on the plate, and – dependent on which type of coating is used – they will appear as white spots on a dark background or vice versa. A large camel-hair wash brush would be satisfactory for this purpose.

At this stage, extra work can be added to the Plastocowell, using crayon, Photopake or similar medium. When the plate is dry, it is exposed against the photo-sensitized plate, in the vacuum frame. Developing and proving follow as described for the particular type of plate used.

Plastocowell and the colour print

This material is widely used for the preparation of mono-chrome or coloured illustrations which demand the authentic or traditional lithographic quality, the chalk character combined with brush and line drawing.

When a design has been made for a colour print, a sheet of Plastocowell is pinned on top of it, and the first colour drawn with photographically opaque materials; registration marks can be added in the usual position. When this drawing is complete, it is photographed down to a positive working plate which is exposed, developed, proved and proofed in colour, much in the same way as the traditional method.

A second sheet of Plastocowell is laid over a proof which has been taken on the offset press, and the second colour drawn. The registration marks are added and then this second colour is put down to the plate, which is processed and proofed in colour over the first colour. The third colour is drawn by laying clean Plastocowell over the combined proof of the first two colours, and the sequence is repeated until the print is complete.

Using this method, registration can be as close as can be desired. There is no need to prepare wasted keys or offsets, or to make repeated tracings on to the plates which are required to complete the print. If the registration marks are drawn in on the first sheet of Plastocowell, they will be printed on the proof of the first colour, so that they can be traced on to each subsequent sheet.

The first major work for which this technique was used was the set of illustrations for an edition of John Galsworthy's *The Forsyte Saga*, drawn by Anthony Gross and published by Heinemann in 1950. More recently, David Gentleman has used the process for his series of lithographs illustrating Kipling's *Jungle Books*, published by the Limited Editions Club of Avon, Connecticut. The freedom which the process allows the artist can be seen in the illustration on p. 51. Also demonstrated is the method of colour separation, which is purely autolithographic, and not trichromatic in principle. Seven printings, two browns, two greens, pink, violet-grey and black, were used for this illustration.

Plastocowell images, provided they have been drawn with media which remain soluble in water or spirit even when they are dry, can be easily washed off with the appropriate solvent and the sheet used again. However, should scraping have been used in the drawing, the resultant destruction of the grain will prevent its re-use for most imagery except that composed of line or solid.

Pre-sensitized and wipe-on plates

Recent developments have supplied the lithographer with wipe-on light-sensitive coatings, both positive and negative, thus ensuring the more rapid demise of the plate whirler. Pre-sensitized plates can be supplied with both types of coating, which can be stored for up to a year without deterioration in their performance. Either the printing-down cabinet or the arc lamp can be used for exposing pre-sensitized or wipe-on plates, but the developing must be carried out according to the maker's instructions and with the materials which he supplies.

AN EXAMPLE

Let me close this chapter by describing the stages and methods used in making the print, *Wasteland* (p. 106).

This lithograph was printed from three plates in the following order: dark violet-grey, semi-opaque magenta, semi-opaque green. The various elements in the design involved photography and transferring.

The original photograph, of some small industrial buildings, was taken on 35-mm Ilford FP4 film, and enlarged to make a positive transparency about 8 in. × 5 in. on Kodalith film. This positive was contact-printed on to another piece of Kodalith to make a tone-separated negative, which was then used in the same way to make a tone-separated positive.

These two films were trimmed so that the image of the tanks and the structure behind them were identically orientated to the edges of both pieces of film.

No registration marks were used in this print, registration being achieved for the offsets and the proofs by accurately placing one corner of the paper into the corresponding corner of the plate, so that the edges adjacent to the angle coincided. Once the position of the image relative to the edges of the first plate had been fixed, the positions of the subsequent colours automatically fell into the same relationship with the edges of the subsequent plates. The print was proofed on the transfer press, but the final proofs were taken on the offset press, accurate registration being possible through fine adjustments on the front and side lays.

The plate which was eventually printed in the dark violet-grey was coated with bichromated albumen in the plate whirler and then exposed in the vacuum frame using the positive tone-separated film, the remaining areas of the plate being masked from the action of the light. The plate was developed in the standard way which left a black, rectangular image of the tanks, with most of the building and the pipes showing either in white or texture against a black background. The rest of the image was then drawn using litho writing ink, allowing space for the circular shape at the top.

It was gummed, washed out and after some proofs in press black had been taken for making offsets, etched and then proofed in colour.

Next, the tone-separated negative was modified on the light table by spotting out some of the smaller detail, the fuel tanks and the roof of the building. This film was used as the basis of the second plate, that which was printed in semi-opaque magenta.

Another zinc plate was coated with albumen and when this was dry, the modified negative was placed on it so that it would register with the photographic image on the first plate. This was achieved by simple measurement on the side of the plate. The only critical registration involved in the print occurred between these two images. After masking the rest of the plate, it was exposed to the arc lamp. When the plate had been developed and dried, one of the offsets from the first plate, which had been dusted with offset

powder, was printed down to it. The two photographic images were carefully orientated by cutting out several of the angles of the shapes, for example the angle at the gable end of the building and one or two of the pipe supports, on the offset, and sighting the plate image through the holes in a manner similar to that employed when registering with cut-out registration marks.

When the offset had been laid down, the plate was put aside to await the transfer of texture from a semi-circular piece of rusty iron sheet. This was mounted type-high and proofed in press black on Everdamp paper in a flatbed letterpress machine. When a satisfactory proof had been taken, it was trimmed down and transferred to the second (magenta) plate, in the position indicated by the offset. This texture can be seen at the top of the circle. The background was completed in writing ink. The plate was then gummed, etched and proofed in colour over the first colour.

The press black was cleaned from the iron sheet, which was then inked with a dense black letterpress ink, and printed on to a sheet of acetate film. The resulting proof was checked on the light table, any necessary strengthening of the image was carried out, and it was then dusted with metallic bronze powder to make it completely opaque.

The third plate was coated with albumen, and when this was dry an offset from the first plate was printed down. The plate was then placed in the vacuum frame and the acetate film placed in position, guided by the offset. After exposure and developing, the circle was completed in free brushwork with litho writing ink. It was then processed and proofed over the previous two colours. Thus the texture printed in green at the bottom of the circle is the photographic negative of the texture printed in magenta at the top.

If no vacuum frame is available, the method described earlier in the chapter, in which a sheet of plate glass is used to ensure close contact between the photographic copy and the plate while the plate is lying on a sheet of foam rubber or plastic, will give good results if a high-powered electric light is used. This type of unit should be placed in a dark part of the studio. The length of exposure will have to be discovered by experiment: natural sunlight or daylight has been used, but the results are not always satisfactory, as while bold shapes are reproduced quite accurately, fine lines lack crispness and sometimes disappear.

8 Lithography in illustration

In the context of book illustration, lithography is at a disadvantage when compared with the techniques of wood-cutting or engraving. Both mechanically and aesthetically, the relief methods are more obviously suited to integration with the printed word. This is due not only to tradition but also to expediency, and was recognized only several decades after Senefelder had made his discovery, when some lithographers of the period, for example, Delacroix, Bonington and Daumier, were attempting to widen their horizons by using their printmaking talents for book illustration. At this time, publishers had not solved the problems of using lithography in this way, so that books illustrated by this method were generally published in two distinct sections, the text pages, and the lithographs which were added as inserts, giving the over-all character of loose-leaf albums. Another factor which possibly prevented its adoption as a primary illustrative medium was the development of chromo-lithography, which, during the nineteenth century, was the only satisfactory process for large-scale colour printing; most commercial lithographers directed their efforts at perfecting this type of work.

Later in the century, in the field of literary books, lithography was rarely used, and then only as a black and white medium. Colour lithography was purely reproductive and used in technical books for interpreting images which had been conceived in terms of paint and paper. Among these would be Owen Jones's *Grammar of Ornament*, Mrs Beeton's *Cookery and Household Management*, books on gardening and lavish exhibition catalogues. More creative were the music books and the chromo-lithographed presentation poetry books, usually of folio size. For books of smaller format, lithography was not the first choice. The craft of wood engraving as a reproductive medium developed rapidly throughout the century, and the reasons for this are not hard to find. As the century progressed, the use of in-text illustrations became very popular, and since the small-scale blocks used for these illustrations can be easily locked into the type forme for printing at the same time as the text, it was uneconomic to print the type by letterpress, and then to lithograph the illustrations as a

la mienne de la droite, j'étais sur le point de l'en percer, quand un nouvel acteur parut sur la scène.

« Soudain un homme se jeta entre nous, et nous séparant : Quoi ! s'écria-t-il d'une voix d'autorité, les fils de ceux qui ont sucé le même lait veulent répandre leur sang, comme si ce n'était pas le même qui coulât dans leurs veines ! Par le bras de mon père, celui qui portera le premier coup périra de ma main.

« Je le regardai d'un air de surprise ; c'était Campbell.

« Tout en parlant, il brandissait sa lance écossaise autour de lui, comme pour nous annoncer une médiation armée. Rashleigh et moi nous gardions le silence. »

separate process, with all the added problems of registration that this would entail. The belief that on aesthetic grounds the lithographic image did not happily integrate with printed letter forms was not properly dispelled until the turn of the century, when Vollard commissioned Bonnard to illustrate *Parallèlement* by Paul Verlaine, and *Daphnis et Chloë* by Longus. In Britain, where the private press movement probably exercised more influence than any other comparable institution on the future of type design and book production, lithography was never a serious rival to wood engraving or cutting as the illustrative process.

R. P. Bonington, chapter ending and tailpiece from *Vues pittoresques en Ecosse* (Paris, 1826). Courtesy, British Museum.

Examples can be found, ranging from before the First World War (Charles Ricketts's woodcuts for *Daphnis and Chloë* for the Vale Press) to John Buckland Wright's engravings to Keats's *Endymion*, published by the Golden Cockerel Press in 1947.

The engraver, then, before he has even started his work, is well on the way to producing an integrated page, while the lithographer, with his palette of atmospheric texture and drawn line, is working within a new discipline.

The field of illustration and book production is too wide to be fully discussed in this chapter, so it might be expedient to consider only the limitations of the illustrator's work. This may fall into two fairly clear-cut sections, traditionally known as book illustration and book decoration. As the names imply, the first is concerned with the subject-matter of the writing, while the second is more concerned with the book as a unit, though of course a degree of literary interpretation may be included. While the illustrator or decorator may not need to be a typographer, a good knowledge of the history and design of type faces and their suitability to the subject-matter of the text, and to various grades of paper and their behaviour when subjected to the various reproductive processes, would be essential to the successful prosecution of his work. In the stricter confines of lithography, the most important of these would be a knowledge of the designs and the various sizes of type faces, and how each would appear on a text page, or in conjunction with monochrome or coloured lithographs. Points to be taken into consideration when selecting a type face for use in this manner would be the over-all tonal quality and the colour values of the print. What might suit a light, chalk-drawn print may not suit a very black and contrasted image. Happily, this knowledge comes with experience and studying the work of lithographers who have been active in this field.

Although many lithographers have chosen to use literary subjects as starting points for single prints, or even small groups of prints, working a hundred or more lithographs within the limits of scale and subject-matter demanded by a book project can be more exacting.

The methods which are now to be considered are those more suited to the production of small editions in the print workshop.

Lithographs which are to be used as illustrations in conjunction with type demand more careful and controlled preparation of the key plates than is usually required for the normal print. This is because the extra discipline of typography is essential for the completion of the final image, and a letterpress machine as well as a litho press will have to be used.

In preparing the key, proper regard has to be paid to the disposition of all the various elements which go to make up the complete page. If the pages are dealt with singly, the

LULLABY

Lay your sleeping head, my love,
Human on my faithless arm;
Time and fevers burn away
Individual beauty from
Thoughtful children, and the grave
Proves the child ephemeral:
But in my arms till break of day
Let the living creature lie,
Mortal, guilty, but to me
The entirely beautiful.

Soul and body have no bounds:
To lovers as they lie upon
Her tolerant enchanted slope
In their ordinary swoon,
Grave the vision Venus sends
Of supernatural sympathy,
Universal love and hope;
While an abstract insight wakes
Among the glaciers and the rocks
The hermit's sensual ecstasy.

Henry Moore, illustration to book of poems by W. H. Auden, 1974. Black-and-white lithograph. By courtesy of the Petersburg Press.

problem is minimal, but as it is more efficient from the lithographic standpoint to consider them in pairs (folio) or in fours (quarto) the procedure is more complicated. This method means that either two facing pages (folio) or two facing pages and two single pages (quarto) will be printed from the same set of plates.

It must be understood that once the illustrations and the type layout have been committed to the plate via the transferred key drawing, it is almost impossible to change the position of the one in relation to the other. This means that the greatest accuracy and care must be exercised in all the design and layout work prior to drawing the key.

It is unlikely that a print workshop would hold an extensive range of type faces, but the three or four that would normally be available would include text and display sizes and related titling. From this, the type face for the project would be chosen, regard being paid to the format and subject-matter of the book.

The next stage must be the design of two opposing full text pages, with decisions about the width and depth of the text, line spacing and margins. These decisions are basic to the whole design structure, as they set the pattern to which the rest of the book must conform, that is, the title page, half title, other preliminaries, chapter headings and endings, and finally pages which include illustration or other visual imagery. When the design for the inside is complete, attention can be turned to the covers, wrapper and slip-case.

Once this unifying style has been settled, it will remain constant for each page, so that the illustrations must be

integrated into this framework. When this has been done, the task of preparing key drawings becomes fairly straight-forward, as the outline is the same for each page, though the disposition of the lithographs within that outline will be different. It is possible that some of the images may spread across the fold to the opposite page, some may take the form of full-page illustrations, while some in-text illustrations may be needed. The choice that is made in the disposition and size of the illustrations is linked to the choice of colour. In a project of this sort, it is advisable, if colour is going to be used, to work within a spectrum of perhaps six colours. From these, a narrower range could be used for some of the images, while others could be in monochrome. The full range should be used sparingly, so that these images act as punctuations throughout the book. Using the full range for every illustration may not be successful, as uniformity instead of unity might be the result.

The design procedure follows the traditional scheme of preparing and developing roughs of the illustrations in conjunction with the type layout. These gradually become more finished and eventually reach the stage when a detailed layout can be prepared from which the type can be set.

The development of the illustrations can be carried out using any graphic media which might be suitable, and could include inks, pastel, and collage. When they are complete, they are cut out and used together with proofs of the type to make a paste-up of the pages. It is at this stage that a final decision must be made on the disposition of the various images and text areas.

The intrinsic merit of the illustrations will not by itself carry the page. Their scale and disposition relative to the type and the page size is also of great importance. It is possibly to experiment only with their tone and colour at the proofing stage, not their placing. Pairs of facing pages must always be designed as a unit. When a satisfactory layout has been completed for all the pairs, they must then be accurately cut out and imposed on a large sheet of paper, in pairs or fours, depending on whether a folio or quarto scheme of printing is being followed. From these imposed sheets, key drawings are carefully made, using litho writing ink and French transfer paper, making sure that each scheme is square to the edges. Alternatively, to avoid the use of transfer paper, careful tracings can be made down to plates which will act as wasted keys. Again, care should be taken to see that all the material is square to the edges of the plates.

After the transfers have been made, and key drawings for offsetting are being printed, it is advisable to take a dozen more proofs than are needed to make offsets, so that the spares can be used for determining the correct registration of the type on the letterpress machine, before printing the finished pages.

The key should be accurately drawn and symmetrical, so that if printed back to back on a sheet of paper, all the

Key transfer for bookwork. Compare the double-spread of pages 18 and 19 on p. 141.

guide lines for the type, the trimming lines and the registration marks will coincide. It can be seen from the diagram above that difficulties can be caused by wrong imposition and drawing the illustrations upside down. This is a common error, but it can be avoided by making a small mock-up which is first folded in the normal manner to make a book section of four leaves, and then starting from the front page and keeping the book folded, each side is numbered consecutively with the number it will bear in the final print, that is, from 1 to 8, or from 9 to 16 and so on. The contents of each page are then roughly drawn in. When the sheet is opened out once more, the correct imposition of the pages will be shown so that the paste-up can be made without difficulty.

On the example shown, page 17 will be on the reverse of page 18, and pages 20 and 21 will be on the reverse of pages 19 and 22 respectively. It will be noted that these two pages, 20 and 21, will be facing pages and thus will give the opportunity of making a large illustration which will spread across the fold. Page 24, which is the end page of the section, will be on the reverse side of page 23. Pages 22 and 23 carry no illustrations, so that the spaces on the plates which would have been used by these drawings were used for images which were printed elsewhere in the book. When they were being printed, the other drawings on the plate not needed at the time were masked, or since the units are quite small and well separated, they could be left in washout solution and not rolled up at all.

With masking, it is also possible to make an illustration which spreads across two unconnected pages, for instance, from the last page of one section to the first page of the next. The illustration is drawn complete in its appropriate position in relation to the guide lines, and when printing one-half of it on to one section, the other half is masked by a sheet of thin paper, with its edge along the central fold line. When the first half has been printed, the positions are reversed and the next section receives the second half of the image. For the illustration to appear whole when the book is made up, careful and accurate working is essential.

The various lines indicating trimming and folding, although drawn out in full on the various key plates, need only be indicated outside the page area on the colour plates, except for some dots showing the central fold down the spine, which would be hidden when the book is bound. While it is possible to fold each section to the trimmed outside edges, it is more important to keep everything square to the spine of the book, as this is the one permanent and static part of the sheet. All through this type of project, all the elements comprising the pages should be made square to the edges of all the plates and the paper on which they are printed. This means that as far back as drawing each transfer, the key drawings of the page plans must be placed as nearly as possible in the same position. When the transfers are laid down on each plate, they must all be placed in the same position relative to two adjacent sides of the plate. When the key drawings are being printed, the corner of each sheet of paper must be laid into the corner formed by these two sides. After being dusted with offset powder and laid on the clean plates for the coloured images,

Christopher Ecclestone, *Dulce et Decorum Est*, 1970. Black-and-white lithograph with photographic imagery, 45.5 × 30.5 cm. Book project involving typesetting and illustrative matter derived from photographs of the 1914–1918 war. Courtesy, Shrewsbury School of Art.

Dulce Et Decorum Est

Bent double, like old beggars under sacks,
Knock-kneed, coughing like hags, we cursed through sludge,
Till on the haunting flares we turned our backs
And towards our distant rest began to trudge.
Men marched asleep. Many had lost their boots
But limped on, blood-shod. All went lame; all blind;
Drunk with fatigue; deaf even to the hoots
Of tired, outstripped Five-Nines that dropped behind.

Gas! Gas! Quick, boys!—An ecstasy of fumbling,
Fitting the clumsy helmets just in time;
But someone still was yelling out and stumbling
And flound'ring like a man in fire or lime . . .
Dim, through the misty panes and thick green light,
As under a green sea, I saw him drowning.

In all my dreams, before my helpless sight,
He plunges at me, guttering, choking, drowning.

If in some smothering dreams you too could pace
Behind the wagon that we flung him in,
And watch the white eyes writhing in his face,
His hanging face, like a devil's sick of sin;
If you could hear, at every jolt, the blood
Come gargling from the froth-corrupted lungs,
Obscene as cancer, bitter as the cud
Of vile, incurable sores on innocent tongues, . . .
My friend, you would not tell with such high zest
To children ardent for some desperate glory,
The old Lie: Dulce et decorum est
Pro patria mori.

WILFRED OWEN

At first it seemed a little speck,
And then it seemed a mist;
It moved and moved, and took at last
A certain shape, I wist.

A speck, a mist, a shape, I wist!
And still it neared and neared:
As if it dodged a water-sprite,
It plunged and tacked and veered.

With throats unslaked, with black lips baked,
We could nor laugh nor wail;
Through utter drought all dumb we stood!
I bit my arm, I sucked the blood,
And cried, a sail! a sail!

'There passed a weary time. Each throat
Was parched, and glazed each eye.
A weary time! a weary time!
How glazed each weary eye,
When, looking westward, I beheld
A something in the sky.

18

'With throats unslaked, with black lips baked,
Agape they heard me call:
Gramercy! they for joy did grin,
And all at once their breath drew in,
As they were drinking all.

'See! See! I cried, she tacks no more!
Hither to work us weal;
Without a breeze, without a tide,
She steadies with upright keel!

'The western wave was all aflame,
The day was well-nigh done!
Almost upon the western wave
Rested the broad bright sun!
When that strange shape drove suddenly
Betwixt us and the sun.

'And straight the sun was flecked with bars,
Heaven's mother send us grace!
As if through a dungeon grate he peered
With broad and burning face.

'Alas! thought I, and my heart beat loud
How fast she nears and nears!
Are those her sails that glance in the sun
Like restless gossameres?

'Are those her ribs through which the sun
Did peer, as through a grate?
And is that woman all her crew?
Is that a Death? and are there two?
Is Death that woman's mate?

19

John Aston, book project *The Rime of the Ancient Mariner*, 1960. Colour lithograph. Courtesy, Shrewsbury School of Art.

d'eau, puis le retiroient avec un embut;
faisoient aller l'eau d'un verre en aultre;
bastissoient plusieurs petitz engins auto-
mates, c'est à dire soy mouvens
eulx mesmes.

Chapitre XXV. *Comment feut meu entre les*
fouaciers de Lerné et ceux du pays
de Gargantua le grand debat
dont furent faictes grosses guerres

N cestuy temps, qui fut la saison de
vendanges, au commencement de
automne, les bergiers de la contrée
estoient à guarder les vines et empescher que les estour-
neaux ne mangeassent les raisins.

Onquel temps les fouaciers de Lerné passoient le
grand quarroy, menans dix ou douze charges de fouaces
à la ville.

Lesdictz bergiers les requirent courtoisement leurs
en bailler pour leur argent, au pris du marché. Car notez
que c'est viande celeste manger à desjeuner raisins avec
fouace fraiche, mesmement des pineaulx, des fiers, des
muscadeaulx, de la bicane, et des foyrars pour ceulx
qui sont constipez de ventre, car ilz les font aller long
comme un vouge, et souvent, cuidans peter, ilz se con-
chient, dont sont nommez les cuideurs des vendanges.

A leur requeste ne feurent aulcunement enclinez les
fouaciers, mais (que pis est)les oultragerent grandement,
les appelans trop-diteulx, breschedens, plaisans rous-
seaulx, galliers, chienlictz, averlans, limes sourdes, faict-
neans, friandeaulx, bustarins, talvassiers, riennevaulx,
rustres, challans, hapelopins, trainne-guainnes, gen-
tilz flocquetz, copieux, landores, malotruz, dendins,

CXVij

Antoni Clavé, double-page spread containing colour lithograph and text
from *Gárgantua* by Rabelais (Paris, 1955). Courtesy of W. J. Strachan.

these offsets again must be laid into the same corner of each plate. When printing the first colour, the corresponding corner of each sheet is laid into the same corner of the plate.

This procedure will standardize the position of each element on each page in relation to one particular corner of each sheet, so that when the type has to be printed, registration problems will be reduced to a minimum. The offset press is very much more efficient for the accurate registration required for this type of work: the registration methods it employs would be the same as those on letterpress proofing machines, that is, two adjacent sides of the paper which are placed against front and side lays.

Thus, if the key offsets have been accurately placed, so that all the colours in each illustration are in the same position relative to the sides of the plates, they will be in the same position relative to the sides of the paper, so that once the registration of the type has been achieved, it should print in its right place on each sheet without trouble.

When the illustrations on one side of the paper have been printed, they must be allowed to dry before printing those on the reverse side. When printing the second side, the first colour must be registered to the registration marks used on the first side, so that this set of illustrations is properly orientated with those already printed on the reverse. If the key drawings involved in preparing both sets of plates were accurately drawn, then the trimming and folding lines on each side of the paper should be back to back. If this is not so but the discrepancy is small, new registration marks should be cut. The positions of these can be determined in the following way. A proof of the colour is taken on a clean sheet of paper (MG or similar quality is best). A sheet on which the first set of illustrations has been printed is laid face downwards on the light table. The sheet containing the first colour of the second set of illustrations is now laid over this, so that both sets of trimming and folding lines coincide. Care should be taken to ensure that the correct pages are back to back. New registration marks are cut through both sheets, using a sharp knife. If the discrepancy is very small, it may be necessary first to block out the existing windows with Scotch tape before laying the sheet on the light table.

When registering by hand on the transfer press, it is difficult to achieve identical placing of each sheet, so that any discrepancy of the images from sheet to sheet will mean that their position relative to the type will also vary. To overcome this problem and to restore a constant relationship between the images and the paper edges, some judicious trimming will be necessary. When both sides have been lithographed, it is possible to trim back two adjacent sides of each sheet to the page trimming lines, and use them for registration on the letterpress machine. This will necessitate more careful handling to preserve the cleanness of the margins.

A Young Poet

Larry Rivers, *O'Hara Reading*, 1967.
Colour lithograph, 124 × 73.5 cm,
on Italia paper, collé. Courtesy,
Universal Limited Art Editions,
Long Island.

When the offset press is being used, the same corner must be used to register both the lithographs and the type. It will be discovered that when the second side is being printed, in order to register in the same corner the side lay will have to be moved from its normal position on the left-hand side of the press, to the right or working side. The same adjustment will have to be made on the letterpress machine. However, should an Albion or Columbia press be used for printing the type, to avoid altering the position of the gauges on the tympan, it would be easier to trim back another edge when the reverse of the sheet is being printed. But it must be emphasized that it is preferable always to use the same corner of the paper.

As well as being good printing discipline, it is convention that when pages of text are printed, the lines on each side of the paper should exactly back up. In the sort of project being considered, if it is impossible to achieve this without measurably affecting the margins and the general balance of the page, then some inaccuracies must have occurred in the disposition of the type areas or illustrations on one or other of the key drawings.

There are certain exceptions to the rule about type backing up, the most important to the printmaker being

poetry. The variations which exist in the number of lines in a stanza, and the number of stanzas in the complete poem, makes such a convention impossible, especially in anthologies.

Since it is not customary to trim handmade paper, but to leave the fore-edge and tail with their natural deckle, registration must be achieved purely by means of two adjacent sides. Thus the greatest care must be exercised in the placing of the images on the plate, especially if the sheets are to be printed quarto. It might be possible to indicate the two folding lines if the head of the book is to be trimmed, in which case, the horizontal line would be trimmed off. The vertical fold line may well be hidden in the spine when the book is being bound.

The finishing of the book will depend on its purpose and the intentions of the designer. It could vary from a wire-stitched booklet to a work of the quality associated with the limited edition. It may be bound or cased, it may have a wrapper or be enclosed in a slip case.

Many of the substances of paper and thin boards used for cover purposes can be easily printed on the offset press, though certain plastic materials will require extra care in their working and possibly the use of special inks. The offset press is essential for this type of printing. It can also cope with cloth, if the weave is not too coarse, and the image is bold and simple. Fairly generous inking will be necessary.

Whatever material is chosen for the cover, if it is to be lithographed the placing of the decoration must again be the subject of careful planning, so that after incorporating the cover material with the boards and the book, the image settles down into its appointed position.

Endpapers have traditionally been regarded as an opportunity for the artist, while keeping within the over-all concept of the book, to work in a more relaxed fashion than would be desirable or possible on the main body of the text pages.

It should be said that these conventions apply to the traditional or classical approach to book design, but since so much of today's work appears to disregard these disciplines, one is left with the comforting observation that used to be made by compositors, 'If it looks right, then it is right.' '

9　Some further methods

GRAINING PLATES IN THE STUDIO

Acceptable surfaces of a mildly granular quality on zinc or aluminium can be produced in the studio. These are admirable for receiving transfers, making washes or drawing with writing ink and pen or brush. Chalk work is not generally successful, although the aluminium tends to take a better grain than the zinc. Plain sheet zinc or aluminium, or used litho plates, can be grained in this way. The thicker zinc etching plates can also be used, and these are valuable if the resulting lithographic image is to be converted into a relief image by deeply etching the plate.

The zinc is prepared by washing the working surface with a solution of caustic soda or caustic potash to remove any grease, or what is left of any previous image after it has been cleaned off with white spirit. With aluminium, the previous image is cleared with white spirit but instead of using caustic to remove the grease, the plate is soaked overnight in a solution of nitric acid diluted with twice its own volume of water. This will not affect the metal. David Cumming gives an alternative solution which is quicker in action: fluorsilicic acid 5 parts, nitric acid 3 parts, water 42 parts. This solution is rubbed into the plate with the addition of some pumice powder, after which the plate is thoroughly washed in water.

For graining, the finer grades of abrasives that are used for stones will work satisfactorily. Sand, pumice or carborundum of about 200 grade should be sprinkled on to the wet plate through a sieve of a similar grade. For a smooth, even grain, which approximates to that of fine-grain aluminium, the grainer should take the form of a piece of thick felt wrapped around a block of chipboard about 6 in. × 3 in., and secured on the top surface by several brass-headed carpet nails. The softness of the felt will prevent the formation of any scratches. Graining is accomplished by using a circular movement identical to that used when graining a stone. If the plate is laid on a sheet of corrugated cardboard or felt, it will remain still, so that both hands can be used for exerting pressure on the grainer. A plate of 15 in. × 10 in. would take about a quarter of an hour to complete. When the abrasive becomes black and slimy, it should be changed.

After graining, the plate is thoroughly hosed on both sides to clear it of grit, and is then flooded with its appropriate counter-etch or resensitizing solution, nitric acid/potash alum for zinc, and nitric acid/fluorsilicic acid for aluminium. This is followed by thoroughly washing the plate and allowing it to dry in an upright position. It is then ready for use.

To obtain a grain of different character, a large cork two or three inches in diameter can be used instead of the felt block. The relative hardness of the cork causes the grit to bite into the metal in a series of fine curved scratches, so that when the plate is rolled up, these grooves become filled with ink and print in an intaglio manner over the normal surface inking.

The ink film carried by both metals is somewhat thinner than that on normally grained plates, and because of this the image is more vulnerable to the action of the etch, which therefore should be rather weaker. For efficient printing, both damping and the ink film used on the roller should be kept to a minimum, firstly to prevent the roller from skating over the surface, and secondly to reduce the possibilities of scumming and image coarsening.

MAKING RELIEF BLOCKS

A sheet of zinc, of the gauge used for etching, and of the required size, is prepared as described above. The image can comprise washes, transferred material and drawings made with diluted press black. It would be better for any washes that are used to be made in press black, because if the whole image is composed of a spirit-soluble rather than water-soluble ink, the processing is more direct and carries less risk of image failure. When the drawing is complete, it is gummed with the gum/etch solution without first dusting the image with french chalk. After washing off the dried gum with water, rolling up proceeds directly over the image, and is stopped as soon as there is any hint of thickening.

The ink must be sparely applied, although as thick a film as possible should eventually be laid on the image. The plate is then dried and the image dusted with resin. Any surplus should be removed from the background areas with a large camel-hair brush. The plate is then gently warmed from the back in order to fuse the resin to the surface. In this state, it will act as a very efficient acid resist. From now on, the process leaves the realm of lithography and enters that of etching or process engraving. The back and edges of the plate are protected by painting them with straw-hat varnish or stopping-out varnish. When this is dry the plate is immersed in nitric acid solution which is sufficiently strong to cause light effervescence (between 6 and 12 parts of water to 1 of acid). The plate should be

removed from time to time, thoroughly washed under the tap and dried. Resin can be brushed with a camel-hair brush against the shoulders of the relief areas and fused to the plate by warming, or these parts can be protected by painting with stopping-out varnish. This treatment is to prevent any undercutting by the acid and should be repeated several times during the etching period. When complete, the plate is cleaned with white spirit and methylated spirits, and the fine grooves scrubbed with a soft hand brush to clean them. The plate can be mounted type-high for printing on a letterpress machine.

Normally, the non-printing areas adjacent to fine work do not have to be etched as deeply as those next to solids, and it is not necessary for the total depth of etching to be extreme. The most that should be necessary would occur in large non-printing areas which surround a solid tint, and the depth in this case should be of the order of one-sixteenth of an inch. It is inevitable that some of the finer particles of image will be etched away, but even so, any washes that may be affected in this way will still retain considerable interest.

REDUCTION PRINTING

This is a perfectly feasible proposition using a litho stone. The method is simple: starting with a large area of printable image, and alternately printing and reducing the area until there is nothing left to print, the image is built up *alla prima* on the proofing paper. The procedure is similar to that employed in reduction linocutting, so there is little chance of going back to correct mistakes. It is a process for the bold-hearted and demands considerable flair.

It is possible to make the exercise less hazardous by working from a tracing which has been made from sketchbook material or from a fairly well worked-out design. Assuming that the stone has been grained and is ready for work, the tracing is secured to it and all parts of the design which are to remain white or, more accurately, which are not to be printed, are traced down to the surface using set-off paper. Registration marks are added in the appropriate places.

It should be decided before commencing, approximately in how many printings the design will be completed, and some idea formed of the tones of the colours to be used. It is better that the number of printings should be kept to a minimum, to avoid the formation of gloss. A maximum of about six should be the aim. As work has to be carried out on the stone between each printing, there cannot be very much forward planning in laying down each colour at the optimum moment. Until some experience has been built up with this method of working, it is safer to print the palest colour first and the darkest tone last. If transparent colours are used, the tones will be additive, and this will make it

impossible to adhere to the original concept, or to any preconceived notion of what the final result will be.

After the tracing is complete, the design is drawn in with litho writing ink. If a very pale colour is going to be used, chalking will be unnecessary as it will be almost invisible. At this stage, the whole of the image area, with the exception of those parts which are to appear white in the final print, must be painted in with the ink. With regard to textures, it is a characteristic of this method that as the print progresses, accidental textures are introduced, and these will usually make drawn ones unnecessary. The stone should be gummed when the ink is dry, and then left for 12 hours. It is then washed out in the normal manner, etched and gummed.

Since these proofs will be the only ones which the stone will give, before starting, it would be as well to give some thought to the size of the edition required. When the stone is being printed in colour, it is possible to ring the changes and take proofs in as many colours as are desired, though it is advisable, even though the colour may be changed, to keep the tone fairly constant.

When the first colour is printed, it should appear on the paper as an area of colour on which are one or more white shapes. When printing is complete, the stone is washed out, rolled up in press black and gummed up.

All areas which are to appear in this first colour are then erased from the image. This can be done by scraping, or by using carbolic acid. After resensitizing with citric or acetic acid, textures or extra drawing can be added to those parts which have been removed by the carbolic. Parts which have been scraped will have had the surface damaged and extra drawing here will not be very successful. It is possible that these areas will begin to scum when printing is resumed, and produce textures which may be retained.

Should work involving critical registration have to be carried out, either as deletions or additions, the tracing must be carefully aligned with the registration marks and the relevant parts traced down.

When this work is complete, and if deletions only have been made, the new non-printing areas must be treated with nitric acid (about 8 parts of water to 1 of acid, enough to give a slow effervescence). This should be done selectively, using a sharpened stick or glass rod. The stone must then be gummed and left to dry.

If new drawing has been added or substituted, then the stone must be coated with weak gum/etch solution. When this has dried, the image is washed out and rolled up in press black. Depending on the behaviour of the stone, a decision must be made about giving it an etch.

The second colour is mixed and rolled out on the slab, and the image washed out, and then rolled up with it. During the printing of this second colour, changes can be made to it both in hue and tone, if desired. If no original design

is being used, at this stage it will be found that it is easier to exercise control over the direction in which the print is moving. This is a progressive state of affairs, so that as more work appears on the print it is less difficult to visualize possible outcomes. Generally speaking, the major problem is to decide on the tones of the colours which are being used, as it sometimes happens that, when approaching the final printing, the discovery is made that each colour has not been sufficiently separated in tone from its predecessor, and that a dark blanket image will have to be drawn at the end in order to unify the print. This is really dodging the issue, as the dark tones should be built up by successive over-printing.

After printing the second colour, the stone is returned to press black so that the image can again be reduced.

All areas which are to be left in this second colour are scraped out, or deleted with carbolic acid. Again, extra drawing can be substituted in some of these areas if required. If no extra drawing has been added, then the new non-printing areas are treated with nitric acid as before, and the stone gummed up. The treatment of extra drawing is repeated as previously, and the third colour is mixed and printed.

This sequence is repeated until the design is complete. It will be noticed that at no time has resin or french chalk been used to dust the image before applying the etch. The process seems to work satisfactorily without them, and indeed the evidence when using them indicates that the repeated application of the etch over a dusted image weakens its ability to accept the printing ink.

There will be a continuous tendency for the deleted parts to roll up, and to some degree this may be encouraged, as it is a means of providing some texture which is spontaneous in character. When more than six printings are used, the work can begin to look laboured. Using three or four, the colours and their tones can be more widely separated, so that the print will gain in freshness.

MONOTYPE LITHOGRAPHS

This method starts with a true monotype technique. It has been used for many years in a painting context and operates as follows. A sheet of glass forms the working surface, and coloured paints are applied to it by roller or by other means selected by the artist. A sheet of paper or canvas is smoothed over the image to pick up the colour. It can then be developed using all the techniques available to the painter. Alternatively, the image can be finished on the glass and one unique proof taken from it.

Lithographically, the method is identical except that press black is used as the medium, and because the transfer must take place in a press, the cleaned non-working side

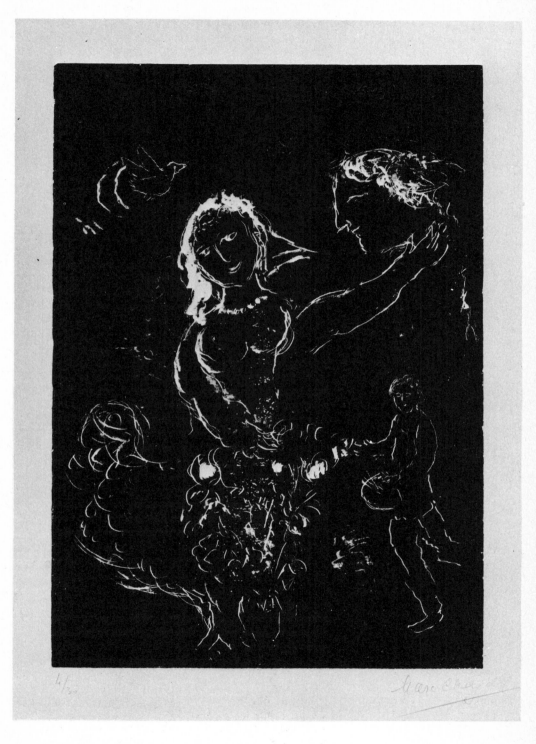

Marc Chagall, *Blanc sur noir*, 1972. Black-and-white lithograph,
67 × 49.5 cm. Courtesy, Galerie Maeght, Paris.

Andrew Stasik, *Night Game*. Colour
lithograph and screen print, 76 ×
56 cm. Courtesy, Pratt Graphics
Center, New York.

of a zinc plate, or a smooth sheet of plastic, is used instead
of the glass. The ink can be applied by rolling or wiping or
with the brush. It can be rolled up into a solid area and then
worked into with a point. The method gives great freedom
as any false start can be wiped clean and redrawn. When the
image is finished, a proof can be taken on Everdamp paper
and transferred to the plate for printing or further develop-
ment.

STONE ENGRAVINGS

This is a well-established technique and is used to produce
a white line drawing against a dark background, as in the
print *Blanc sur noir* by Chagall.

A polished or fine-grained stone is rolled up with press
black, which is then dusted with resin. To preserve a margin
around the image, the edges should be gum/etched before
rolling. Using a burin, the design is drawn into the black
to expose the clean stone underneath. A fairly strong nitric
acid solution is applied to the lines of the drawing. This is
washed off and plain gum rubbed well in. The stone is then

Andrew Stasik, *Summer XXXVI*.
Colour lithograph and screen print,
76 × 56 cm. Courtesy, Pratt Graphics
Center, New York.

allowed to stand for several hours, when it can be washed
out, rolled up and printed.

MIXED-MEDIA PRINTS

The combination of the main printmaking processes is a
fairly recent development, although both lithographs and
etchings have been used for many years in conjunction with
relief methods in the production of books.

The decision to start a print in one technique and perhaps
finish it in another can be made for several reasons, the most
important being that the second process can give the print a
dimension or quality unobtainable by more limited or
conventional means. Among the more obvious examples
would be any form of embossing that might be needed on
a lithograph, or a large flat area of colour which has to be
combined with an etching, and which would be more
economic to do lithographically or by relief methods,
rather than aquatinting an expensive plate.

The practical considerations involved with mixed-media
prints mainly concern registration and printing order.

Lithography with relief or screen printing

This is a fairly straightforward combination, as neither of the additional processes distorts the paper as radically as intaglio printing, but even so the indentation of the paper which occurs in relief printing and the palpably thick film of ink deposited from the screen indicate that any lithographic work which will be printed in the same area must be accomplished at the beginning while the surface of the paper is untouched, so that the image can be efficiently transferred.

Overprinting from the screen or the relief block on to a previously printed lithographic image presents few problems apart from registration. If the lithographed work does not overprint on to the other images, but is confined to the background, it may be printed last.

Registration can be effected from a key drawing which is traced down to the plate, the block or the screen, but if relief methods only are added, an offset from a wasted key can be printed on to the relief surface, using the following method. The relief block is locked on to the bed of a cylinder press, and the offset laid on it in the same manner as it would be laid on the plate, that is, by using two adjacent sides to register with the corresponding sides of the block. One or two sheets of larger paper are laid over as backing, to cover it completely. The impression cylinder is then wound along the press, while the backing papers are held firm. When this operation is complete, the papers can be removed and the block released from the press. A similar method can be used on the Wharfedale, though the operation must be carried out by hand and not under power. Theoretically, it should be possible to place the offset into the grippers of the cylinder and allow it to print down to the block during a normal printing stroke, but this method does not give as sharp an image as the first one.

Lithography with etching

This does not appear to be as popular a combination as the previous two; this may be due to two factors, the main one being the pronounced distortion of the paper which occurs when printing intaglio, which may complicate registration. Another reason may be that, compared with relief and screen printing, both lithography and etching processes are capable of rich textures, so the need for mixing them is not as great.

Here again it would be better, if the images overlap, for the lithographic one to go down first. A deeply bitten plate means a heavily embossed paper, which even if it goes through a flattening process afterwards, would prevent efficient overprinting. Another consideration would be that etching inks are more coarsely ground than litho inks, and would make a surface that is unsympathetic to lithography.

Opposite: Robert Rauschenberg, *Sky Garden,* from the *Stoned Moon* series, 1969. Colour lithograph with screen print and photographic imagery, 226 × 106.5 cm. Courtesy, Gemini G.E.L., Los Angeles, California.

Q-BALL

LAUNCH ESCAPE
MOTOR

BOOST PROTECTIVE COVER

KCS ENGINES

SERVICE MODULE

INSTRUMENT
UNIT UMBILICAL

INSTRUMENT UNIT

S-IVB FORWARD
UMBILICAL

S-IVB STAGE

COMMON
BULKHEAD

MAIN TUNNEL

FUEL FEED DUCT

S-IC STAGE
UMBILICAL

RETROROCKET

ULLAGE ROCKET

AFT INTERSTAGE

2 ENGINE

S-IB STAGE

ANTENNA PANEL

CENTER LOX TANK

ANTISLOSH BAFFLES

OUTER LOX TANK

PROPELLANT
SUCTION LINE

HYDRAULIC
ACTUATOR

HEAT SHIELD

Arnaldo Pomodoro, *Untitled – Blue, Black and Silver*, 1970. Embossed colour lithograph with collage, 77 × 56.5 cm. Courtesy, Marlborough Graphics, London.

If there is no overlap, the lithographed image could be printed after the etched one.

Problems of close registration are more acute when using this combination, as the size of any image printed before the paper was damped would be different when the etching was being printed, and different again after the paper had dried out. Thus, when preparing a key drawing, consideration must be given to the printing order, so that if the litho plates are to be printed last, the key tracing must be made when the paper has dried out after proofing the intaglio plate. If the lithographed image is being printed first, then the etching image must be keyed to this.

EMBOSSING

This technique is normally used on selected areas of the print, and is achieved by placing the finished proof over a surface which has been prepared with slightly raised plateaux, and then running it through an etching press. This causes the selected areas of the print to be raised above the flat surface of the paper. The print may have to be damped before embossing is carried out. The etching press is used because it is designed to withstand the high pressures used in the method, though it can, with care, be done on a cylinder letterpress machine. It should not be attempted on the transfer press as the tympan would be damaged.

The materials used for building up the areas can include card, metal sheeting, acetate film or other similar thin-gauge material which can be cut to the various shapes required. To register these shapes accurately, they can be mounted on a discarded but properly registered proof. Since this sheet will be under the print, there is no need to reverse the positions of the material laterally. Acetate film has an advantage over other materials as it can be mounted, and, because of its transparency, can be accurately cut according to the image showing through it.

If the print is on a heavyweight or sized paper, it would normally require damping before embossing, and in this case, it should be placed in the damping book for several hours. Although waterleaf and other unsized papers are usually more flexible, the embossing will be sharper if they are also damped.

If no copperplate press is available, embossing can be done on the cylinder press, but in this case the embossing material will have to be built up to a fraction under type height, to allow space for sufficient soft packing – felt or a few sheets

Opposite above: Roy Lichtenstein, *Bull III*, 1973. Colour lithograph with screen print and line-cut, 89 × 68.5 cm. Courtesy, Gemini G.E.L., Los Angeles, California.

Opposite below: Roy Lichtenstein, *Bull VI*, 1973. Colour lithograph with screen print and line-cut, 89 × 68.5 cm. Courtesy, Gemini G.E.L., Los Angeles, California.

of blotting paper – between the print and the cylinder dressing. The cylinder is used purely for pressure, the print being positioned on the embossing plate by hand.

THREE-DIMENSIONAL PRINTS

These can take any form which the lithographer thinks would best realize his ideas. The most basic method employs techniques borrowed from the packaging and display industry, and involves the cutting and folding of the image after it has been printed. Apart from this influence, some of the work being done in this field appears to have been inspired by the model theatres made during the nineteenth century by Benjamin Pollock. This type of image depends on careful registration and planning while it is still in the flat, and if very complicated, demands some preparatory model-making. Examples of this type of print have been made by Richard Smith.

An alternative method has been explored by Rauschenberg at Universal Limited Art Editions. By lithographing on plexiglass, he has been able to build up a box-like structure which is artificially illuminated from the back. The sheets containing the various images can be slotted into the box, in any order in which the viewer might choose; the permutations are said to be over a million.

LINE-CUT

This is a mechanical process in which a photo-engraved metal plate (zinc) is made from a hand-cut negative of the artist's drawing. The plate is inked in relief as in a woodcut or other relief process, and printed under firm pressure. The result is a score line which holds a distinctive lip of ink. This technique was used in the Lichtenstein prints on page 157. (Definition kindly supplied by Gemini G.E.L.)

Opposite: Nicholas Parry, *Bathers*, 1958. Colour lithograph, reduction print, 46 × 25 cm. Courtesy, Shrewsbury School of Art.

Ann Jones, *River Scene*, 1956. Colour lithograph, reduction print,
38 × 30.5 cm. Courtesy, Shrewsbury School of Art.

10 Lithography since 1950

The technical advances made in lithography since the mid nineteen-fifties have not all been advantageous to the lithographic printmaker who wishes to exploit his talents in the wider field of communication. There now exists a dichotomy between the artist using it as a creative medium and the designer who uses it as a reproductive medium. Lithography has become a ubiquitous reproductive process, having taken over much of the work originally done by letterpress methods, and for this, according to one's outlook, American practice should accept much of the credit or blame. In their cost-conscious economy, the advantages of lithography *vis-à-vis* letterpress were realized during the nineteen-thirties, so that even then it was not uncommon to find the process being used for book production. Lithography was not extensively used in Britain for this purpose for another twenty years, when the advent of photo-composition during the nineteen-fifties radically changed the picture, enabling lithography to move easily into the fields of book and newspaper printing. Since all the material, whether visual images or text, now has to go through a photographic process to make the plate image, it would be difficult to exploit the unique qualities of the method in the manner practised by Toulouse-Lautrec, or any of the anonymous designers who produced the music titles, valentine cards or bottle labels during the nineteenth century. It is now easier to incorporate autographically made images such as wood engravings or linocuts with type for letterpress printing.

The processing of visual material for lithography has now achieved a benevolent neutrality towards the designer, so that he no longer has to work within the limitations of the medium, and the results of his labours could now equally well be printed by gravure or letterpress. The development of fine-grain plates, and the finer halftone screens to go with them, has meant that while original designs on paper can be more faithfully reproduced than was considered possible two decades ago, any design control is exercised with regard to a paper image and not a lithographic one.

One design-conscious firm of printers, W. S. Cowell of Ipswich, who were aware of this problem, have partially solved it by the introduction of Plastocowell (see p. 128), which allows the resulting images to be photographed down

to the printing plate in conjunction with photoset type or any other photographically opaque material such as Letraset or Letratone.

Thus, in the wider field of communication and commercial graphics, while there is still a place for true autographic images in letterpress printing, there exist few opportunities for the lithographer to practise the real disciplines of his craft. Although locally produced autographic posters may occasionally be seen on the hoardings in provincial towns, this branch of lithography is now almost entirely reserved for printmaking and the illustration of books, mainly of limited editions.

It has often been said with regard to letterpress printing during the nineteenth century, when the craft became the preserve of commerce, that the typographic designer lost his birthright, and that the history of printing since William Morris is a chronicle of his efforts to reclaim it. That this has been reasonably successful is demonstrated by the generally high level of design now prevailing in books and ephemera. It would be tempting to draw a close parallel when discussing lithography, but although there is some similarity in development, the rapid technical progress in this field which has enabled lithography to advance at the expense of letterpress printing would make such a comparison unjust to the older method.

The artist's involvement with the printer with regard to working in the factory and supervising the proofing of his plates has been an accepted fact in France since the nineteenth century, but there has often been distrust for this arrangement in Britain, where the craft printers have generally considered their chapels as sacrosanct. It may be that the diversion of the craft to the status of a skilled trade was in part responsible for the reluctance of artists to practise it, and for the pedestrian quality of lithographs which were produced in Britain during the nineteenth and early twentieth centuries.

One firm of commercial lithographers, the Curwen Press, stands out as an exception to this, and has maintained a long and fruitful relationship with the printmaker. This is demonstrated in the series of *Contemporary Lithographs* which they published between 1935 and 1938. These were drawn at the factory by artists who included Barnett Freedman, Eric Ravilious, John Piper, Frances Hodgkins, John and Paul Nash, and Graham Sutherland. After the interruption caused by the war, this liaison was continued with a wider circle of lithographers. During this period, the Guinness lithographs were produced, the lithographers including Barnett Freedman, Bernard Cheese and Edwin Ladell. A logical outcome of this activity was the decision, in which Robert Erskine of the St George's Print Gallery played a persuasive role, to set up the Curwen Studio, in 1958, under its director, Stanley Jones. The first fruits of this establishment was the *Hammerklavier Suite* by Ceri Richards. Each lithograph in

this series is presented under the title of a piano work by Debussy. Both in the monochrome and colour print this artist displays a fine sympathy for the medium and his work possesses breadth and very personal colour. His *Dylan Thomas Suite*, made approximately ten years later, contains lithographs which carry quotations from this poet's work. The imagery in this set is harsher and in marked contrast to that employed in the *Hammerklavier*.

Other artists who have worked, or are working, at the Curwen include John Piper, Henry Moore, Robert Colquhoun, Elizabeth Frink, Lynn Chadwick, Mary Fedden, David Hockney, Man Ray, Barbara Hepworth and Patrick Proctor.

Associated with the studio is the Curwen Print Gallery. Copies of each lithograph made in the studio during the first 15 years of its existence, now form the nucleus of the print collection at the Tate Gallery.

The technical advances made in the field of commercial lithography have been matched by a corresponding increase in the technical resources available to the lithographic printmaker. It can be said that much of this is due to Picasso's work in the medium during the early post-war period. This does not imply that most of the techniques which are now practised by lithographers were invented by him, but that through his work in lithography he destroyed much of the accepted dogma surrounding the craft, thus enabling the lithographers who followed him to work in a more open-minded and experimental manner.

In February 1946, on the occasion of the first post-war London exhibition of Picasso's paintings, and about the time that Picasso was starting his apprenticeship to the craft, the BBC broadcast a discussion on Picasso between Herbert Read, Professor Thomas Bodkin and Barnett Freedman. In this, Freedman made the point that Picasso was one of the great 'performers' in paint, as a musician performs on an instrument. This observation may also be applied to his lithography. Even though the creative function of these prints is not sacrificed to technical innovation, the virtuosity displayed by some of them has rarely been equalled by any other lithographer. While admitting this, the skill exercised by Mourlot in establishing these images as prints must also be recognized: just as there can be no doubt that the questions of technical invention were posed by the artist, there can be no doubt that the answers, at least in part, were supplied by his printer.

Although many of his contemporaries of the Paris school were making lithographs, their work is more closely related to their painting, so that for instance, a Léger or Chagall lithograph is a lateral extension of their other work and displays a similar approach. In Picasso's lithographs, there appears to be no reliance on a preconceived painting method. That this was all new ground to him is supported by the fact that the majority of his lithographs were in black and white,

and therefore well removed from his approach to painting. He did not use colour printing consistently until making his series of linocuts during the late nineteen-fifties and early sixties.

Among the younger artists working in the shadow of this 'old guard', Antoni Clavé forged his own very personal development, initially influenced by Picasso. He produced many lithographs both in monochrome and in colour which are characterized by richly textured surfaces and excellent presswork. His illustrations to Prosper Mérimée's *Carmen*, Voltaire's *Candide*, and particularly to *Gargantua* by Rabelais, play an important part in the high quality of these books. In the last example, the combination of the coloured lithographs and the large type create a monumental page, and the technique of drawing and manipulating the 12 or so plates for each illustration is remarkably assured. He combined this work with designing sets for films and the theatre.

In Paris, the decade starting during the middle nineteen-forties is especially noteworthy for the production of fine books in which lithography was used as the illustrative process. Apart from Clavé, other artists involved in these projects included Carzou, Jean Cocteau, Edouard Goerg, Gischia, Jean Lurçat, André Minaux, Miró and Henry Moore. The lithography workshops used for the various productions were the Atelier Maeght, Atelier Mourlot and Desjobert et Détruit.

Carzou, who before the war had been an engineer, developed as a painter in the romantic tradition, but with a distinctive graphic style. Although figurative and tightly drawn, as might be expected from his background, his paintings are suspended on the border between reality and fantasy. His many lithographs reflect this quality. Much of his subject-matter is drawn from engineering sources and from the decaying and abandoned fortifications around the coast of France.

Campigli's paintings of Etruscan maidens abstractedly passing the time are very well known and his many lithographs of this period display a similar dreamlike quality.

More vigorous and urgent are the prints of Marini and Giacometti, which clearly show their derivation from the highly personal three-dimensional work of these two sculptors. They are both masters of the chalk drawing.

One artist who pursued a lonely and individual path was Maurits Escher. His prints, mainly relief or lithographic, display an almost obsessive preoccupation with perspective and obliquely seen natural phenomena. His later work is characterized by a certain claustrophobic quality reminiscent of the verbal images of Kafka. His work is extremely professional and is drawn in an uncompromising chalk and ink technique.

It could be argued that lithography has always been a technique appropriate to romantic expression, and apart from isolated printmakers such as Odilon Redon and Paul

James Rosenquist, *Campaign*, 1965. Colour lithograph with airbrush, 65 × 56 cm. Courtesy, Universal Limited Art Editions, Long Island.

Claes Oldenburg, *Letter Q as Beach Hut with Sail Boat*, 1972. Colour lithograph, 99 × 64 cm. Courtesy, Gemini G.E.L., Los Angeles, California.

Claes Oldenburg, *Soft Toilet 1*, 1972. Colour lithograph, 53 × 37 cm. Courtesy, Gemini G.E.L., Los Angeles, California.

Klee, abstraction or surrealism had little influence on its development up to the nineteen-fifties. The movement which could be said to have influenced it more than most others is Expressionism, with its emphasis on the simplified line and emotional use of colour.

The most far-reaching revolution to have taken place in American art occurred during the nineteen-fifties, when quite suddenly American artists ceased to follow European trends and themselves became initiators of world movements, first with Abstract Expressionism, followed by Pop Art and Op Art. Their graphic output has been more significant in the last two movements, particularly in the use of silk screen, but it cannot be an accident that the surge of interest in lithography which is now taking place in the United States commenced with the birth of these movements.

Thus, during the past two decades, lithography has succumbed to the influences of Pop Art and Op Art, with some contributions being made by abstract expressionism, minimal art and concrete poetry. To accommodate these trends, the printmaker has had to embrace the skills of photography, mixed-media printing and three-dimensional image-making, as well as exploiting and furthering the experiments with transfer paper, collage and the sophisticated wash techniques initiated by Picasso.

Although atmospheric lithographs in the romantic tradition are still made, they are in the minority, and the influence of printmakers like Bonnard or Vuillard, which was very

M. C. Escher, *Ascending and Descending*, 1960. Black-and-white lithograph, 35 × 28 cm. Courtesy, Escher Foundation, Haags Gemeentemuseum, The Hague.

strong among artists and students up to the early nineteen-fifties, has waned, while the influence of artists with a more trenchant but less poetic message has increased.

Technological and industrial subjects have always been well represented in the medium, but during the nineteenth and early twentieth centuries these achievements were shown mainly with an idealism which reflected the almost unquestioning belief that, through their agency, the millennium would arrive. There were dissidents from this point of view, whose ideas were expressed in the engravings of Doré and Cruikshank, apart from some writers of the period who seemed to think that life was degenerating into something quite different. The romantic and idealized approach is seen at its strongest in many of Pennell's lithographs, which reflect his belief that engineering construction is the modern equivalent of the mediaeval castle. During the past twenty years, the vision has become less clouded, and some artists have approached the subject with irony and satire.

In his book *The Human Zoo*, Desmond Morris compares masculine behaviour in the animal and human kingdoms. He describes how the men of certain primitive tribes attach to themselves long artificial male members in order to impress the enemy with their virility. Later, he describes

similar behaviour by a tycoon, who aggressively flourishes a cigar in the face of a business rival. In one lithograph from his *Stoned Moon* series, Rauschenberg has lifted this symbolism to the international level by superimposing a rocket on its launching pad against a phallic drawing. In the rest of this cycle, which concerns the American space programme, Rauschenberg varies the symbolism from print to print. The majority of these lithographs use photographically derived imagery in conjunction with drawing and montage.

Claes Oldenburg pinpoints our reverence for trivial artefacts and the throwaway society by using such objects as windscreen wipers and w cs as images for his sculpture and lithographs.

This need for the instant communication of ideas has led to the employment of what were once considered as slick commercial techniques, not to be mentioned by serious artists. Thus Rosenquist's large-scale lithographs, drawn with the air brush, acquire the form and immediacy of film posters. When Richard Hamilton used a colour photograph of a television screen showing a film of the riots at Kent State University as the basis of a powerful and evocative lithograph, he was exploiting the contemporary need for instantly identifiable symbols.

Thus, many of today's prints, while appearing specious and superficial, are manifestations of a deep concern about our society, and although their imagery is very different and the techniques used are more sophisticated, they are the result of the same motivation which guided Daumier or Käthe Kollwitz.

SOME PRINTMAKING WORKSHOPS

The most revered of lithographic workshops, the Atelier Mourlot, has been involved with the printmaker since 1914, when Fernand Mourlot's father bought an old transfer press and set up his own business in the rue de Chabrol, Paris. However, the main history of the studio did not commence until 1918, when Fernand Mourlot returned from war service. Since then the printmakers who have worked in this studio form a chronicle of the most distinguished artists of this century. The list includes Bonnard, Braque, Dufy, Léger, Maillol, Matisse, Utrillo and Vlaminck, and more recently, Chagall, Manessier and Picasso. Among foreign artists are Alexander Calder, Henry Moore, Miró, John Piper and Graham Sutherland.

In common with other similar establishments in Paris, the workshop has been deeply involved with book production and has worked in conjunction with the Imprimerie Nationale.

Mourlot has always trained his own craftsmen and the success of his methods is demonstrated in the way in which

Fritz Glarner, *Colored Drawing*, 1963.
Colour lithograph, 63.5 × 51 cm.
Courtesy, Universal Limited Art
Editions, Long Island.

the wide range of technical problems presented by the work of these artists has been solved.

The Atelier Maeght, with its associated gallery in Paris, is possibly the largest publishers of artists' prints in Europe. It is mainly involved with lithography and etching, although occasionally some of its publications have been screen- or relief-printed. Apart from this work, it is involved with printing and publishing in two spheres. The first of these concerns illustrated books mainly devoted to contemporary fine art and artists, and the second, in the realm of the *livre d'artiste*, that is, limited and signed editions autographically illustrated. An extension of this work is the publications *Derrière le Miroir*. This is a long series, and each set takes the form of a folder containing original lithographs by a particular artist, together with text, or text and poetry. A related poster, lithographed by the artist, accompanies each folder. Among the printmakers working for the Galerie Maeght are Pol Bury, Chagall, Alexander Calder, Miró, Riopelle, Tàpies and Ubac.

The first printmaking workshop in America was founded in Long Island in 1957 by Tatyana Grosman, and the first collection of prints, *Stones*, was lithographed by Larry Rivers, Fritz Glarner and Grace Hartigan. Contributing

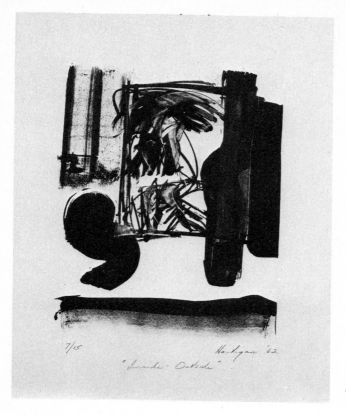

7/15 Hartigan '62

"Inside-Outside"

Grace Hartigan, *Inside-Outside*, 1962.
Black-and-white lithograph,
63.5 × 51 cm. Courtesy, Universal
Limited Art Editions, Long Island.

artists to later portfolios included Rauschenberg, Helen
Frankenthaler, Jasper Johns, Robert Motherwell and Barnett
Newman. This workshop, which is now known as Universal
Limited Art Editions, is under the discerning leadership of
Mrs Grosman and has extended its field of operations to
include intaglio and relief methods of printmaking and the
preparation of photographically derived images. Successful
explorations have also been made into the realms of three-
dimensional prints, but the main work of the studio is
orientated towards the problems of integrating text with
illustration, and book production. Tatyana Grosman en-
courages the collaboration of poets, printmakers and typo-
graphers and, to this end, the facilities of the workshop
include a letterpress studio for setting and printing type.

The first print in *Stones* was the result of a collaboration
between the painter Larry Rivers and the poet Frank O'Hara,
and takes the form of a page of a *livre manuscrit*.

The Tamarind Workshop occupies a unique position in
that it is entirely devoted to the practice of lithography.
Apart from this work, it has initiated programmes of
research into the quality and behaviour of materials used in
the craft, and into many technical and professional matters
of direct concern to the artist working in this medium. It

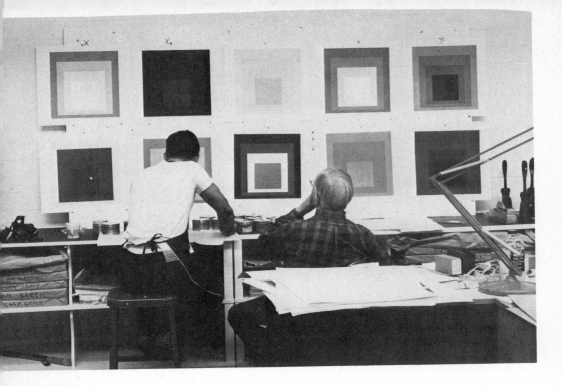

Josef Albers working at Tamarind.
The prints are his suite of
lithographs *Day and Night*, 1963.
Courtesy, Tamarind Institute,
University of New Mexico.

is also involved in the training of lithographic master
printers who later enter professional careers to work col-
laboratively with artists in the making of their prints.
Founded in Los Angeles in 1960 as Tamarind Lithographic
Workshop Inc., it was moved to Albuquerque, New
Mexico, in 1970, where it has continued as the Tamarind
Institute, a division of the University of New Mexico.

Gemini G.E.L. (Graphic Editions Limited), was founded
in Los Angeles in 1966 for the purpose of printing and
publishing limited editions of signed, numbered litho-
graphs by major contemporary artists. Since that time the
facilities have expanded to include screen printing, line cut,
etching and the fabrication of three-dimensional objects in
limited editions. Gemini is an invitational workshop which
offers its entire staff and all facilities to each artist with whom
it works. Collaboration, the willingness to experiment with
new techniques and the desire to meet the demands of the
artist are essential aspects of Gemini's success. Gemini has
also endeavoured to protect the artist and the purchasers of
its publications by thoroughly documenting each edition
which is produced. This includes the listing of all the existing
proofs, dates of collaboration, signing and cancellation as
well as a description of the processes used. The document
is signed by the artist and by Gemini's director and is issued
to each purchaser. Gemini's publications are sold in most
major cities and appear in many museums and galleries
throughout the world.

The Pratt Graphics Center, New York, exists as a practical
printmaking workshop, organized as a non-profit-making
institution. It also runs a gallery devoted to prints, both

historical and contemporary, and an extensive travelling exhibition service. It publishes the magazine *Print Review* twice a year, and through its other publications and programmes of enlightenment furthers the interests of the artist/printmaker.

In a different sphere, the Philadelphia Print Club, through its educational programme *Prints in Progress*, has introduced, on a professional level, the various printmaking crafts into the schools throughout this city. This has been achieved by the use of a portable multi-purpose press and other necessary equipment which visit the schools accompanied by a notable printmaker, who demonstrates his chosen process. An essential part of the exercise is that the print should be created during the morning or afternoon session, or that one colour should be added to a print already started, the artist describing the preliminary stages in an accompanying lecture. About 90 demonstrations take place during the school year.

In a wider context, the Print Council of America is open to membership to lithographers.

In London, apart from the Curwen Studio already described earlier in the chapter, the Petersburg Press in Portobello Road concentrates on lithography and intaglio methods. While the making of artists' prints is carried out, the workshop is deeply involved in book production and publishing. Their work in this field conforms to the long traditions and high standards of the British private press movement. Recent publications include a selection of Grimm's Fairy Stories with etchings by David Hockney, but of more immediate concern are two books illustrated by lithography.

Henry Moore's prints are the result of a collaboration with W. H. Auden; in this folio book of poetry, the rich, black chalk drawings contrast well with the spare and uncluttered typography. An interesting feature is the choice of a display size of Times New Roman, using the short descender, rather than the book version with long descenders. At first sight, this, together with the wide leading, gives the impression of a printed Latin text. The book is punctuated by several illustrations in restrained colour which extend in narrow bands from edge to edge across the fold. All these prints were worked on the stone, and the text is impeccably printed by letterpress. Henry Moore also drew the endpapers, incorporating the titles of the poems with characteristic imagery.

Jim Dine's work is an adaptation into script form, for dramatic presentation, of Oscar Wilde's novel, *The Picture of Dorian Gray*. Eschewing the cult of fine typography, the edited text was typed out direct on to litho plates with a Varityper. The plates were then embellished with *graffiti* in the shape of marginal notes and diagrams drawn over the typed script, or on to other plates to be printed in colour. There are also some full-page coloured lithographs of

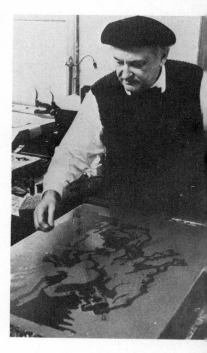

Jacques Lipchitz cancelling the zinc plate for his lithograph *The Bull and the Condor*, 1962. Courtesy, Tamarind Institute, University of New Mexico.

leading characters in unlikely costume, and others of equally unlikely stage props. The over-all character of the book is one of irreverent and inconsequential humour.

A new venture is the lithography workshop in Clerkenwell started in 1974 by Jean Maddison. While professional printing of artists' lithographs is carried out, the workshop is also available for artists to do their own printing, supplying their own paper and plates.

The outlets for prints in Britain are too numerous to list, but they include many of the private galleries in London and practically all similar establishments in the provinces. Most recurring public exhibitions, such as the Royal Academy summer exhibition, accept lithographs on the same footing as paintings or sculpture, while frequent exhibitions limited to prints are held throughout the country. The Bradford Print Biennial is open to all printmakers, whether British or foreign.

Certain galleries will commission prints from artists, examples being Marlborough Graphics, Editions Alecto and Christies Contemporary Prints.

The Printmakers' Council of Great Britain is open to membership to lithographers, and at the time of writing

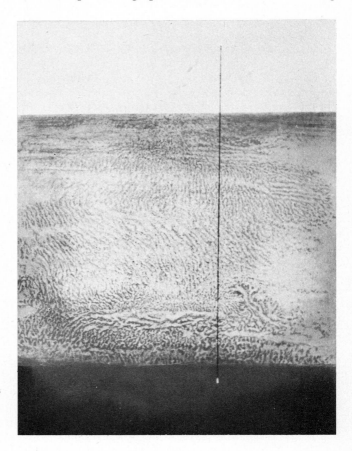

Marietta Burman, *So God created man*, 1974, from a series of prints on Biblical themes, published in Caracas by the Venezuelan government. Colour lithograph with wash, 48 × 39 cm. Courtesy, The Lithography Workshop, London.

there are signs that the Senefelder Club is being reborn. In this case, prints will be limited to those which are truly autographic, that is, made without the use of any photographic or mechanical aid.

Jean Maddison, *Tunnels*, 1974. Colour lithograph with airbrush, 77 × 58 cm. This print exploits the airbrush, and this technique is combined with staging out with gum arabic to produce the foreground texture. Courtesy of the artist.

PRINTMAKING IN THE USSR

The making of prints receives great encouragement in the Soviet Union, and the new national schools of printmaking which are developing in the various republics are fostering new methods and ideas, and the growth of regional identities.

It is not the intention in this section to discuss the role of the printmaker in Soviet society and it need only be said that his capacity to respond quickly to contemporary events and to 'reflect the pathos, the heroism and revolutionary impulses of the people' was recognized fairly early in the post–1917 period.

There is a pronounced literary or illustrative element in Russian painting which is particularly marked in work produced since the middle of the nineteenth century, and since the continued practice of folk art also receives the highest encouragement, it is not surprising that many Soviet prints reflect both these influences. Although all the work is basically figurative, some prints have been pushed to the

borders of abstraction, while some betray expressionist or cubist methods of working. The bold and decisive idiom employed by the designers of the small- and large-scale posters to be seen in the cities has not yet been adapted to Pop Art or a printmaking context, most prints being conceived in a poetic vein, either derived from landscape or else reflecting the day-to-day life of the people. The cynical and disillusioned approach, the near-pornographic or erotic subject matter now appearing so frequently in Western graphics are not to be found in Soviet prints; satire also is a rare quality and it is possible that this may be reserved for the cartoons in the coloured newspaper *Krokodil*.

There is little evidence of experimentation in lithography, the materials being used in their traditional ways, although some recently executed colour aquatints do betray a knowledge of overprinting techniques developed by S. W. Hayter.

The importance which is attached to the autographic nature of printmaking is manifested in several ways, the most obvious being that in spite of the high quality of photo-litho reproduction, it is not uncommon to find mass-produced books illustrated by woodcuts or engravings, or by lithographs.

As in Britain, the main work of printmaking is carried out in the fine art departments of the various schools, or in the Academies of Fine Art in the larger cities. Schools of Art and Industry, which are more concerned with training designers, are closely linked with the relevant industries, and in these establishments printmaking is practised as a necessary peripheral activity, its autographic qualities being used to balance and add dimension to the more precise disciplines of industrial designing. The other handcrafts, such as ceramics, textile printing and weaving, are used in the same context.

Of the main processes, the most popular seem to be relief methods, although many examples of lithography and the various intaglio processes can be seen. Screen printing does not appear to be used for printmaking, nor has the mixed-media print yet been developed.

Russia is fortunate in having discovered unlimited resources of good-quality litho stone in the mountains of Georgia, so that the emphasis is on the use of this material, although zinc and aluminium plates are also used in the printmaking schools.

Artists' proofs in hand-printed editions of about 15 are sold in the Artists' Shops at prices approximating to those in London. Also etchings, lithographs and linocuts in editions of from 500 to 1,000, signed but not numbered, and professionally printed in monochrome or colour as required, can be bought for about £3 in some of the many large bookshops and universal stores.

Appendix 1 : papers for printing

There is a general rule, broadly applicable to all forms of printing, that for the most efficient transfer of ink, the printing and the receiving surfaces must be contrasted – smooth against rough, hard against soft. Apart from choosing papers which contrast in this way with the plate, certain measures can be taken to establish this relationship between the two areas, such as damping the paper, or using the offset press, in which the resilience of the blanket is naturally complementary to the hardness of the plate.

With the continuous problems of registration in colour lithography, it is essential that paper of stable dimensions should be used. Paper, being mainly vegetable, is hygroscopic and expands when moisture is absorbed. This factor, unless controlled, causes registration problems, as paper moves with changes in relative humidity. All good-quality machine-made papers are conditioned at the mill to minimize this movement, by being deliberately exposed to conditions of high relative humidity after manufacture. This first exposure creates greater expansion than any later exposure, and is usually of the order of 4 per cent across the grain and 0·5 per cent along the grain.

Most printmakers prefer the type of surface provided by waterleaf and unsized papers; these carry definite advantages in that they discourage the formation of gloss. However, there is one disadvantage: large areas of opaque tint can become so matt that the ink film is almost lifeless. The addition of a small amount of varnish may prevent this trouble.

It is essential that the paper make a positive contribution to the final image: it should never be regarded as a passive vehicle for supporting the ink. If it is possible to make a choice, the selected paper should match the quality and content of the image. Some prints may demand a brilliant white surface, while others, possibly of a more atmospheric character, may be better displayed on a more muted and textured paper.

HAND AND MOULD-MADE PAPERS

Rives BFK from Rives Mill, Rives, Isère, France. Mould-made. Weight varies from about 180 gsm to 250 gsm. Half-sized.

Arches from Arches Mill, Archés, Vosges, France. Mould-made. Weight about 250 gsm. Half-sized.

English Etching Paper from J. Barcham Green, Hayle Mill, Maidstone, Kent, England. Hand-made and hot-pressed. Weight about 300 gsm.

Crisbrook from the same supplier. Hand-made and hot-pressed. Imperial size: 140 lb. About 300 gsm. Both of these papers are waterleaf.

JAPANESE PAPERS

Hodomura white and tinted, unsized.

Hosho white, unsized with very light laid marks. Both of these papers are obtainable in various weights. Other Japanese papers, e.g. *Bugegawa* and *Tatsumaki*, have large fibres in their make-up. These can range from a silky white, through straw to brown. In some cases, they are raised so much from the surface that good ink transfer is problematical. However, some of them have been used very successfully in colour lithography. Japanese papers can be obtained from Messrs T. N. Lawrence and Son (see Appendix 4)

MACHINE-MADE PAPERS

Snocene Cartridge from Thomas Tait of Inverurie, Wheatsheaf House, Carmelite Street, London EC4. Available in various sizes and weights up to 170 gsm. Sized. Neutral pH.

PAPERS supplied by Grosvenor Chater & Co. Ltd (see Appendix 4)

Royal Cornwall Cover. Available in weights 163 gsm and 265 gsm; made in various colours including white.

Design Cover. Weight 142 gsm. Available in various colours including white.

Ivorex Boards. Hi-white or Super white matt. Available in weights 190 gsm., 224 gsm. and 300 gsm.

MG paper for proofing. Weight 63.5 gsm.

Mechanical SC printing for proofing. Weight 71 gsm.

PAPERS supplied by G. F. Smith & Son Ltd (see Appendix 4)

White Tranby Antique. Weight 273 gsm and 310 gsm.

Caslon Bright White. Weight 270 gsm.

Appendix 2: ancillary equipment

Bridge or barrel stave for drawing stones

Buckets for damping, etching and cleaning (should not be interchanged)

Cellulose sponges for damping and cleaning (should not be interchanged)

Small sponges for applying etches (should not be interchanged)

Craft knife or Stanley knife

Damping book

Drawing instruments

Electric fan or heater

Flag fan

Funnels for decanting turps and solutions

Glass fibre brushes

Graduated measure for mixing solutions

Household paintbrush

Ink slabs

Jars or containers for gum, gum/etches and other solutions

Levigator

Linen prover

Litho pens and nibs

Oil cans

Palette knives

Push knives

Rags

Registration needles

Rollers (nap, glazed and rubber)

Sable brushes, various sizes

Scissors

Set of tools for press maintenance (spanners, screwdrivers etc.)

Sieves for graining

Small hand rollers for taking transfers

Stone files, rasps etc.

Straight-edge

Surform plane and an ordinary plane

T-square

Tools for various purposes around the studio: woodsaw, hacksaw, pincers, pliers, hammer, hand drill etc.

Turps sprinkler

Type scale for bookwork

Vises: preferably both a metalwork and a woodwork vise, but if a choice has to be made, the metalwork vise is more versatile, as its jaws can be lined with wood when holding a soft material.

Appendix 3: materials and solutions

ACIDS: BASIC SOLUTIONS FOR MIXING OR DILUTING

Nitric acid: etch for stones and for mixing counter-etch for zinc

Tannic acid for mixing plate etches. Alternatively, Victory Etch and Atzol

Carbolic acid for erasing work on stones

Sulphuric acid for erasing work on aluminium plates

Caustic potash for erasing work on zinc plates. Alternatively, Erasol

Acetic acid and citric acid for resensitizing stones

Nitric acid/potash alum for resensitizing zinc plates. Alternatively, Prepasol

Fluorsilicic acid: incorporated in counter-etch for aluminium

Phosphoric acid for incorporating in gum/etch for aluminium

SOLUTIONS FOR PHOTOGRAPHICALLY SENSITIZING AND DEVELOPING PLATES

Ammonium bichromate: light-activated solution

Household or cloudy ammonia for slowing the action of the light

Egg albumen, either natural or in flake form, for making negative working plates

Plate developer: this can be made by dissolving a little press black in washout solution

OTHER SOLUTIONS

Washout solution

C1175 white washout solution for use before colour printing

Turps substitute or white spirit

Paraffin

Petrol

Methylated spirit

Carbon tetrachloride

POWDERS AND DRY INGREDIENTS

Gum arabic, in lump and powder forms

Resin: acid resist for the image

French chalk: acid resist for the image

Light magnesium carbonate: additive for printing inks and for gloss prevention

Violet offset powder. This is very scarce: recommended substitutes are powdered red ochre, jewellers' rouge and pottery pigments

MATERIALS FOR STONE PREPARATION

Coarse grinding sand

Sand of various grades for graining

Pumice powder for graining

Pumice block

Snakestone block and slips

Other abrasives as dictated by personal choice

MATERIALS FOR IMAGE-MAKING

Litho writing ink (stick or liquid)

Litho chalks or crayons, various grades from 00 to 5

Distilled water

Transfer papers

Appendix 4:
suppliers of materials

UK:

E. J. Arnold & Son Ltd, Butterley Street, Leeds LS10 1AX:
 paper plates; Rotafix B lithographic preparation
Ault & Wiborg Ltd, Standen Road, London SW18 5TJ:
 printing inks; litho hand rollers
L. Cornelissen & Son, 22 Great Queen Street, London
 WC2B 5BH: grained zinc or aluminium plates; litho
 hand rollers; lithographic materials and sundries; printing
 inks (these may still be inks specially formulated for direct
 printing)
W. S. Cowell Ltd, P.O. Box 32, Butter Market, Ipswich
 IP1 1BN: Plastocowell (see p. 128)
The Forrest Printing Ink Co., 48 Grays Inn Road, London
 WC1X 8LX: printing inks (also makes very satisfactory
 gel reducers, matting compounds and driers)
Hawthorne Baker Ltd, London Road, Dunstable LU6 3DT:
 pre-sensitized aluminium plates; printing down units
Frank Horsell & Co. Ltd, Howley Park Estate, Morley,
 Leeds LS27 0QT: pre-sensitized aluminium plates; offset
 rubber blankets; C1175 white washout solution; printing
 inks (will make specialized inks for individual customers)
Hunter-Penrose-Littlejohn, 7 Spa Road, London SE16 3QS:
 grained zinc or aluminium plates; lithographic materials
 and sundries; litho hand rollers; polyurethane hand rollers
 or brayers; materials and chemicals for photo-litho plate
 making
T. N. Lawrence & Son Ltd, Bleeding Heart Yard, Greville
 Street, London EC1 8SL: polyurethane hand rollers or
 brayers
Soag Machinery Ltd, Transport Avenue, Great West Road,
 Brentford, Middlesex TW8 9HB: offset presses
Second-hand presses are occasionally advertised for sale in
 Exchange and Mart, *Arts Review* and various trade journals
 such as *Litho Printer* and *Printing Machinery*

USA:

Apex Printers' Rollers Co., 1541 North 16th Street, St
 Louis, Mo. 63106: litho rollers and brayers
Charles Brand Machinery Inc., 84 East 10th Street, New
 York, N.Y. 10003: presses; transfer presses; scrapers

The Crestwood Paper Co. Inc., 263 9th Avenue, New York, N.Y. 10001: home-produced machine- and mould-made paper, 100% cotton

Anthony Ensink & Co., 400 West Madison Street, Chicago, Ill. 60606: paper plates and processing material

Graphic Chemical and Ink Co., P.O. Box 27, 728 North Yale Avenue, Villa Park, Ill. 60181: presses; transfer presses; Dickerson combination press (can be used for both direct lithography and intaglio printing); plates; pre-sensitized plates; scrapers; litho stones; lithographical materials and sundries; printing inks (including coloured inks for use on paper plates); transfer papers; litho rollers and brayers; paper (hand- and mould-made, machine-made including imported paper)

William Korn Inc., 260 West Street, New York 13: lithographical materials and sundries

Harold N. Pitman Co., 515 Secaucus Road, Secaucus, N.J. 07094: plates; pre-sensitized plates; materials for photo-litho; printing down units

Rembrandt Graphic Arts Co. Inc., Stockton, N.J. 08559: presses; transfer presses; plates; pre-sensitized plates; grained zinc and aluminium plates; litho stones; scrapers; lithographical materials and sundries; printing inks; paper (hand- and mould-made, machine-made including imported paper)

Glossary

ADSORPTION A physico-chemical phenomenon manifested as a close union between certain substances. Carbon, for instance, can adsorb toxic gases, and is therefore used in respirators. Limestone can adsorb fats and gum arabic, thus forming the basis of the lithographic process.

ALBUMEN The white part of an egg. Used in preparing light-sensitive coatings on plates for photographically derived images.

ALGINATES Gummy organic compounds, salts of alginic acid, obtained from seaweed.

AUTOLITHOGRAPHY Lithography as practised by artist-printmakers: the plates are drawn, proved and printed by the artist.

BED A general term describing that part of a press on which the block, type or plate is fixed, ready for inking and impressing.

BICHROMATE Lithographically, this usually means ammonium bichromate, a light-sensitive salt used in the preparation of plate coatings for photographically derived images.

BLANKET The thick sheet of rubber and fabric used as the offsetting surface on the cylinder of the offset press.

BODY The quality of an ink which is governed by the relative proportion of solids (pigments) and liquids or semi-liquids (the vehicle or medium).

BRONZING Dusting metallic powder on to the wet ink, or varnish on to a print, to make a gold or silver image.

CHROMOLITHOGRAPHY A term used by Engelmann to describe his patent of 1838, involving the overprinting of colours to form polychromatic images – with which invention Senefelder is also credited.

COUNTER-ETCHING An alternative term to describe the preparation of plates or stones to make them more sensitive to grease, or the re-sensitizing of non-printing areas to make them sensitive to grease.

DEEP-ETCH A method of securing an image on a machine litho plate by etching it slightly in intaglio. It is used when the edition or run is going to be very large.

DELIQUESCENT Of certain salts (e.g. caustic soda), tending to liquefy by absorbing moisture from the atmosphere.

Processing the non-printing area of a plate or stone so that it can accept no grease. Usually achieved by the application of gum arabic. DESENSITIZING

Bringing out the image from the blank photographic paper or film in the developing tank. Has been borrowed to describe the similar phenomenon after litho plates have been exposed. DEVELOPING

Book page numbers. The first fold of a book section, giving four pages. Folio books are large. FOLIO

The process of taking brass rubbings. The same technique used in making lithographic transfers. FROTTAGE

Small spherical growths on oak trees made by the gall wasp. One of the richest natural sources of tannic acid. GALL NUTS

Shiny surface on a printed image, caused by the build-up of successive layers of ink, or by using an ink film which is too thick. A type of ink which is designed to dry with a shiny surface. GLOSS

The quality of texture of the working surface of the stone or plate. The texture which has been applied to it by the process of graining. Also, an indication of the direction in which the fibres are lined up in machine-made papers. GRAIN

Solutions of gum arabic to which have been added small amounts of the appropriate etching solution – nitric acid for stones, Victory etch for plates. GUM/ETCH

The process of drawing an image in gum or gum/etch before applying the ink, chalk or transfer. The method produces a negative image of light against dark. GUMMING OUT

Coating the surface of the plate or stone with gum arabic solution, after the drawing is complete, or whenever it becomes necessary at any other stage to protect the background, e.g. after etching or erasing ink. GUMMING UP

The infinite range of tones of grey existing between black and white. HALF-TONE

Absorbing moisture easily. Gum arabic is a hygroscopic substance. HYGROSCOPIC

A mark or series of marks produced by printing. The image area is the over-all space occupied by such marks. The actual printing area of the plate surface. IMAGE

The assembling of type, blocks or plates so that they print in their allotted position on the finished page. IMPOSITION

A proof. The act of printing. The pressure exercised during printing. IMPRESSION

The bed on a flat-bed offset press which backs up the paper during printing. IMPRESSION BED

IMPRESSION CYLINDER	A cylinder on the rotary offset press which backs up the paper during the moment of printing. The cylinder on the offset proof press which carries the image from the plate to the paper. The cylinder on a letterpress machine.
INTAGLIO	The method of printing in which the image area is recessed into the non-printing area. Etching and photogravure are examples.
INTERLEAVING	Thin paper which is placed between proofs to prevent the wet ink from offsetting to the back of the print above it in the pile.
KEY DRAWING	A linear drawing showing all the boundaries of the shapes in a design, and also including the various colour changes. It is used as a guide for drawing the colour plates which, printed together, make the complete image.
LAYS	Adjustable stops on the front and side of the impression bed of the offset press, against which the paper is laid so that accurate registration can be achieved. Identical systems on other forms of printing press.
LETTERPRESS	General term for all relief methods of printing.
LINO–CUT	A relief print made by printing an image which has been cut, engraved or etched in linoleum.
NEGATIVE	A relative term denoting tone reversal, as transposing black to white or vice versa.
OCTAVO	Also written 8vo. A sheet of paper which has been folded three times to form a book section of eight leaves or sixteen pages.
OFFSET (O/S)	To print on to the receiving surface via an intermediate surface. Offsetting is a term popularly used when referring to a wet proof printing back to the plate which holds the next colour, or, when in a pile, on to the back of the print above it. 'Set-off' should properly be used for these phenomena, to differentiate between them and the true meaning of 'offset'.
OVERPRINTING	The printing of one colour over another to produce a third. The printing of type or text over a visual image.
PASTE-UP	The final design stage of a typographical layout, incorporating all the elements of text and visual images, pasted to a sheet of paper in their correct positions.
PATCHING UP	Lithographically, this is an archaic term and refers to the assembly of small cutout transfers on a large sheet of paper so that they can be transferred to a stone or plate, enabling many copies of the same design to be printed at once, instead of singly. In the printmaking context, it describes the process of building up a collage of various elements, in transfer form, to transfer to a plate as part of a complete design. Should not be confused with 'paste-up'.

This is a relative term, and can refer to an image and its laterally reversed or mirror version, or an image and its negative version. — **PHASE**

The bed on the flatbed offset press to which the plate is fixed. — **PLATE BED**

Printing papers as opposed to writing papers. In print-making, it means the number of times the proof has been impressed; the number of colours may not always be synonymous with the number of printings – as, for example, in split duct inking, or its hand rolling equivalent. — **PRINTINGS**

A series of proofs taken when proofing in colour, to show all the intermediate stages of overprinting, before the finished state. In a three-colour print the progressives would be as follows: 1 by itself, 2 over 1; 2 by itself; 3 over 2 over 1; 3 by itself. If colour changes or changes in the printing sequence are contemplated, extra progressives can be taken, e.g. 2 over 3 etc. — **PROGRESSIVES**

The process of printing the plates in sequence, in colour, before making a firm decision about the choice of colours for the final edition. — **PROOFING**

This term covers the processes of preparing a stone or plate, after the initial drawing has been gummed, until the rolled-up image has been etched and gummed. — **PROVING**

Also written 4to. A sheet of paper which has been folded twice to make a book section of four leaves, or eight pages. — **QUARTO**

A method of making prints in which only one printing block or plate is used. In this method, the image is built up on the paper by alternately printing and erasing parts of the printing surface, until a satisfactory result has been achieved, and there is little of the original surface left. Examples of this method are the Picasso linocuts of 1958–1960. — **REDUCTION PRINTING**

A measure of the amount of water in the atmosphere compared to the maximum amount that the atmosphere could contain at the same temperature. — **RELATIVE HUMIDITY**

See Counter-etching. — **RESENSITIZING**

The very fine grid which is used to break up half-tones into tiny dots of solid black, which vary in size and proximity to one another according to the depth of tone in the original photograph or other image which is being reproduced. — **SCREEN (HALF-TONE)**

The unwanted deposits of printing ink or press black on the non-printing area of a stone or plate. — **SCUMMING**

The effect which an unsized or soft-sized paper has on the ink film, manifested by a reduction in the bite of a colour. Owing to the porous nature of the paper, much of the vehicle is absorbed, causing the ink to dry with a matt surface. The effect on dark and luminous colours is particularly marked. — **SINKING**

SPLIT DUCT INKING	This involves inking the image simultaneously with two or more differently coloured inks. The process originates from automatic presses, on which the ink duct can be divided into separate compartments by specially shaped pieces of metal. When the machine is running, the reciprocating action of the rollers produces a smooth transition from one colour to another. A similar technique can be adopted when hand rolling colour on the slab. See *Comet over Lower Falls* on page 34 and *Ealing* on page 32.
SPOTTING OUT	The process of editing a film prior to exposing it to a light-sensitive plate. It consists of covering, with a photo-opaque substance, areas or spots of white on the black part of the film.
STRIPPING IN	The process of adding or substituting photographic material to a larger negative film prior to exposing it to a light-sensitized plate. The film to be added is placed in its proper position and carefully secured with scotch tape. It is then trimmed with a sharp knife, so that a hole identical in shape is simultaneously cut into the large negative underneath. The new film is placed into this hole and secured with transparent scotch tape.
TACK	The sticky or adhesive property of printing ink, which can be gauged by the length of threads which are formed when the roller is lifted clear from the ink film on the slab. The longer the threads are stretched before snapping, the more tacky the ink. Tack can be modified by the addition of a little linseed oil or a gel reducer. Inks that are too tacky can strip the surface from the printing paper. This is known as 'picking' or 'plucking'.
TONE SEPARATION	A darkroom technique which effectively eliminates the half-tones in a photograph. The lighter tones become white and the darker ones become black. The final image possesses great contrast and dramatic power.
TUSCHE	The name by which liquid writing ink is known in the USA.
VARNISHES	These are made from linseed oil or resin, which are partially oxidized by boiling, thus increasing their drying power. They are the bases of all printing inks and, in their pure state, are used as ink additives in the studio.
VEHICLE	The drying oils, varnishes or gums in which pigments are suspended to form paints or printing inks. Synonymous with 'medium'.
VICTORY ETCH	A proprietary brand of plate etch based on tannic acid; can be used diluted with water or gum arabic.
VISCOSITY	A printing ink's resistance to flow. This is a prime quality in litho printing inks, to prevent the ink on the plate image from spreading to the adjacent non-printing areas.

A key drawing on a litho plate, used for preparing a series of colour plates but not used in the print itself.

WASTED KEY

The greasy ink used for drawing on plates and stones. Supplied either as a stick – in which case it must be dissolved in distilled water or white spirit – or as a ready-prepared fluid, which can be diluted only with water

WRITING INK

Bibliography

CRAFT THEORY AND METHODS

ANTREASIAN, Garo, and Clinton Adams: *The Tamarind Book of Lithography*. New York, 1971. (An exhaustive analysis of the research programmes and printmaking methods carried out in the Tamarind Institute.)

CUMMING, David: *Handbook of Lithography*. London, 1904; new ed. 1949. (Although a printer's manual, it contains much of value to the artist.)

DOKUCHAEVA, V. N.: *Engravings and Lithographs by Soviet Artists*. Moscow, 1975.

GRIFFITS, Thomas: *The Technique of Colour Printing by Lithography*. London, 1940; reprinted 1944.

HARTRICK, A. S.: *Lithography as a Fine Art*. Oxford, 1932. (Written by a founder member of the Senefelder Club. Includes first-hand accounts of the pre-1914 scene.)

JONES, Stanley: *Lithography for Artists*. Oxford, 1967. (The author is director of the Curwen Studio.)

KNIGEN, Michael, and Murray Zimiles: *The Technique of Fine Art Lithography*. New York, 1970.

PENNELL, Joseph and E. R.: *Lithography and Lithographers*. London, 1915. (Valuable for its detailed history of nineteenth-century lithography.)

RANCOURT, A.: *A Manual of Lithography*. London, 1932.

RIDDELL, George: *A Physico-Chemical Study of Certain Aspects of Lithographic Printing*. London, 1929. (An account of a research programme investigating the nature of gum arabic and its behaviour on stone and metal plates, carried out under the auspices of London University.)

SENEFELDER, Alois: *A Complete Course of Lithography*. London, 1819.

WEAVER, Peter: *The Technique of Lithography*. London, 1964.

WOODS, Gerald: *Introducing Lithography*. London, 1969.

HISTORY

BERSIER, J.: *La Lithographie originale en France*. Paris, 1943.

GILMOUR, Pat: *Modern Prints*. New York, 1970.

KNIGEN, Michael, and Murray Zimiles: *The Contemporary Lithographic Workshop Around the World*. London, 1975.

MAN, Felix: *150 Years of Artists' Lithographs*. London, 1953.
LINDEMANN, Gottfried: *Prints and Drawings*. London, 1970.

ARTISTS

ADHÉMAR, Jean: *Toulouse-Lautrec. Oeuvre Lithographique*. Paris, 1965.
ESCHER, Maurits: *The Graphic Work of M. C. Escher*. London, 1961.
ROGER-MARX, Claude: *The Lithographs of Toulouse-Lautrec*. Monte Carlo, 1948.
— *L'Oeuvre gravé de Vuillard*. Monte Carlo, 1948.
— *The Lithographs of Renoir*. Monte Carlo, 1951.
— *The Lithographs of Bonnard*. Monte Carlo, 1952.
MOURLOT, F.: *Picasso lithographe*. Monte Carlo, 1949–56.
NAGEL, Otto: *Käthe Kollwitz*. London and New York, 1972.
SANESI, Roberto: *The Graphic Work of Ceri Richards*. Milan, 1973.
WARTMANN, Wilhelm: *Honoré Daumier*, 240 Lithographs. London, 1946.

BOOK PRODUCTION

BLAND, David: *The Illustration of Books*. London, 1953.
LEJARD, André: *The Art of the French Book*. London, 1950.
— *Modern Book Production*. London, 1928.
— *Modern Book Illustration*, London, 1931.

JOURNALS

FREEDMAN, Barnett: 'Lithography, a painter's excursion', in *Signature*, 11 Jan. 1936.
TRITTON, F. J.: 'A study of the theory of lithographic printing' in *Journal of the Society of Chemical Industry* 51 (1932), pp. 299–313. London.

Penrose Annual is a fertile source of information about lithography, and has always tried to bridge the gap between the artist and the printer. A selection of articles which have appeared in it is given below, where possible with the author.
LADELL, Edwin: 'Autolithography at the Royal College of Art' in *Penrose* XLVI.
'Early lithography in England' in *Penrose* XXXVIII.
GRIFFITS, T. E.: 'Texture in autolithography' in *Penrose* XLVI.
'Art in the teashops' in *Penrose* 47. (On lithographs commissioned by Lyons.)
'The return of illustration' in *Penrose* 47.
'George Macey and the Limited Editions Club' in *Penrose* 48.

RODO, Ludovico: 'The graphic work of Pissaro' in *Print Collectors' Quarterly*, October 1922. (The author is Camille Pissarro's son, Ludovic Rodolphe.)

Articles on prints have frequently appeared in *Studio* or, as it is now called, *Studio International*. Some are listed below, with author's name where possible.

'Contemporary British Lithography' in *Studio*, September 1950.

'Contemporary American Lithographs' in *Studio*, June 1954.

STRACHAN, W. J.: 'Recent colour lithographs of the School of Paris' in *Studio*, May 1955.

—'Le beau livre maintenant' in *Studio*, May 1960.

VON GROSCHWITZ, Gustave: 'International prints' in *Studio*, September 1960.

JALALUDDIN, Ahmed: 'International prints in Japan' in *Studio*, February 1963.

The magazines *Alphabet and Image, Image,* and *Typographica,* all of which are now defunct, carried on the traditions of scholarship associated with such publications as *Fleuron* and *Signature*, which flourished during the nineteen-twenties. Some of their articles are listed below, where possible with the author's name.

'The drawings and book decorations of Lynton Lamb' in *Alphabet and Image*, September 1947.

STRACHAN, W. J.: 'Three French illustrators: Gischia, Houplain and Clavé' in *Image* 4, Spring 1950.

MAYES, Jonathan: 'The graphic work of Anthony Gross' in *Image* 4, Spring 1950.

—'The book illustrations of André Marchand' in *Image* 6, Spring 1951.

—'Experiments for a book: Henry Moore lithographs' in *Image* 8, Summer 1952.

STRACHAN, W. J.: 'French lithographic illustration' in *Typographica* 10 (old series, pre-1960).

SOME BOOKS ILLUSTRATED BY AUTOLITHOGRAPHS

Baron Taylor: *Voyages pittoresques et romantiques dans l'ancienne France*. Lithographs by many artists. Published at intervals 1820–50.

Goethe: *Faust*. Lithographs by Delacroix. Paris, 1828.

Les cent et un Robert Macaire. Lithographs by Daumier. 2 vols., Paris, 1839–40.

Georges Clemenceau: *Au pied du Sinai*. Lithographs by Toulouse-Lautrec, Paris, 1898.

Paul Verlaine: *Parallèlement*. Lithographs by Bonnard. Paris, 1898.

Longus: *Daphnis et Chloë*. Lithographs by Bonnard. Paris, 1902.

Jean Richepin: *La chanson de Gueux*. Lithographs by Steinlen. Paris, 1910.

J. M. Richards: *High Street*. Lithographs by Eric Ravilious. London, 1938.

Phoebe Pool (ed.): *Poems of Death*. Lithographs by Michael Ayrton. London, 1945.

The Arabian Nights. Lithographs by Chagall.

Voltaire: *Candide*. Lithographs by Clavé. Paris, 1948.

Prosper Mérimée: *Carmen*. Lithographs by Clavé. Paris, 1946. (There is another edition, with lithographs by Rene Ben Sussan, published in Paris in 1930.)

Rabelais: *Gargantua*. Lithographs by Clavé. Paris, 1955.

Jean de la Fontaine: *Contes*. Lithographs by Derain. Paris, 1950.

Baudelaire: *Les Fleurs du mal*. Lithographs by Goerg. Two vols., Paris, 1948, 1952.

Amis et Amille (trad.). Lithographs by Derain. Paris, 1957.

John Galsworthy: *The Forsyte Saga*. Lithographs by Anthony Gross. London, 1950.

Jacques Audiberti: *La Lagune hérissée*. Lithographs by Carzou.

Rudyard Kipling: *The Jungle Books*. Lithographs by David Gentleman. Avon, Connecticut, 1968.

SOME PORTFOLIOS OF RELATED LITHOGRAPHS

Elles, by Toulouse-Lautrec.
Quelques aspects de la vie parisienne, by Bonnard.
Paysages et intérieures, by Vuillard.
Hammerklavier Suite, by Ceri Richards.
Dylan Thomas Suite, by Ceri Richards.
Leda Suite, by Sidney Nolan.
Rinder, by Sidney Nolan.
A Retrospect of Churches, by John Piper.
A Bestiary, by Graham Sutherland.
Stoned Moon, by Robert Rauschenberg.
Mythologie sexuelle, by André Masson.
Terre érotique, by André Masson (poem by André Pieyre de Mandiargues).

Index

Page numbers in italics refer to illustrations